Developing Effective Websites:
A Project Manager's Guide

Developing Effective Websites:
A Project Manager's Guide

Roy Strauss
Patrick Hogan

Focal Press
An imprint of Butterworth-Heinemann

Boston Oxford Auckland Johannesburg Melbourne New Delhi

Focal Press is an imprint of Butterworth–Heinemann.

Library of Congress Cataloging-in-Publication Data

Strauss, Roy.
 Developing effective websites: a project manager's guide / Roy Strauss, Patrick Hogan.—2nd ed.
 p. cm.
 Rev. ed. of: Managing multimedia projects, c1997.
 Includes bibliographical references and index.
 ISBN 0-240-80443-0 (pbk. : alk. paper)
 1. Multimedia systems. 2. Web sites—Management. 3. Application software—Development. I. Hogan, Patrick. II. Strauss, Roy. Managing multimedia projects. III. Title.

 QA76.575 .S775 2001
 006.7′6—dc21 2001023144

British Library Cataloguing-in-Publication Data
A catalogue record for this book is available from the British Library.

The publisher offers special discounts on bulk orders of this book.
For information, please contact:
Manager of Special Sales
Butterworth–Heinemann
225 Wildwood Avenue
Woburn, MA 01801-2041
Tel: 781-904-2500
Fax: 781-904-2620

For information on all Focal Press publications available, contact our World Wide Web home page at: http://www.focalpress.com

10 9 8 7 6 5 4 3 2 1

Printed in the United States of America

This book is dedicated to:

Melinda, Ilana & Alex
and
Christine, John & Clare

Contents

Preface

In the chit-chat of a family party, the subject of this book came up. "I need to read that," said a brother-in-law, a managing partner of a small law firm. "Our website hasn't changed in two years."

"Who's managing it?" we asked.

"Nobody. That's the problem," said the brother-in-law. Indeed. And it didn't take a C++ programmer to figure it out. We recalled our first visit to the site a few years ago. A modest site, what we call a "Web presence," with lawyer biographies, contact information, and little more, it was nonetheless impressive to see that the firm was on the Web.

In those early days of the Web, enthusiasts touted its democratizing power. "Now everyone can be a publisher," they proclaimed. Organizations of all types, sizes, and missions came forth to fulfill that promise. The sheer quantity of Web content is astounding, but just being there is no longer enough. Managers are asking, "How does the site further our goals?" Finance people are asking about return on investment. Perhaps the only way to launch a new medium like the Web was the all-out blitz that ensued. As a more mature medium, the Web now requires a more disciplined approach, and the principles of project management have much to offer.

Project management has its roots in large-scale projects in construction, aerospace, and the military. Now its principles are applied in all sorts of industries. Project management is a natural ally of business management trends such as reengineering, outsourcing, teams, and flat organizations. Some will claim that Web development projects are inherently out of control and in fact defy the linear, studied approach of project management. We believe that an out-of-control approach is a matter of choice. Web developers do not have to be the victims of their process. They can choose to be masters.

Woven throughout this book, lending context to every aspect of development, are the three dimensions of project management: Time, Resources, and Task. Connected like the three corners of a triangle, restricting one dimension constrains the other two, or conversely, investing in one lends license to the others.

Any Web developer can tell stories of meeting with a client who cannot articulate the task (what they want to accomplish). "We just need to be on the Web"

may have been the most common strategic objective for corporate websites in the mid- to late 1990s. The best developers could guide the client to a clear objective if only by writing a proposal. Even so, a project with such beginnings is getting off on the wrong foot. Time and resources will fill the vacuum of a vague task.

Nonetheless, Web development challenges project management principles because it is, at its essence, an iterative process. Between us, we have 40 years of experience in developing products for print, video, CD-ROM, and the Web. Clearly, the processes long in place for print and video do not fit the Web development environment. We recall the multimedia craze of the 1980s and early 1990s, preceding the Web. The word *multimedia* became a marketing buzzword slapped on just about any product or service, thereby losing much of its original meaning. Amidst all the glitz and hoopla, we thought, "It's only software." The same might be said of the Web. Software project management is nothing new, and its principles greatly inform the Web development process.

We refer a couple of times in this book to the software project management classic *The Mythical Man-Month*, by Frederick P. Brooks, Jr. Written in 1975, this book is still strongly recommended to the website project manager. Brooks speculated on why programmers tend to be overly optimistic with scheduling. He posits a few hypotheses, one of which is that programmers tend to be young, and the young tend to be optimistic. Although programmers may tend to be young, the ones Brooks was writing about aren't! The point is that if you can take a larger perspective and look beyond Web hype, you will see that Web development is not all uncharted territory. Grizzled veterans of software development have blazed some trails for us.

To an extent, the Web is fulfilling its promise of making publishers of us all. People in all sorts of organizations find themselves responsible for websites. We wrote this book to share the principles of project management and software development with a wider audience.

As the Internet drives new business development, the value of website project management skills can only grow. You do not have to be a Java programmer to be a website project manager, but you do need to be familiar with the technology. We have stressed project management in this book, giving only a cursory coverage of technology. The choice was one of focus. For those moving to the Web from product development in other media, we strongly recommend immersing yourself in the technology and learning as much as you can. Technology knowledge is critical to your success. The rapid growth of the Web has afforded many young people lots of hands-on experience on Web teams. These people will be the leaders of Web development in the next decade. For those readers, we hope to give a larger perspective that will help in the move to a project manager or team leader role.

Our goal for all readers is that this book will illuminate the Web development process and help you manage your projects with confidence and expertise.

Project Management in Three Dimensions

Managing complex projects, such as websites, often entails many conflicting issues and concerns. You may think the time available to accomplish the task is insufficient, the job is too complex, or the budget is inadequate. Determining the proper course of action can be difficult. Understanding the three dimensions of project management—time, task, and resources—can help you get a grip on things.

Without an understanding of how these three factors interrelate, you can easily slip into a reactive mode, constantly responding to the crisis of the moment. Once these three factors are understood and appreciated, however, they become the reins of control by which you can effectively manage the development and maintenance of a complex website.

These three factors of time, task, and resources constantly interact in a Web project, changing priorities and fluctuating in importance as the project advances. Understanding how they interact gives you a valuable and objective perspective that helps demystify the development process. The project manager must juggle these factors and make decisions about tradeoffs and compromises along the way.

In *Dynamics of Software Development*, Microsoft's Jim McCarthy writes: "As a development manager, you're working with only three things: resources (people and money), features (the product and its quality), and the schedule. This triangle of elements is all you work with. There's nothing else to be worked with."

These three factors can be represented as the three points of a triangle (Figure 1.1).

THE THREE PROJECT FACTORS

Time

For the purposes of a website, the available time is indicated in the project schedule—specifically, the period from start date to completion deadline; that is, when

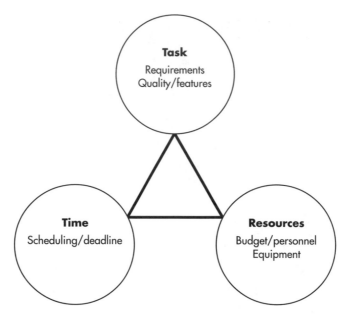

Figure 1.1 The project management triangle: time, task, and resources.

the site is to "go live." The schedule relates to the nature of the task (as designed) and the available resources (people and equipment). As a rule, the more resources available and the simpler the design, the faster the task can be accomplished, but only to a point. One might suppose that a project that takes one year with only one person working on it would take six months with two people and one month with twelve. In practice, however, adding more people does not reduce the amount of time at the same rate; a point of diminishing returns occurs when the overhead of communication and administration to coordinate the myriad of people and activities negates the increased work actually being performed.

For example, during the development of an expanded, highly interactive version of a map publisher's website, the development team included more than one dozen internal programmers, artists, and content/editorial personnel, as well as external website developers. With so many team members, it became increasingly difficult to coordinate their activities and ensure effective communication to avoid wasted and duplicated effort. With the release date approaching, it became evident that some of the individuals were working at cross-purposes, thereby actually slowing down the development process. The only solution possible at this point was to reduce the project staff to only those who were essential to the completion of absolutely necessary tasks. By doing so, the project was able to pick up speed and finish on time, albeit with the minimally required content and functionality.

You may also have experienced this effect of more resources slowing down development when working on a project that has fallen severely behind schedule. Management, seeing a problem, decides to solve it by throwing more people at it. This actually slows the project down further, at least temporarily, as the new-comers get equipped, trained, and worked into the process. The work often is not speeded up appreciably, even after these new recruits have been assimilated, because of the increased overhead for administration and communication within the team.

Some tasks, by their nature, take longer and depend heavily on the talent, skills, and experience of the individuals performing them. Software programming is the best example, where the effectiveness of different programmers can vary by several orders of magnitude. An experienced, creative programmer may complete a task in a few days, whereas another programmer lacking experience or motivation may need several months or may be incapable of completing the task at all. Even a particular individual's temperament may be more or less well suited for a particular task. In some situations, a programming task can be speeded up considerably by hiring the right programmer, or slowed down a similar amount by adding several inappropriate programmers.

Occasionally, the fastest way to complete the project is not to change anything. Even though progress may appear to be going exceedingly slowly, maintaining the existing situation may be the most efficient option.

Task

The task refers to exactly *what* is being built. Task expresses the scope of the work to be performed: the magnitude, complexity, and design of the project. For a website, this consists of the site design, including quantity of content and programmatic features. This definition of the end product determines the number of people necessary to produce the site, the skills they must have, the kind of equipment they will need, and how long it will take them to complete the first version of the site. For example, all else being equal, a Web presence consisting of six pages with a basic design takes less time and fewer resources than a database-driven, searchable informational site with e-commerce capabilities.

Resources

Resources refers to the funding for the project and all that it purchases in terms of people's time and services, materials, and equipment. In general, more funding enables a faster development schedule (time) or a more complex, higher-quality site; however, as noted earlier, if a project has fallen behind schedule, adding resources (people and money) does not always speed it up. Adding people to a project that has fallen behind schedule can cause it to fall even further behind if the wrong resources are added or are added at the wrong time. When more

highly skilled and specialized resources are needed, they should be added early or not at all. For example, adding programmers early in the project can speed it up, but adding them toward the end may well delay the project even further. Frederick Brooks, in his software project management classic *The Mythical Man-Month*, wrote: "Adding manpower to a late software project makes it later." The maxim expresses such a fundamental truth that it has come to be known as Brooks' Law.

The project's fixed variable, and thereby its limiting factor, is often resources. When no more money or people can be thrown at a project, the time (schedule) and task (functional requirements) variables are where adjustments must be applied. When a project with fixed resources runs into difficulty, you must simplify the design or extend the deadline or a combination of both.

SEEING IT IN THREE DIMENSIONS

In the heat of a project, all three factors—time, task, and resources—are ever changing, constantly interacting variables. The job of the project manager is to constantly balance these three factors (Figure 1.2). Suppose management transfers a key team member to another project, restricts access to equipment, or cuts the budget. As a result, the project either takes longer to complete (time factor changes), becomes less ambitious in scope (task definition changes), or both. Likewise, if the design is scaled back (features are dropped or simplified), the project

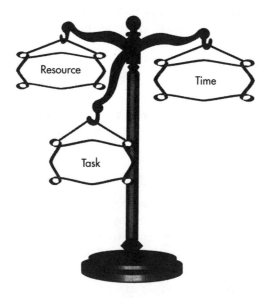

Figure 1.2 Balancing the three project factors.

can be finished faster or with fewer people. The main goal of project management is to constantly balance these factors in flux.

Your consciousness of the interplay of these three factors and ability to act on them will make you a master of the development process rather than its slave. By manipulating these factors, you can exert considerable control over the project. Your command of their interplay will help you:

- Explain schedule delays.
- Say "no" to design changes and "feature creep" with good reasons.
- Justify increased personnel and equipment requests.
- Recognize opportunities to improve project dynamics.

Only by examining these factors on an ongoing basis can you identify trouble spots and proactively address growing problems. Once a crisis hits, your analysis will help you learn from your mistakes, but you will fall short of saving the project at hand. Prevention always works better. Project management software can help you monitor progress. When you watch these factors on a daily basis, you can make minor adjustments along the way and avoid crises before they develop.

For example, our project developing an e-commerce website for an association publisher was slow getting started because of a resource problem. The plan for the site required a full feature set, including an online catalog of books and promotional items with cross-referencing ability, user surveys, a guest book, customer reviews, and multiple searching options. The project was adequately funded and scheduled accordingly. As development began, however, it became apparent that not enough people were working in content development. This limiting factor set a slower top speed for product development, lengthening the schedule requirements in other project areas. Next, the effect of the lengthened schedule lowered the project's priority in the eyes of the external programming team, compounding the scheduling problem as the work took a backseat to more active projects. As development drifted on at this slow pace, the site was at risk of stalling entirely. With little to show in the way of progress and the deadline approaching, the project managers feared that their funding might be withdrawn. Saving the project called for drastic measures.

First, the project manager trimmed the task by narrowing the feature set to the minimum necessary. Next, a new content lead came to the project and staff was brought over from other projects to quickly populate the backend database with content. The project manager rescheduled the due date with the external programming staff and sought their commitment, with assurances that the project was on track and would move quickly. The abridged first version was ready to go live in a few months. In terms of the three factors, a shortage in the anticipated resources was addressed by lengthening the time factor and decreasing the task.

A natural reaction in such a situation, however, is to make up for lost time by pressuring programmers, while avoiding any adjustment to the project. Although this approach may improve appearances in the short term, it is usually not effective in the long haul. You may inspire spurts of super-productivity, but this pace is difficult to sustain. Work patterns gravitate toward their equilibrium. If you must apply pressure to change programmers' behavior, then you may have to keep the heat on for the remainder of the project. As the programmers become desensitized to such pressure over time, you will need to become increasingly firm. This tactic can create an uncommunicative, dysfunctional, and potentially explosive situation as the project grinds along. By the end of the project (if you make it that far), you may no longer be on speaking terms with the programmers. Costs emerge in employee dissatisfaction and the long-term quality of work. You will be subject to the law of diminishing returns. People working excessive hours tend to make more mistakes and usually do not work as fast as they normally would. So while you take on additional cost, you may not gain proportional benefits in productivity. Asking team members to work longer hours is usually beneficial only at the end of the project.

A better course of action is to identify as early as possible the source of the problems, without blaming individuals. Then try to fix the system or situation dynamics causing the problems. Perhaps yours is a bigger job than originally estimated, and without more funds to hire additional personnel, the project specification needs to be changed in order for you to meet the deadline. As Microsoft's Steve McConnell puts it in *Rapid Development*, "Cut the size of the software so you can build it within the time and effort planned." You may need to make changes to your team because current personnel are not well suited to the task at hand. Perhaps your programmer has a mainframe programming background, without the necessary Web programming experience to be effective on your project.

SOLVING PROBLEMS

No single method will solve these kinds of problems, and no rulebook tells you when to adjust which factor; however, budgets are usually fixed. Obtaining more resources (money) is always a difficult, if not impossible, proposition. And extending the delivery date does not necessarily decrease the cost and may conflict with other organizational objectives. Increasing the schedule is a quadruple threat for the following reasons:

1. Changing the timing of the product introduction can have all sorts of negative marketing and sales consequences.
2. Costs increase because people must be paid to work on the project for a longer amount of time.

3. Additional schedule time leaves an opening for additional "feature creep."
4. Extended timelines sometimes take the pressure off the development staff, which can lessen the urgency they feel to complete the task.

By process of elimination then, the decision often boils down to changing the design specification. Depending on the specific situation, however, fine-tuning any of the three factors is a possibility. Discuss the options with members of the Web development team as well as others in the organization who may be affected by your decision. Specialists in marketing, sales, and technology can often suggest alternatives of which you are unaware. As the project manager, you are responsible for finding a way to fix things through creative problem solving and an intimate knowledge of the development process.

Tightening Up a Loose Project

By identifying bottlenecks in the development process and reassigning tasks to widen those bottlenecks, you can often tighten up a loose project. For example, imagine creating a Web-based training program that contains numerous interactive simulations, all of which are individually programmed. The whole project may depend on a single programmer who is placing graphics, programming the simulations, and performing software testing. This heavy individual responsibility represents a substantial bottleneck. Perhaps another programmer could create and place graphics, and another could test the simulations once they are programmed, thereby widening the bottleneck.

Crises

Websites tend to be prone to crises, for the following reasons:

1. As software projects, they are subject to the many unknowns inherent to the invention or development process.
2. Cultural differences among team members from different disciplines (e.g., programming, writing, art and design, network technology, systems analysis) can lead to miscommunication and other management difficulties.
3. Team members new to website development projects must climb a steep learning curve, which slows down the process and leaves you vulnerable to mistakes.

Crises can usually be identified by a significant shortfall in two of the three project factors. For example, if your deadline is only one week away (time) and your

programmer just quit (resources), then the project is probably in a crisis—even with a reduced feature set. Or if you have implemented only half the features (task) and the budget is exhausted (resources), you have another kind of crisis on your hands.

The way to deal with a crisis is to break down the project factors, identify the main problem and how to fix it, and then balance and readjust the three factors.

Breaking It Down

When a crisis develops, separate the project factors and examine each issue to see what's wrong. With a bit of luck, they can be fixed and realigned.

For example, when Commodore was developing AmigaVision, one of the first icon-based authoring systems, the project stalled in the Beta phase. We couldn't seem to move into the final testing phase. The original deadline came and went, development costs were skyrocketing, and management was ready to pull the plug on the project. By breaking it down, we realized the following:

- Given the original product specification, our resources should have been adequate.
- The original time estimate was overly optimistic.
- "Feature creep" had struck.

Concerned about features that were thought to be under development in rival authoring systems, the marketing department had dictated numerous modifications and additions, superseding the original design requirements. Our analysis showed that continuous "feature creep" was responsible for the stall in Beta. The obvious answer was to freeze the application with the existing features, which had already considerably surpassed the original set. We took this step with senior management's approval and were then able to test, debug, and ship the software in a few months.

Maintaining Balance

So much of work comes down to people, which are categorized as resources in the project management model. If a key programmer finds another job halfway through the project, you face a resource problem. Personnel performance problems or interpersonal relations on the development team are not uncommon sources of delay. If a squabble breaks out between the programming and testing personnel, you also have a resource problem. Not that you do not have enough resources, but in this case, they cannot be used effectively because of the argument.

Websites are fluid, ever-changing works in progress. They reside in an online medium where change is an expectation. Often, shifting company priorities

require updates, reorganization, and even redesign; therefore, the task factor is often a moving target. Estimating the resource and time factors of the "final application" is especially difficult because the application is never truly finished. The resources necessary to maintain a reliable commercial website include internal project management and data preparation staff, along with external Web developers knowledgeable in the latest technologies.

2

Technologies of the Web

To a certain extent, project management is project management, regardless of the industry. As an established discipline, project management (as described in Chapter 1), has its eternal truths, systems that work no matter what project you're managing. In theory, project management is portable from industry to industry; however, project management is more than a theory, it's a practice. The project manager's practice involves communication, problem solving, and decision making, all of which require a solid technical grasp of the field. Even in the role of facilitator and motivator, the project manager needs technical knowledge to earn the credibility and respect of team members.

This chapter introduces some of the basic technology underlying websites and website development. It is meant as a jumping off point. To those new to website development, this discussion will at least help you become conversant in the technology and know the sorts of questions you should be asking. It will also help you identify the gaps in your knowledge. It's up to you to bring yourself up to speed, whether through outside reading, classes, seminars, or workshops. Project managers of websites often grow into the position from a specialty within the development process and boast detailed technical knowledge within the specialty. As for the specialized skills plied by others on the team, they may possess only superficial familiarity. The systems analyst, for instance, may be an expert on the architecture of a database but may have no understanding of what the designer has done to prepare image files that go into it.

CLIENT-SERVER SYSTEMS

The Internet is sometimes referred to as a network of networks, a grand and complex system of clients and servers. In a world where computers and networks are ubiquitous in all sorts of organizations, the terms *client* and *server* are bandied about regularly, but they are not always clearly understood. The operating premise of a network is that computers are called on to perform specialized tasks.

The client requests and uses a specific service. The server provides the service. The World Wide Web, and the Internet in general, at its essence is a series of platform-independent network protocols that enable identification of remote machines, connections between those machines, and the transfer of files back and forth.

INTERNET PROTOCOLS: HOW FILES TRAVEL THE INTERNET

The many clients and servers that constitute the Internet can cooperate because they speak the same language. Beneath the many operating systems and software programs working the Internet is a *lingua franca*, specifically a series of protocols. For instance, when you surf your way to a new site, your Web browser is using HTTP (hypertext transfer protocol) and a URL (uniform resource locator) to identify a file to be retrieved. TCP (transmission control protocol) and IP (Internet protocol) route the request to the proper server.

You can think of the protocols at work in the Internet as a series of layers (Figure 2.1). Protocols such as FTP (file transfer protocol) or HTTP work at the application layer. TCP and IP work closely together to create logical channels to the application layer. Messages are broken into datagrams or packets routed across networks, then reassembled.

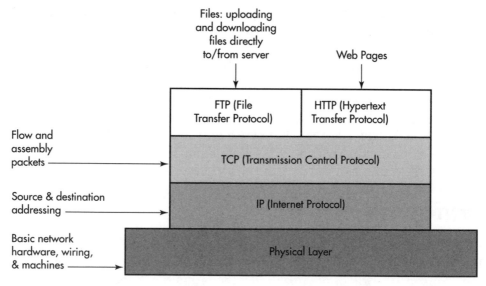

Figure 2.1 Internet protocol layers.

Applications require specific formats in order to present the data in a useful format. If you have ever opened up an e-mail attachment and found gobbledy-gook ASCII text when you expected a stunning picture of your newborn niece, then you know what happens when the requirements are not met. In networking parlance, this is referred to as the presentation level. Examples of data formats that make files useful over the Internet are HTML, JPEG, or MIME.

The genius behind these protocols is that they make the Internet scalable. Remarkably, protocols developed in the halcyon days of the ARPANET long ago still work for today's robust, commercial Internet environment.

TCP/IP

TCP/IP is the protocol that takes care of all of the networking details of a file so that the application can treat it like a simple data stream. TCP and IP work closely together and often are considered as one but are actually separate protocols. IP is the most fundamental protocol. It runs on all the computers of a network as well as routers, which connect two or more networks together, allowing these multiple machines and networks to function as one logical network. IP is so generic and un-demanding that just about any network technology that might turn up in a net-work can handle it. IP is used to make routing decisions. Using hierarchical addresses, it finds a route for a packet and gets it to the other end. These addresses are represented as a series of numbers, separated by dots (e.g., 192.12.69.248 or 200.3.6.2). Every computer on the Internet can be represented by an IP address. A technology called *subnetting* allows a single IP address to denote multiple physi-cal networks, effectively adding a third level to a two-level hierarchical address. IP is a connection-less, "best effort" service; it carries no guarantee to deliver your packet. That's where TCP comes in.

TCP breaks up a message into packets (which are then routed through IP) and reassembles them at the other end. A data packet contains headers with TCP and IP codes, which allow these functions to occur. It resends what gets lost, and it puts things back in the correct order. TCP opens a connection to the specified computer, tells it what you want, and controls the transmission of the file. Servers will have "well-known sockets" or assigned ports for specific functions, like FTP or the Web.

DOMAIN NAME SERVERS

IP addresses effectively identify computers on the Internet and enable routing. The numerical IP addresses work fine for computers but are not so friendly to humans—we like names. Domain name server (DNS) is the naming system of the Internet. Domain names, like IP addresses, are hierarchical. The names are

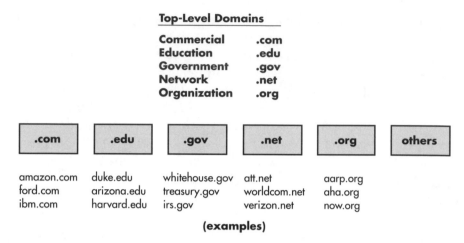

(examples)

Figure 2.2 Top-level domains.

processed from right to left. The top-level domain is to the far right (Figure 2.2), common examples of which are:

.com

.edu

.gov

.org

.net

Figure 2.3 shows how a client's request for a domain name is matched to IP addresses through the use of name servers. The process will, therefore, always travel through a root name server. In this case, a ".gov" server finds and sends an IP address for the domain "whitehouse.gov"; the request is then routed through the domain name system of servers to find the IP address for the "www" server in the "whitehouse.gov" domain.

To keep up with the increasing demand for domain names, it is likely that new top levels will emerge. When you type a domain name into the URL field of your browser, your request goes to a DNS, which routes it to an IP address in a process called *name resolution.* DNSs reside throughout the Internet to set up a system for name resolution. There is no central repository of Internet domain names.

Any number of companies can register your domain name. Most have websites that allow you to search the Internet to see if a name is available. Various "whois" services can help you search for information on names and their owners.

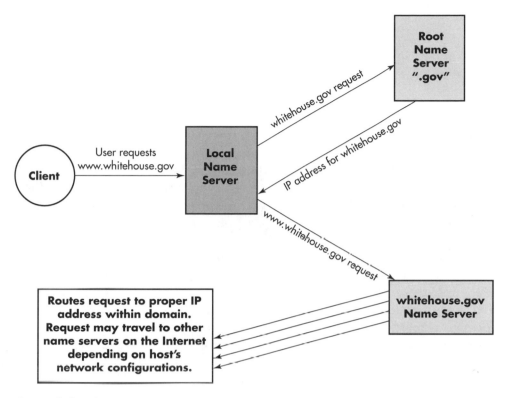

Figure 2.3 Domain name server (DNS) and IP routing.

See the Yahoo category: Computers and the Internet>Internet>Domain Name Registration.

If you do not have a domain name registered for the site you're developing, you should start the process early on. You don't want to be caught late in the development process and still waiting for your name registration to be processed. A useful web resource for this is Domain Buyer's Guide <www.domainnamebuyersguide.com>.

APPLICATION PROTOCOLS

The primary application protocol at work on the World Wide Web is HTTP (hypertext transfer protocol). HTTP is the common protocol that enables any browser (e.g., Netscape, Internet Explorer, Opera) to access the same Web page.

You can also use FTP through a Web browser. The fact that FTP is both an application protocol and a software application is a source of some confusion.

When you use Internet Explorer to visit an FTP site, your application, Explorer, is using the FTP protocol. Browsers present a graphical interface for downloading or uploading files, but the protocol at work is still FTP. Another example of application protocols is SMTP (simple mail transfer protocol), which is used for e-mailing.

INTERNET FILE FORMATS

At the presentation level, applications depend on specific file formats so that data can be displayed in a useful way, as intended. Graphics, for example, need to be either JPEGs or GIFs to display through a Web browser. As you manage the content development of your website project, you will be working with multimedia content in any number of file formats.

All Web browsers read a few basic file formats, which are sometimes called Web-native. The format for text is HTML (hypertext markup language). JavaScript adds features that HTML cannot support independently—programmatic features such as variables, logic branching, and math calculations. XML is a developing standard for tagging content that offers much greater functionality than HTML. For graphics, the common compression formats are GIF or JPEG; or for sound, WAV files. Through the use of plug-ins (small programs used by browsers), additional formats can be read. (They will be discussed later.) The point here is to illustrate the path these files follow, the breakdown and reassembly in order to travel from the Web server to the user's screen.

STANDARDS FROM THE WORLD
WIDE WEB CONSORTIUM

The organizational body developing these standards and protocols is the World Wide Web Consortium. The W3C, as it's known, develops interoperable technologies (e.g., specifications, guidelines, software, and tools) to lead the Web to its full potential as a forum for information, commerce, communication, and collective understanding. The W3C advocates against proprietary technologies that will not work across a range of applications. Among the services offered on its website <www.w3c.org> are HTML and CSS (cascading style sheets) validation. The W3C website is a good place to check out established and evolving standards. The standards process is necessarily slow, subject to debate, discussion, and deliberations in order to negotiate a common middle ground among sometimes competing technologies. The standards cannot possibly keep up with the rate of innovation coming from individual companies. Website project managers should be able to distinguish between emerging technologies, which raise questions of portability and interoperability, and established standards, which are always safer but not cutting edge.

SERVERS AND WEB TECHNOLOGIES

Move over, you flashy designers and hotshot producers. The real action of the Web is on the server. Unfortunately, to much confusion, the term *Web server* is used interchangeably to refer to hardware, software, or both. At the most basic level, the server receives requests from the clients around the Internet and serves up the requested files. In sum, it performs a myriad of other functions that keep a website humming. The specialized services that are capturing the public's interest in the Internet, such as e-commerce, distance learning, online auctions, or file-sharing services, all depend on sophisticated server software and programming.

SERVER HARDWARE AND SOFTWARE

The tasks that the machine performs define a server, not the hardware itself. Theoretically, just about any computer running any operating system can be used as a server, whether an old 486 desktop, a laptop, or a mainframe; however, Web servers are usually rack-mounted boxes with a powerful processor and lots of storage and memory.

The location and spatial requirements of servers also vary. A small operation may serve its needs with a desktop computer. You will also see small racks or huge racks with hundreds of servers rarely touched by human hands. Fundamentally, the server is a computer that is attached to the Internet and can run the required software.

Basically, the hardware end of the Web servers is just a computer—any "box" will do. The brains and grunt work of Web services takes place on the software side. The requirements of the software determine how powerful the box needs to be. Common examples of server software include Microsoft Internet Information Server (IIS), Apache Web Server, or iPlanetWeb server.

Server software must be compatible with the operating system platform of the computer it's running on, and Web server software comes bundled together with the box. For example, the Apache Web Server program would not run on a machine with the NT operating system, but you could run it on Red Hat Linux Professional or the Solaris 8 Operating Environment. Microsoft IIS runs with the Microsoft Windows 2000 Advanced Server of NT.

A question that regularly arises from clients working with their first website is: "Why do I need Web server software at all?" They've seen a designer come in with a directory of HTML files and images created in Dreamweaver and residing on the local hard drive, then clicking away through a series of pages that look just like they do on the Web.

The distinction should be obvious from reading about Internet protocols. One function of Web server software is to recognize the "dumbed-down" packets

traveling the Internet and to translate these messages into instructions to be executed. Web server software responds when its IP address is called on. It monitors traffic and provides the glue that connects your website to the outside world. In addition, many websites demand more than simply serving up static Web pages. Among the functions that Web server software may perform are verifying credit cards, registering users, and creating database records.

To achieve more sophisticated functionality, specialized server applications have emerged for customized tasks, beyond simply serving up Web pages or connecting to a database. For example, Web-based training servers, like Saba, construct content pages on the fly, test users through multiple choice and other types of questions, score answers, store results, and register users for courses. Accomplishing these tasks with general-purpose Web server software would take an inordinate amount of programming. E-commerce provides another example, with needs like a shopping cart process and completing online credit-card transactions. E-commerce servers require a high level of security, with the ability to handle digital signatures and encrypted files. In short, for anything besides static Web pages, the server needs to be programmed.

CONNECTED DATABASES

Web developers often talk about performing a function "on the back end," which means on the Web server (rather than on the user's browser). The most common function performed on the back end is interactivity with a database. Interaction with a backend database delivers a qualitative jump in the capabilities of a website. All sorts of functions can be delivered that otherwise would be economically unfeasible, if not impossible.

For example, imagine a music website that categorizes bands by type of music, showing a page for each band, all of which are identical except for the specifics of that band. You might use static pages, creating long lists of the bands in each category, and individual pages for each band (Figure 2.4). This manual approach might work fine for 10, 20, maybe even 50 bands. But what happens when you're ready to go to the next level? Would the process work for a website featuring thousands of bands? Not very efficiently. Creating, maintaining, and testing so many individual pages would give you headaches and bust your budget in no time.

With a backend database, you could grow your band website with ease. Your standardized categories of information about each band would consist of records in the database (Figure 2.5). When a user picks a particular band, the server software queries the database, and the appropriate data flow into a master template on the site. Your job would be to populate the database, and fill-in forms would make this task easy. Scalability is a key consideration in website design,

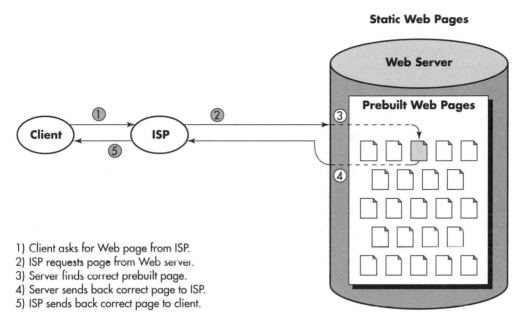

1) Client asks for Web page from ISP.
2) ISP requests page from Web server.
3) Server finds correct prebuilt page.
4) Server sends back correct page to ISP.
5) ISP sends back correct page to client.

Figure 2.4 Static (prebuilt) Web pages.

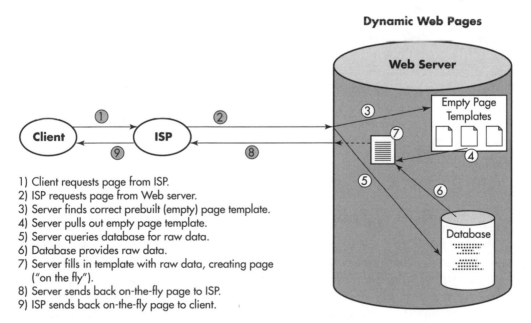

1) Client requests page from ISP.
2) ISP requests page from Web server.
3) Server finds correct prebuilt (empty) page template.
4) Server pulls out empty page template.
5) Server queries database for raw data.
6) Database provides raw data.
7) Server fills in template with raw data, creating page ("on the fly").
8) Server sends back on-the-fly page to ISP.
9) ISP sends back on-the-fly page to client.

Figure 2.5 Dynamic (backend database-driven) Web pages.

and databases can provide it. On the user's end, a database would allow more reliable searching than a static Web site. Users search for bands playing country music or another favorite type of music. The search function is merely a query on a database, and the server software is the engine behind it.

A database allows many functions that are impossible on a static site. For example, let's say you want to invite users to submit their e-mail addresses in order to receive new product announcements. Users would submit the required information in a form, and the server software would send it to a database where it could be stored or exported, enabling e-mail marketing to self-selected customers. Many websites require user registration and assign a password for future access. Again, this function is accomplished through communications between the user and the database, and the server software makes the interaction possible. The most common databases used in website development are Oracle (for UNIX computers) and Microsoft SQL-Server (for Windows NT). Informix is another supplier of database applications.

The conceptual leap from static Web pages to dynamic pages constructed "on the fly" using database information is a fundamental one that must be appreciated by any aspiring website project manager. To the extent that you want an interactive website, which everyone seems to, you are probably going to want a database on the back end. Almost any large, useful website, from on-line trading to maps and auto shopping sites (to name a few), requires using a database.

HOW SERVERS AND DATABASES TALK

The Web server and the database behind it are separate applications and come from any number of software developers, as noted previously. Several proprietary technologies build the bridge that allows back-and-forth interaction between the server software and the database. The most common applications are Microsoft's Active Server Pages (ASP) on Windows NT/2000 and Cold Fusion on Unix/Linux.

These technologies basically embed "behind-the-scenes" commands to the server and database in the information being exchanged. The server or database recognizes the commands and responds accordingly. For example, consider user registration to a website running on Windows NT. After you fill out the fields shown on the Web page and click the Submit button, the server looks up your information in the database using ASP commands. If the server finds a match, indicating that you are a valid user, it lets you in and returns the appropriate screen. If the user name and password are not both in the database record, the server sends you an error message or displays a registration page. All of this functionality is accomplished through ASP. Cold Fusion would operate similarly on a UNIX-based system.

OTHER SERVER FUNCTIONS

Site Search

Searching a website is another common function carried out by Web servers. A feature now ubiquitous in websites, the search function allows users to submit a word or words and then delivers back a list of hotlinked URLs that contain the word. To do so, the server scans a prebuilt list of words from various pages on the site. The server, therefore, must constantly track data from all of the pages on the site, keeping up with any changed page, and then index them for searchable words. The server works off of its own list, which is kept independent of the Web pages themselves for quick, direct access. Because the server is not scanning all of the Web pages, when users submit search terms, the server can return the results almost instantly.

Cookies

Server software provides many ways to read information kept in the user's browser files. By reading specialized files in the browser, the server can learn important information about that browser's user. These special files in the browser are called *cookies*. The server can write cookies to the browser for future reference. For example, if you've ever bought books from Amazon.com, when you revisit the site, you are greeted with a personalized message and book recommendations based on your previous purchases. Server software recognized you by looking at the cookie file it wrote to your browser the last time you visited. Cookies are widely used for features such as registration, online ordering, and access to protected sites. Cookies are an important way for servers to provide such capabilities.

Security and Access

Web servers also provide security mechanisms that restrict access to certain data only to authorized users and transmit or receive data in encrypted formats, so the data cannot be intercepted and "opened" by anyone else. This capability is extremely important for financial transactions, from the shopping carts of e-commerce to investment and brokerage services.

The standard Web protocols, such as TCP/IP and HTTP, which are deliberately dumbed-down and designed for universal compatibility, make impersonating a person or organization fairly simple. When you connect to your preferred Big Name Broker website, you need to be absolutely assured that they are indeed Big Name Broker and not a clever hacker who's managed to impersonate them to steal your funds. Likewise, Big Name Broker needs to be certain that you are who you claim to be. This process is called *authentication*. User names and passwords

should not flow across the Internet in the clear, where a hacker's "sniffer" programs might pick them up. Big Name Broker will probably want to provide single users with log-in services to offer you a range of services involving several different servers, while avoiding costly user name and account maintenance. As the Internet becomes more of a commercial marketplace where legal and financial communications occur, the need for security becomes ever greater.

Cryptography is the umbrella technology that offers a solution, encompassing such technologies as encryption, decryption, authentication, digital signatures, and signature verification. Industry standard protocols such as SSL (secure socket layer), SET (secure electronic transactions) and S/MIME (secure multipart Internet mail encoding) offer a foundation for security.

Server Side Programs

For additional capabilities, special-purpose and custom software programs can be run on a server. For example, spreadsheet charting software can respond to users' data and easily create pie charts. The server receives the data, then calls on the special-purpose program, transferring the data over. The charting software constructs the pie chart, saving it as a GIF or JPEG. The server creates the page, placing the pie chart graphic on it.

The programs that run on the server can be written in everything from Java and C++ to Visual Basic and Perl. In the case of Java, the processing work may also be sent to the client side, through use of applets.

PUBLIC INTERNET VS. INTERNAL INTRANET

While the Internet enables distribution of your content worldwide, many organizations are using Web technologies to deliver proprietary information or services to employees only. A key consideration in designing your server and network configuration needs is whether you are designing an *intranet*, internal to your organization, or a public-access Internet. A hybrid that has emerged between these two extremes is referred to as an *extranet*. Specific distinctions among the three technologies are as follows:

- Public-access Internet connects your network to the world (Figure 2.6).
- Intranet is localized to your organization but might include several different physical sites. It is a vehicle for sharing proprietary information within the organization as well as facilitating human resource services like benefits management (Figure 2.7).
- Extranet permits limited contact outside the organization, opening up communications for key customer/vendor relationships, for instance (Figure 2.8).

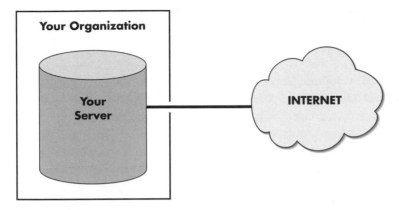

Figure 2.6 Internal server connected to Internet.

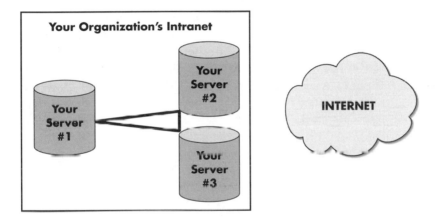

Figure 2.7 Intranet configuration (not connected to Internet).

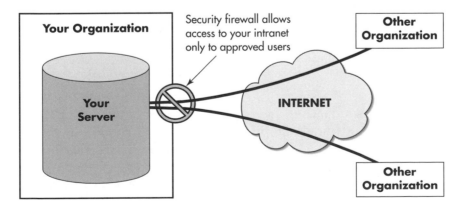

Figure 2.8 Extranet configuration (using firewall to control access).

HOSTING OPTIONS

Outsourcing vs. In-House

The decision about whether to host your website in-house or to outsource primarily comes down to issues of cost and control. In the case of intranets and extranets, the control advantages of in-house hosting and the proprietary content suggest the need for local, in-house hosting. For any particular website project, project managers should consult their technical people in considering such factors as volume of traffic, security needs, server administration, and general performance expectations. Following are descriptions of various levels of websites with associated server-level requirements.

Personal Home Page

The basic site—and one that by nature of being personal is unlikely to require a development team—is the personal website. Typically, personal websites are hosted externally, through a consumer Internet service provider (ISP), such as America Online (AOL) or any number of others. Files reside in a subdirectory of a member's Web pages with no domain name address, although domain name registration and maintenance is offered at a premium. This basic-level hosting, with limited storage available, is usually included in the user's monthly access charge, with additional services offered at a premium.

Light Site

What we describe as a light site is a basic Web presence such as a consultant or sole proprietor might want. It consists of one website with an IP address and registered domain name, hosting static pages, perhaps with some minor scriptable functionality, such as CGI (common gateway interface) scripts. Externally hosted, this level of site allows you to put some pages and content up, receive e-mail, and link to the rest of the Web. You could promote and market yourself but not actually transact business online.

Data Site

What we refer to as a data site adds database connectivity to our light site description. It enables dynamically built pages, whereby the server makes Web pages as needed "on the fly," or data collection through backend databases, as described earlier. Hosting services may also allow shopping cart and e-commerce for an additional charge. This level of site can accomplish a lot, but it does have

limitations. With a shared server, there are traffic restrictions, and you must play by the rules of the ISP regarding database access and what exactly you can do on the server.

Dedicated Server Site

The distinction from a data site to a dedicated site, as we move up the hierarchy, is that you no longer share a server. Although still externally hosted, the dedicated server allows you to do whatever you want remotely. You can have many IP numbers and run many websites on your own server. It's your server, but it is located at your ISP's location and uses their connectivity to the Internet. The dedicated server site model affords lots of flexibility, power, and traffic. The limitation may occur at extremely high levels of traffic. Also, when relying on a single server, you have no backup for data or to maintain service if your server goes down; however, solutions are available, at an extra cost. Or you can take the big step up the hierarchy and move in-house.

In-House Server Site

In this model, you deal directly with primary-level carriers for Internet service. You will need a Webmaster at least, and perhaps additional staff as well to maintain equipment and make sure you stay connected. The Web server connects to the Internet through a digital subscriber line (DSL), cable modem, T1, T3, or the like, and the carrier provides you with a static IP address provided by the ISP.

Web Farm

The Web farm is an externally hosted cluster of servers that allows massive levels of traffic. While enjoying the same functionality as the dedicated server, this hosting level spreads traffic across several servers. The benefits include redundancy of data and added assurances that the site will not go down. You can keep the database on a separate box to allow for fine-tuning and specialization of capabilities. Web farms are used for most large-scale corporate websites, such as Disney or CNN.

Internal Cluster

Here you are at the top of the heap—the most powerful, flexible, expensive, and maintenance-intensive option. The internal cluster is basically a Web farm hosted internally. It requires a top-flight connection (T1 or T3) and continuous technical staff support to manage it.

FACTORS IN YOUR HOSTING DECISION

The following factors play into the hosting decision:

Traffic: The greater the traffic, the more reason to have a dedicated server or even a cluster.

Functionality: The greater your range of required functions, the more you need a dedicated server that you can control and program without arbitrary rules and procedures.

Ability or desire to maintain server: If you do not have the technical staff or desire to maintain a server, your best option is to host externally and contract for those services as part of the hosting fee.

Security required: Theoretically, the most secure solution is to host internally, so that you can ensure your own control against hackers, with a firewall, proxy servers, and other safeguards. Again, in-house capabilities figure in here. A trusted vendor may in practice offer greater security.

Response time required: The fastest response time is obtained with a direct connection to the Web, through an external ISP, especially one with a primary/direct connection to the Internet backbone.

Development complexity: A complex development process benefits from an internal server, so you can move files, change partitions, and hook up databases locally. Although you can achieve these goals with an external connection, it has to be done remotely, through software such as PC Anywhere. An internal server is a convenience for fast-moving development, allowing you to work on the server keyboard itself, then bring the site live without moving files.

Cost: As the complexity and magnitude of the site increases, the external options become more expensive relative to internal options; however, external hosting reduces internal staffing and administration. Maintenance can be more efficiently handled by people who do it all the time for many servers. For large-scale solutions, the most economic alternative is often to buy your own equipment and place it in an external Web farm for good connectivity and maintenance.

A reasonable strategy is to move through the options as your site and its needs expand. If you are going to stay external, using a provider with the capacity to upgrade service levels as necessary is a good bet. Generally, this growth follows the path:

Shared Server → Dedicated Server → Web Farm (Clustered Servers)

WEB BROWSERS AND PLUG-INS

The Internet is a grand network of clients and servers. On the World Wide Web, the key applications on the client end are the browsers and plug-ins. The playing field of browsers has now been essentially eliminated to the big two—Netscape and Internet Explorer; however, Web users might be using any version of these two browsers. Website project managers will want to determine, or at least make some good guesses about, the browser and version of choice for their users because it will factor into development decisions. Browsers display a series of file formats and run certain kinds of programs that are referred to as Web-native because no additional technologies are needed. Examples of these programs are HTML, JPEG, GIF, JavaScript, and Java.

Browsers can also display media and program types that are not Web-native, but they need some help. Plug-ins, which are essentially mini-programs that are compatible with browsers, provide special instructions on how to display certain file types. When the browser encounters an unfamiliar file format, it checks its plug-ins for instructions on handling it. Common plug-ins include the following:

> *Adobe Acrobat Reader:* Displays PDF files—high-quality printable documents that retain formatting and fonts for the same look of the printed page across platforms. ·
>
> *Macromedia Shockwave:* Runs Director, Flash, and Authorware, which allow interaction with users.
>
> *Real Audio or Real Video:* Enables streaming audio or video.

Not all users can or want to install plug-ins. Unless you are sure that your audience is accustomed to using a particular plug-in, you should try to avoid the extra step. Do not use content requiring a plug-in gratuitously because you may lose potential viewers. Look for a strong argument that your message or service demands a plug-in, and then make it as easy as possible for users. For example, be sure to clearly indicate that a plug-in is needed, and give users simple instructions on downloading it.

WEB DEVELOPMENT TOOLS

In the early days of the Web, pages included little or no formatting, modest graphics, and little if any sound or video. The Web promised that anyone could become a publisher. Indeed, a rudimentary level of HTML was easy to pick up for anyone accustomed to word processing. One of the first best-selling books on HTML, *Teach Yourself Web Publishing with HTML in a Week*, by Laura Lemay,

fulfilled its promise for thousands of readers. As new versions of the HTML standard evolved and more capabilities were added, however, even the experts grew weary of coding in a text environment. Now almost everyone uses a Web-authoring program to some extent. These tools offer novices the opportunity to build a feature-rich site without writing or even knowing HTML. Knowledgeable coders may want to get in and tweak the scripting generated by these programs, and many other programs support that activity as well. Most Web-authoring tools now offer a WYSIWYG (what you see is what you get) interface. We won't present a detailed description here because the programs are always changing, and new tools are sure to emerge as well.

Programs vary in power, features, and user sophistication, and you should choose one that fits your project and capabilities. For beginners, some programs work much like word processors. Midrange products such as FrontPage, HoTMetaL, and WebEditor serve users who are not experienced in graphic design or HTML. At the expert level, programs like Macromedia's Dreamweaver or Adobe's GoLive are loaded with tools for graphic designers; or there's HomeSite, a code-based editor. You might also look at tools that are designed for collaborative Web development in teams, like NetObjects Authoring Server.

Among the features on which to compare editors are the following:

- Ease of creating effects through JavaScript or Dynamic HTML
- Tools for creating pages from backend databases
- Automatic navigation bar and link updating when moving files
- Guidance on features that won't work in earlier browser versions
- Methods used to upload files on remote servers.

KEEP UP ON TECHNOLOGY

We believe that technical knowledge is critical for a successful website project manager. This chapter is in no way meant to provide everything you need to know. First, everything you need to know is changing constantly. No matter what your career, if you've decided you know it all, then you might as well hang it up. In few fields is that adage truer than in website development. Opportunities for learning about website development abound, whether networking with colleagues, enrolling in workshops, or experimenting with new technology on your own. Unless you want your career in website development to last the proverbial nanosecond, keep learning. This chapter has surveyed the field, but it's up to you to dig in.

3

Scheduling

To schedule the workflow on a project, you need to do the following:

- Identify as many of the individual tasks as possible.
- Place them in a logical sequence.
- Identify the dependencies (i.e., tasks that depend on the completion of other tasks).

Only then should you start scheduling those tasks. The resulting workplan should include as many of the tasks as possible—not only software development tasks but the production of related print, audio, and video materials as well. Content and software development processes are interdependent and must be coordinated.

Although you should attempt to make the initial workplan as accurate as possible, do not imagine that it will remain unchanged for long. Workplans are in a constant state of flux. Managing and updating the workplan to account for the reality of the project workflow is an ongoing task and arguably the main function of the project manager. Current, sometimes daily, events drive the workplan. Scheduling and planning a Web project can have the feel of building a bobsled run just downslope from a hurtling bobsled. Therefore, the team leader must have some measure of management control over the resources assigned to the project.

Scheduling addresses one of the three main project management factors (time) and depends on the other two factors (task and resources). If your access to personnel and equipment (resources) is restricted, you will lose opportunities to gain efficiencies. Without such actions, the project may miss its completion date. Likewise, if the task is overly ambitious, the only possible outcome is a missed deadline without adjustments to task or resources.

PERSONNEL

Websites are developed by people. Your success depends on the right people working on the project at the right time. Not only must the right people be available for sufficient time, but the quality of that time is extremely important. A

29

programmer available for half as much time as needed will get only half as much done as needed. Even a full-time person will find it difficult to maintain the schedule, however, if constantly interrupted by nonproject tasks. The project manager must protect the staff from distractions and requests that interfere with the timely completion of assigned tasks.

A dedicated, full-time team assigned for the duration of the project is the ideal arrangement for managing staff. Only then can you avoid the resource contention that often occurs in less optimal situations. This full-time team arrangement has other benefits, including stable budgeting, decreased administrative time tracking hours on each project, and increased individual commitment to the project; however, a full-time team assignment is often not possible. The realities of business and production department workloads often limit the availability of key personnel, such as skilled programmers and talented artists. In such situations, you can identify the risk to the schedule and quality of work and inform management of it.

DELIVERING ON TIME

When it becomes apparent that a project with a fixed deadline is running behind schedule, sometimes the only way of getting it back on schedule is to add resources or decrease the magnitude of the project. This decision should be made as early as possible to maximize the benefit. Removing features is pointless if they have already been programmed and tested; in fact, removing features in the later stages of a project may actually increase the amount of work to be performed; however, if a feature is yet to be programmed, data has not been prepared, and the feature does not affect any screen layouts or graphics, removing it from the design could reduce the workload significantly and help bring a project back on schedule. In fact, decreasing the quantity and complexity of features is one of the most effective means of achieving the schedule. This technique must be employed judiciously, though, to avoid impairing the basic usefulness of the application. Sacrificing a feature that is central to the site's objectives is too high a price to pay to make a deadline.

Why the Date?

The project manager will benefit by understanding why a particular delivery date was chosen. Was the July 1 deadline a "drop-dead" date because it correlates with a new product release? Or was the date selected because the human resources department is experiencing a personnel shortfall and wants to start making a good impression on prospective hiring candidates? If the latter situation is the case, then a week or two may not make much difference. Was the "go live" date assigned by someone with intimate knowledge of the sales cycles for products high-

lighted on the website? Or was it set by a junior accountant to make it easy to track cash flow in the production department? Your knowledge of the rationale for the deadline will help you make decisions or recommendations for adjusting it.

Importance of Deadlines

Although deadlines can be onerous, they are also beneficial and are, in fact, an important element in the development process. Deadlines force you to set dates for the completion of intermediate tasks (milestones), which help you gauge and track progress. Deadlines motivate project staff like nothing else. In addition, deadlines can be doubly important to the financial health of a company engaged in e-commerce. The sooner the site is available, the sooner products can be sold, and the sooner the company will recover its investment. The production staff who may simply desire a more leisurely pace of development would not be looking at this benefit.

PROJECT MANAGEMENT SOFTWARE

One of the best ways to plan, schedule, and track projects is with project management software. Project management software packages, such as Microsoft Project or SureTrack Project Management, provide useful, highly specialized project management tools like PERT (Program Evaluation and Review Technology) and Gantt charting capabilities, resource leveling, and cost reporting. These tools provide you with a bird's-eye view of the development plan and process, which is invaluable in tracking the organization, sequence, and completion of tasks and events to ensure timely delivery. With such attention, you are more likely to foresee potential crises looming ahead and can work to avoid them. Project management software allows you to adjust the workplan to try different scenarios. When these workplans are shared with others on the development team, they become an excellent means of discussing the project, keeping team members informed of their tasks and the required completion dates.

Some people assert that project management software is necessary or useful only for large projects, like building a nuclear power plant or erecting a dam across the Colorado River; however, with the exception of small, simple projects of short duration, most Web projects benefit from project management software, and many require it. Project management software allows you to structure the workflow, delineate tasks, assign task durations and dependencies, and show the ripple effects of delays at various points. They can also calculate the critical path of task dependencies and provide various reports and charts to help you effectively focus your attention and energy.

Project management software programs typically offer multiple views of a project, the most common being PERT and Gantt charts. PERT charts are diagrams

that show the individual project tasks, connected by arrows marking the dependencies between those tasks. Gantt charts show task durations organized on a timeline. Project management programs also provide various histograms and other reports. Some views are essential, and others can be extremely helpful in a given situation. You can usually sort the tasks according to various criteria. Grouping tasks by whom they are assigned to, for example, might make you aware of individuals who are overcommitted or underutilized. Listing the tasks that were supposed to have been started by a particular date will help you assess current project status.

PERT Charts

A powerful planning and scheduling tool, a PERT chart is a network of interconnected boxes, each of which represents a task or milestone in the development process (Figure 3.1). By identifying which tasks are prerequisites for other tasks, you can clearly see the interdependencies of team members. The chart reveals dependencies between tasks and bottlenecks in the workflow that may not otherwise be apparent. A PERT chart can help you make adjustments to finish the project by the deadline date. You can reorganize tasks and interdependencies and see the results on the schedule immediately. For example, you may originally have scheduled the user manual to be written at the end of the project; however, a PERT chart may demonstrate that doing so will make the project several weeks overdue. You might then decide to break up the user manual production into separate tasks (e.g., outlining, writing, editing, and screen shots), which can be done simultaneously with software development. The strategy will shorten the overall time frame but increase the need for more personnel earlier.

Gantt Charts

Also a powerful project management tool, a Gantt chart is a type of bar graph that depicts how long a task is scheduled to take, when it can be started, and when it must be finished (Figure 3.2). This graphical representation also shows the relative magnitude of individual tasks and the completion percentage to date for each task. Gantt charts measure progress and can be used to show team members what they need to do and when they need to do it. Gantt charts can group tasks by individuals, to show what each person is responsible for; by date, to show the overall sequence of tasks; and in many other ways.

A Planning Method

Nearly everyone has a preferred method of planning and scheduling projects. One useful method is to create a "blue sky" PERT chart, diagramming your preferred workflow for the project, including reasonable task durations without

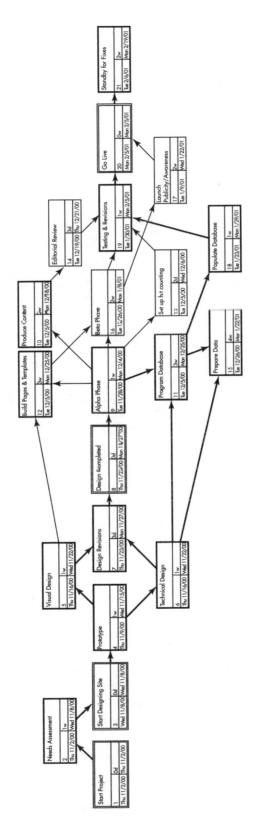

Figure 3.1 Sample PERT chart.

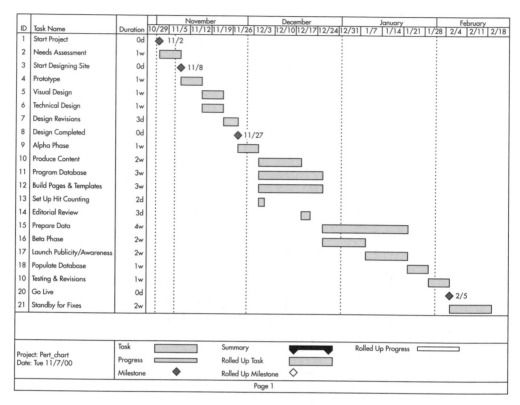

Figure 3.2 Sample Gantt chart.

regard to schedule. Generally, this initial "blue sky" PERT chart generates a projected release date that is well beyond the project deadline. The chart then becomes a tool that promotes creativity and research to identify ways to shorten the schedule and still get the work done. Once the PERT chart realistically shows the development tasks and the sequence of events required to achieve the deadline, you can use the Gantt chart to track the completion of these tasks. By using the PERT chart as the primary interface for the workplan and the Gantt chart for tracking, you can maintain a global perspective on the project. You will see the ripple effect of various plans, where scheduling conflicts arise, and where the critical path is at any given point. Some people, however, find it easier to work with the Gantt chart as the primary interface. Whatever method you feel most comfortable using to schedule tasks is probably the best way for you to operate.

Bells and Whistles: Diminishing Returns

The sheer volume and complexity of features in project management software can intimidate new users, contributing to a lack of acceptance by some project

managers. Packed with advanced, sometimes marginally useful features, software offers dozens of reports and charts showing resource allocation conflicts, incorporating subprojects, and tracking almost every conceivable variable a project has to offer. This proliferation of features is analogous to the "feature creep" associated with other software categories, such as word processing software. Most people use only a small percentage of the features available in the typical consumer word processing program, like Microsoft Word. Likewise, you can avoid most of the learning overhead that dissuades some people from employing these incredibly useful project management tools. Use features that are obviously helpful, like PERT and Gantt charts, and then explore others on an as-needed basis.

Maintenance and Modification

Remember that your charts and reports are not meant to be a theoretical blueprint that is cast in stone at the beginning of the project. Web projects are subject to many unforeseen events and unpredictable progress, and the PERT and Gantt charts must be revised, modified, and updated regularly and continually to reflect the current state of affairs. The charts and reports are tools by which the project is accomplished. Once the project is finished, such charts are also helpful to review what really happened, to learn by experience and prepare for future projects.

SCHEDULING TIPS

Rule of Thirds

Many studies on the relative amount of time and resources invested in the various phases of software development projects have revealed some general truths that can inform Web development scheduling. One is the "rule of thirds," which basically holds that the amount of time and effort spent in design, production, and testing are roughly equal within a particular application, as follows:

> Analysis and Design (e.g., initial design, prototyping, usability revisions) = 33% of project time
>
> Development (e.g., programming, content development, debugging) = 33% of project time
>
> Testing (e.g., bug testing, final user testing, compatibility testing) = 33% of project time

An application that takes one year to develop will probably take roughly four months to design, four months to produce (program and data preparation), and four months to test (and debug). This may seem a disproportionately large percentage of project time for design and testing, but in practice, this rough rule of

thirds seems to hold across various applications, whether they are scheduled that way or not.

This rule is not a bad way to quickly estimate the overall time for project completion and set some useful parameters. For example, if a website must launch in six months, you can plan to spend two months in design, two in development, and two more in testing. With two months to design a website that can be developed in two months, you've set some constraints on the site's complexity.

In validation of these allotments, project personnel commonly regret that more time was not spent upfront, in the analysis and planning stage. The simple reason for spending more time thinking through interface issues, designing preliminary screens, conducting focus groups, and prototyping is that this design work eventually must get done. The sooner you do it, the better. When you design late in the game, it costs more and can cause greater problems. Addressing design issues when programming for the website is already underway greatly diminishes efficiency.

Further validation is the rude surprise many project managers experience in the sheer length of time necessary to test and debug most Web applications. Even sites created by programmers with efficient code must go through a full quality assurance cycle, if only to certify that they work correctly. Usually, a fair amount of debugging is called for, especially when several programmers are working together on a site. Testing should start relatively early in the development process and usually continues well past the point where intensive coding has ended. This time and effort spent in testing can be extremely frustrating, especially if it was not built into the schedule. As the last step in the process, testing always seems to catch the blame for schedule delays that were actually caused by earlier mistakes in design and coding. Like a relay race, success or failure of the last runner depends on those who came before. If code is delivered late and has been hacked together, testing personnel cannot be held responsible for finding problems that need to be fixed.

Testing Takes Longer

Not only does testing usually take longer than anticipated, but it sometimes takes two or three times longer. The number of testers, their skill level, the sophistication of the testing methods, and the responsiveness of the programmers to the results all affect the schedule. Testing is sometimes imagined and planned as if it were a simple certification process, when it is actually a crucial and time-consuming development phase. It may take as many full-time testers working on the product as there are programmers, depending on the complexity of the code and the amount of data. This quantity of testers is often not anticipated, much less budgeted. Therefore, if the testing resources allocated are inadequate, it will take much longer to accomplish the work. If a single individual is assigned to test a product that really requires two testers, testing will take twice as long; if the web-

site is complex enough that it requires three testers and only one is assigned, testing will take three times as long.

The skill of the testers also makes a huge difference. A single, experienced quality assurance professional, working from a test plan and tracking findings in a well-designed database, can outperform a whole roomful of inexperienced interns or students simply asked to "try to break this program." The experienced tester knows what to look for, where to find it, how to report it, and how to check it later to see if it was fixed. Experienced software testers should be able to write a test plan, manage a software defect database, and perform regression testing. A person of this caliber will be able to find more defects faster and will significantly improve the programmers' ability to fix the defects. Therefore, when planning software development, the testing process and personnel must be determined with as much care as the design and programming processes, including the use of test plans and automated testing tools, if appropriate.

Cool Under Fire (Drills)

Web development projects tend to be subject to false crises, commonly called "fire drills." These "tempest in a teapot" situations, which arrive without a moment's notice, are quickly forgotten. To adequately manage these situations, keep a respectable mental distance from the problem, and above all, don't panic. The urgency of these episodes is often inversely related to their actual importance. For example, while working intently on attaining the Beta release date for a new marketing website, you might receive an urgent message from the secretary of the vice-president of marketing that you have to demonstrate the site-in-progress later that day. Faced with a command performance and little or no advance warning, you might drop everything to comply, knowing full well that the site is not really in a showable state. Rather, you should maintain your composure and quickly get to the source of the request to find out exactly what is wanted and by when. Check first with your own manager to validate the relative priority of the request, and then contact the requester. Perhaps the individual did not realize the amount of work the request entailed or is actually looking for something different than was conveyed by the messenger. If you react in a less controlled way, perhaps by succumbing to panic or by hastily posting the latest untested pages and files, you may find yourself wasting time and emotional reserves. It can also be helpful to document the work interruption for future reference, in case you miss a deliverable date.

Measuring Progress

Slippage
"Slippage" is one of those intangible factors in a project that seem to constitute an effect without a cause. Tasks usually slip because of events beyond your control

or unforeseeable difficulties in implementation; however, just because slippage on an individual task is unpredictable does not mean that the overall slippage rate cannot be predicted. Slippage must be monitored closely from the beginning because projects that start behind schedule cannot easily catch up.

By carefully measuring slippage in the beginning stages of a project, you can develop and apply a slippage factor across the full project. Applying the slippage factor improves the accuracy of your time estimate for completion of later stages. For example, if a 12-week project has a 4-week design phase scheduled and the actual design takes 5 weeks, then the slippage is 20 percent. Therefore, the end date is not simply the 13 weeks you might assume (the original 12 plus the 1 week the design phase was late). Rather, the actual schedule will be closer to 15 weeks than the original 12 in the plan. Early slippage is usually symptomatic of the general development conditions and is a useful indicator of factors likely to continue throughout the entire project. This initial slippage factor may also provide evidence for adding resources early in the process or for scaling back the design to meet the deadline.

Slippage Graph

Measuring slippage can be enlightening, and there is an interesting way to use slippage and time estimates themselves to get a "slippage-corrected" estimate for the most likely completion date. This technique simply involves recording your original time estimates and the date on which they were made. For example, imagine that at the beginning of January you estimate that the site will take three months to develop, giving it a completion date of March 31. At the beginning of February, a couple of focus groups have shown the need for some significant design changes, which will add work. You then revise your delivery date estimate to mid-April. In mid-February, a technical problem is encountered, and you must revise your estimated completion date again, this time to late April.

At this point, you might well start to wonder, given the way things are going, when the site will really get done. Using the information cited previously, you can easily create a data table, as in Table 3.1. These points can be mapped on a graph, as in Figure 3.3. From this graph, you can see that given current progress, the project is actually headed for a release in mid-June. The graph also shows

Table 3.1 Estimation/slippage table for the sample application

Date estimation was performed (on date . . .)	Estimated delivery (. . . I estimated the project would be done)	Development time remaining (weeks) (project length remaining)
January 1	March 31	12
February 1	April 15	10
February 15	April 21	9

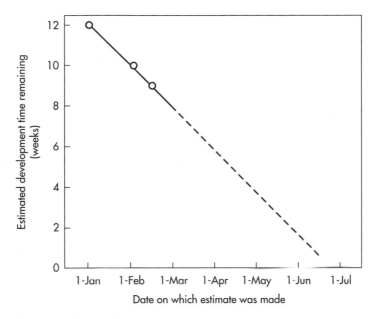

Figure 3.3 Estimation graph, showing data from Table 3.1 graphed to extrapolate most probable project completion date.

how easily even relatively small projects can miss deadlines by 100 percent or more, and hence the great necessity of getting a slipped project back on schedule quickly.

No Partially Done Tasks

A common misconception of project managers is that unpredictable and possibly nonquantifiable tasks can be accurately measured by the percentage of work completed. Some elements, like data preparation, can often be measured quantifiably. If 50 out of 100 photos have been digitized, it is fair to assume that the task is about half done. On the other hand, some tasks, such as design, programming, and testing, are not done until they are done. In other words, the design process can continue ad infinitum, so it is sometimes meaningless to measure the percentage of the task completed. Likewise, programming may be finished, but testing results will require more programming to fix errors. Testing itself is not finished until the first site goes live, and it may even continue afterward. Therefore, the precision of the scheduling and time estimation process has inherent limitations.

Rather than try to quantify every task, it is sometimes wise to pay close attention to whether a task has been started or not, how it seems to be progressing, and if anything can be done to facilitate its completion. Carefully tallying the

percentage of programming that has been completed based solely on a programmer's estimate is of little value and may well represent a waste of time or, worse, misinformation. When a programmer says a task is about 80 percent done, it may actually still require another 80 percent of the effort to finish the code and test and debug it. Programmers are not incapable of estimating accurately, but project unknowns often make percentage-complete estimating inaccurate. Therefore, note when tasks are started and when they are completed, and use this information to manage a project. Percentages of task completion for design, programming, and testing, on the other hand, may be of little value and should be taken with the proverbial grain of salt.

No Shortcuts

When you are developing a website under tight deadlines, a great temptation to cut corners arises. You may want to just get something up and running to demonstrate progress, assuming that it can be fixed later; however, this approach may well be precisely the wrong strategy and can sometimes cause problems more severe than what it was meant to fix. If you attempt a programming shortcut because of schedule pressure, three counterproductive effects may ensue

1. Schedule pressure itself rarely leaves time to adequately design the shortcut, meaning that the shortcut will have to be debugged, possibly to a greater extent than the original implementation.
2. Schedule pressure still exists, and if the shortcut fails to work, the time invested in it is lost, thereby increasing the pressure.
3. If the shortcut is meant to be a temporary fix, then the work will have to be redone the right way anyway in the future.

A better strategy is to trim the features for the first version of the site. Get it up and running reliably while keeping a wish list for the second and subsequent versions. Then, you can continually update the website with more content and features, without getting caught with too large a task to complete all at once. You can obtain some good real-life data on the site quickly, before prioritizing features for following work.

Concurrent Tasks

Finally, one of the most useful strategies at the project manager's disposal is to constantly maximize the amount of work that can be done concurrently on a project. If you are watchful and creative, you can find ways to get people started on tasks sooner than originally planned.

For example, a programmer who has been included early in the design process may know enough to start laying out the basic software architecture,

even before a final functional design has been approved. Data preparation people can immediately start producing sample data to work out the details of their file conversion processes, rather than waiting for some arbitrary date to get started. Most projects present dozens of such opportunities. It is up to the project manager to recognize them and respond creatively to keep a project running on schedule.

Planning and scheduling website production is as much art as science, requiring both intuition and analytical skills. If you can obtain the resources necessary to do the job and apply them efficiently, you will be well prepared to deliver high-quality products on time.

4

Estimating Costs

Website development costs are notoriously difficult to estimate. Cost overruns usually result from unknowns inherent in the software development process or changing design specifications during development. Estimating development costs and then getting funds approved is an essential starting point. Websites are not created out of thin air. Whether a site is developed with a generous budget in a well-furnished studio or as an after-hours skunk-works project, it requires people, equipment, time, and materials. Your ability to accurately estimate the cost of these resources is crucial to your success in managing such a project. Cost estimates for websites that function as a marketing tool of an existing business are important. For dot-com businesses, where the website essentially *is* the business, estimates are crucial.

Like scheduling, cost operates in the dynamic of the three project management factors. Directly corresponding to resources, cost depends on time and task. A simple website (small task) will cost less (fewer resources) than a large, complex one. In order to develop an accurate cost estimate, the task and time available must be predetermined. This interrelationship among the dimensions is a primary cause of confusion in determining how much a project will cost. Without setting two of the parameters, the third cannot be accurately derived.

COST ESTIMATES VERSUS BUDGETS

Cost estimates and budgets, although related, differ significantly. Both predict expenses and are used to monitor them. Cost estimates predict how much the development will cost to complete the project by deadline. Budgets are an organizational spending limit, typically set yearly. Cost estimates differ from budgets in various ways, including their purpose, source, and response to changing conditions.

43

Purpose

Cost estimates determine the size of investment required to complete the project, serving such purposes as:

- deciding whether or not to build a site
- planning projects
- allocating resources
- determining whether remaining funds are sufficient to complete a project already underway

Budgets set spending limits for a company according to expected revenue, serving such purposes as:

- ensuring profitability and efficiency
- planning projects
- allocating resources
- categorizing expenses

Assigning expenses to specific budget lines not only supports analysis but also is required for proper accounting practices. In some cases, types of expenses are handled in different ways. For example, rented equipment can be written off as a business expense in the current year, whereas purchased equipment must be depreciated over at least several years. Budgets allow individual departments to function efficiently and in coordination with the rest of the organization. The organization's budget then informs project-specific budgets, such as website development.

Source

The project manager, in consultation with the development staff, creates the cost estimate for a website project. The project manager usually needs to go to somebody else in the organization to gain approval and a set budget for the project. Generally, budgets are developed at the departmental level as part of the ongoing fiscal year cycle. After review of proposed organization-wide budgets, the upper management team ultimately sets the final budget.

Such layers of approval encourage fiscal responsibility and serve as a system of checks and balances, but the process can also create problems. Not only can innocent misunderstanding and miscommunications arise, but budgeting can also fall prey to interdepartmental competition. For example, if the financial department is competing with the production department for visibility or control, budgeting can be a potent weapon in that struggle.

Dynamic versus Static

Accurate cost estimating is a dynamic, iterative process. Not until the latter part of the design process is a truly valid estimate possible. Without a fairly complete design specification, a cost estimate is mostly guesswork because the website (task) is undefined. The clearer the definition, the more accurate the estimate. As the project progresses and more actual specifications enter the equation, the estimates become more accurate. As the design progresses, the estimate becomes yet more accurate.

Budgets, on the other hand, are usually set early in the development process, sometimes as a precondition for project approval. The budget usually remains unchanged for the duration of the project. Thus stands an inherent contradiction: the cost estimate can and does change, but the project budget remains fixed. Therefore, the project manager often must choose between "going over budget" or trimming features late in the development process, in order to stay within budget.

Risk

Cost estimating and budgeting represent the largest inherent risk in the whole development process. Software projects usually go over budget because budgets are linked to inaccurate cost estimates that are prepared early on when enthusiasm is high and foresight is low. The combination can have disastrous implications for companies with significant resources committed to such a project. The higher the final cost, the more effective the site must be in accomplishing its goals. For example, for an internal e-learning site, the higher the development cost, the more effective it must be to justify the increased cost.

COSTS

The costs of developing a website fall into two main categories:

1. the initial development costs
2. the costs of maintaining and enhancing the site (on a yearly basis)

Initial Development Costs

Initial development costs include whatever it takes to get the project to launch, including:

- writing specifications
- creating design elements

- developing content
- programming code
- testing the site
- hosting the site

Like other software development projects, some form of "time and materials" is typical. New software development is notoriously difficult to estimate accurately. As a hedge bet, estimate a range using worst-case and best-case scenarios. You can also ask the people who are actually doing the work to review your estimates.

Finally, you might add a safety percentage (e.g., 15 percent) as a margin of error. The nature of software development—the unpredictability, continual learning, and trial-and-error of invention—makes cost qualitatively different from that of other, more defined, activities, such as manufacturing or marketing.

Initial cost estimates that fall within 15 percent of actual expenses are fairly good. This safety factor takes into account unforeseen expenses. Most overruns are caused by unforeseen items, which is the cause of most overruns. Those who insist on clinging to precise estimates are generally schooled in areas where more predictable estimates are possible, and who may have little experience with software development and websites, or perhaps new product development in general.

For in-house projects, presenting the cost estimates as a range both increases your chances of being accurate and effectively communicates the ambiguities of website development. Management will see that the cost estimate is simply that—an estimate, not a price quote. If management budgets an amount at the lower end of that range, they will have done so knowing they are choosing to be optimistic. Outside development firms should be prepared to quote a fairly firm "not to exceed" estimate for the initial site development.

Maintenance Costs

Regardless of the size of the site, it must be maintained on an ongoing basis or it will eventually lose its effectiveness. The cost to maintain a website is real and must be budgeted if the site is to have a viable future. The cost may run as little as $100 per month for monthly hosting fees on a site, with minimal updating by employees already on the payroll. Or it may require hundreds of thousands per month to finance the ongoing efforts of a full department to keep content updated, answer e-mail, maintain a database, build new features, and process e-commerce transactions. Wherever you are on the spectrum of maintenance, without estimating and budgeting for these items and their associated costs up front, you may lose the chance to obtain the necessary funds later.

COST OF COST ESTIMATING

According to some researchers, most software projects are actually out of control from the beginning, if only because the resources and skills to accurately measure the size and progress of the application are lacking in most situations. The exercise of measuring bears a cost itself but is rarely part of the estimate. Without accurate measurements, the true scope of development activity and actual progress remains unknown. Most projects are in some sense unmonitored and hence more or less "out of control," accounting, at least in part, for the scale of estimate inaccuracy on many software projects and websites. It is not uncommon for an application to run 100 percent or more over budget.

For example, if the Alpha version of a site was scheduled to be delivered one-third of the way through the development process and the deadline is met, you might conclude that the project is one-third finished. The reality, however, may be that only a small sample of the data has been prepared, the programming is full of errors with more being found every day, and design additions are being approved right and left. In this situation, the project may actually be only 10 percent completed.

The Mythical Man-Month

Frederick Brooks addressed the vagaries of programming in his seminal book *The Mythical Man Month: Essays on Software Engineering*. Brooks' insights on managing software projects still hold true 25 years later.

One crucial consideration for most Web projects is the quality of the programmer(s). Not all programmers are created equal. Productivity among individuals can vary by a factor of 10 or more in time spent on a task. And it is extremely difficult to gauge relative productivity, even by other programmers who have worked together.

First, programming tasks themselves can vary in complexity by an order of magnitude, which makes it difficult to objectively compare the work of various programmers. In addition, programming is a solitary activity; the only way to observe it is to inspect the code itself, which can be costly, labor-intensive, and highly subjective. Another way to assess a programmer's performance—keeping meticulous records of the number of errors found through testing the code—requires a significant and ongoing investment.

In larger software projects that involve a dozen or more programmers, individual variations in productivity among programmers start canceling out toward an industry average; however, most Websites are programmed by just a few individuals—usually six or fewer, and often just one or two. Therefore, the possibility of accurately estimating the cost and time necessary to develop a

website is inherently limited. If you can maintain a stable programming staff rather than bringing in different programmers for each new project, however, at least you are dealing with a known entity, and the chances of estimating more accurately are better.

Cost of Content

Website cost estimates can be even more problematic than genetic software cost estimating because of all the content rights and permissions issues of publishing on the Web. The rights to use photographs, for example, may be free in some cases but may have to be purchased for hundreds of dollars apiece in others. Additionally, it is almost impossible at the beginning of the project to determine exactly how many photographs will be needed. Unplanned purchases of content rights could cause huge variances in the budgeted versus actual costs.

METHODS OF COST ESTIMATING

Again, cost estimating should be an ongoing process throughout the life of the project. The accuracy of the estimate improves as the application progresses because the number of variables decreases. You can approach cost estimating in two ways:

1. Setting the budget ahead of time and designing the site to meet the budget
2. Designing the site and then developing a cost estimate based on the design

Realities of organizational life usually point to the first approach. Although the second option might be considered the "correct" way, money matters, even in website development. For example, a marketing department may have budgeted $50,000 for a website and then goes to a Web development team essentially asking: "What can you produce for $50,000?"

You should know which approach is in effect and avoid assumptions. After designing a site and providing a cost estimate, you will often hear back that the cost estimate is "too high." If the comment means anything more than a negotiating stance, it reveals that a budget is already in place, information that unfortunately was not shared with you. A good first question when asked to design a site is: "What's the budget?" If you can learn that amount, then you can design your cost estimate to fit.

Budget-First Estimating

If you are given a budget within which the site development is expected to fall, the design parameters must be very flexible. A set budget fixes one of the three project factors—resources. Usually, an implicit schedule expectation is also in place, fixing a second project factor (time) and leaving the task as the only remaining variable. In such a situation, you should be extremely conservative in your choice of features and functionality. Such caution flies in the face of developers' creative nature and clients' high expectations; however, every additional feature tends to increase the cost of the application exponentially because of the ripple effect on the rest of the site's functionality.

Every new feature must be designed, programmed, and data/content prepared. The new feature must be integrated into the site design, tested, debugged, and documented as appropriate. The later in the development process features are added, the more they will cost, because the more difficult it is to retrofit the balance of the site design to accommodate new features.

In fact, if the budget target is strictly defined, it is not unreasonable to choose a design that you think can be executed with only half the target budget (i.e., if the budget is $100,000, design a site that you think you can build for only $50,000). Such an overly conservative estimate allows you to obtain and allocate resources with relative certainty, to incorporate the 15 percent safety factor, and to possibly add features to the design later if necessity (or opportunity) arises.

Design-First Estimating

If you have designed the site first, independent of the constraints of a budget, you can choose among three strategies for estimating costs:

1. time and materials
2. feature and data costing
3. contractor proposals

By developing two or more of these estimates simultaneously and comparing them to each other and to the cost of similar projects in the past, you can often obtain a relatively accurate range of the costs required to develop a given website.

Past experience can do much to inform such estimates. Capturing detailed cost information for website development requires a significant investment and commitment by the organization; however, measuring development costs delivers a clear benefit when it's time to estimate the next project. To approach some degree of accuracy, you need to refer to thorough and detailed cost measurements from comparable projects.

Accurate cost estimates can be promoted by performing a postmortem on completed projects. This activity helps uncover hidden costs charged to a project (e.g., overhead, materials, equipment rental, administrative costs), which can amount to a significant portion of the total development expense.

Time and Materials

Sometimes considered a "wet-finger-in-the-wind" estimate, the time-and-materials method is not always precise, but nonetheless is useful for:

- quickly sizing up a project
- developing a baseline with which to compare other estimates
- assessing resource needs

With a thorough knowledge of the design and a good idea of how many people and what skills will be needed to carry out the project, you can estimate costs for payroll, equipment, and outside services. Overhead, testing, and administrative support must also be considered. Again, as a hedge bet, multiply the estimate by some safety factor (say, 15 percent) as a buffer against the unknown expenses that are sure to occur.

In addition to encouraging a clear assessment of resource needs, the time-and-materials method is quick and not easily dismissed. It will get you in the ballpark and show whether the application as designed will cost closer to $5,000, $50,000, or $500,000. It is often surprising to see how fast the costs can add up.

Imagine a website design with dozens of static content pages, also featuring interactive Java applets, that tracks frequent user login and usage and provides a custom online survey. Will it cost $5,000, $50,000, or $500,000? Such a site would require a small development team of at least four people (e.g., programmer, artist/HTML author, editor, project manager/tester) working for six months at an average yearly salary of $75,000.

$$4 \text{ people @ } \$75,000/\text{year} \times 0.5 \text{ years} = \$150,000$$

On top of $150,000 in wages, you can add $50,000 in equipment and fixed costs as well. All together it comes to approximately $200,000. This estimate may appear outrageously high, and indeed, it could easily be off by 25 percent or more. Even so, the project would most likely come in somewhere between $150,000 and $250,000—a huge range, but still useful in setting expectations and a starting point for refining our accuracy.

Feature and Data Costing

A second method of cost estimating, feature and data costing draws on a detailed examination of the design and the individual features. Analyzing the de-

sign can be time consuming, however, and your accuracy depends on previous experience developing similar websites.

Such a detailed analysis of the design can be a significant undertaking itself, assuming the design is thorough and detailed enough to support such analysis. This analysis should be performed anyway, as part of the normal development process. The criteria you choose to measure depend somewhat on the nature of the website (e.g., heavily database-driven, number of static pages, or complexity of Java applets), as well as the hosting and development environment. For example, the estimate for a simple Web presence site (home page plus six static informational pages) may consist of a count of the pages, the number of graphics anticipated, content development time, and any programming time required. The simplest of sites entails minimum fixed startup costs, such as basic graphic design for site pages and navigation, posting on a server, and domain name registration cost. Adding to these fixed costs are project-specific, variable costs. Some costs will increase in a linear fashion, according to the number of screens, amount of text, and number of illustrations; others, like programming for Java applets or database access, may ripple into exponential increases.

For more complex applications, like a database-driven e-commerce site with interactive applets, it might be necessary to quantify not only the number of screens but also the user interface points on each screen (e.g., buttons, list boxes, menu items), the complexity of each interface element, the quality of original artwork, the quantity of photos, order processing, and other pertinent items. Again, the accuracy of such an estimate depends largely on one's previous experience developing a similar site, or at least the individual features to be combined in such a site. Previous projects used for comparison purposes should preferably be those built and maintained with the same development tools and using the same technology and of similar complexity.

Another important aspect to the accuracy of the estimate is the stability of the design because adding features later in the development process increases costs and time disproportionately. If the design is still in flux or if much opportunity for design changes occurs during development, the initial estimates may be off by a wide margin. Hence the need to perform ongoing cost estimates.

The more complex the site, and the more custom-programmed features required, the higher the risk of inaccuracy in the cost estimate, both because of the greater overall investment required and the larger number of unknown factors. In addition, the design must be analyzed at a finer and more highly technical level if a detailed technical design and prototype have been produced.

Contractor Proposals

When an organization hires out for website development, the contractor performs the cost estimating. So from the perspective of the in-house project manager, sending out requests for proposals (RFPs) constitutes a method of cost estimating.

Please note that it is highly unethical to send out RFPs if you are not truly planning to contract out the development. For a developer to prepare a decent proposal takes significant time and effort. Presenting a false opportunity for the purpose of getting a free cost estimate is stealing these professionals' time and energy, which is essentially all they have to sell. The most experienced and savvy developers will quickly sniff out your ruse after asking a few questions and will simply not respond. Therefore, what you receive back (from inexperienced developers) may be less than reliable. Additionally, your future prospects are hurt if word gets around the Web development community that you send out bogus RFPs. Finally, aside from the ethical questions, the very process of requesting proposals and comparing bids is too costly to pursue unless you are actually going to contract out.

Obtaining cost estimates from several developers may appear simple at first blush. In reality, however, obtaining reliable and high-quality proposals takes a significant investment of the in-house manager's time and energy as well. The quality of the developer's proposal and estimate depend largely on the quality of the information the in-house contact supplies (your design requirements). The more thorough and well specified those requirements, the more accurate a cost estimate will be. Creating high-quality design requirements is a big effort. Even the most complete document will leave many issues unresolved. A good developer will collect as much information as possible. The in-house manager must answer questions, discuss options and responsibilities, and, in effect, partner with the developer to create a feasible proposal. Soliciting such a proposal from several developers simultaneously can become a full-time job. Chapter 7 addresses contractor–client relations and the bidding process in greater detail.

SAMPLE COST ESTIMATES

Tables 4.1 and 4.2 represent only a generic estimate for two types of sites and should not be construed as anything more than an example of what an estimate might look like. Marketing or promotional costs, which may easily equal or exceed development costs, are not addressed. The estimate assumes that the people are fully skilled, not on a learning curve, and that necessary equipment and software development tools are in place.

Basic Web Presence Site

The estimate in Table 4.1 is based on the following conditions:

- The website consists of a home page with six subpages.
- The site will have a banner, navigation buttons on the left, and a couple of graphics or photos per page, along with some text and a table or two.

Table 4.1 Sample cost estimate: simple "Web presence"

	Days	*Hours*	*Hourly rate*	*Overhead (@ 50%)*	*Total*
Personnel					
Artist/Page Author	5	40	$80	$40	$4,800
Content/Editor	5	40	$80	$40	$4,800
Tester	2	16	$50	$25	$1,200
Services					
Site hosting with e-mail (1 year)					$1,200
Domain registration					$100
Subtotal					$10,900
Safety factor (15%)					$1,635
Total					**$12,535**

- Fully loaded labor costs include a Web page author or artist to design and build the pages, a content person to write copy and provide editorial oversight, and an external ISP server on which to host the site.

Database-Driven Informational Site

The estimate in Table 4.2 is for a website that delivers substantial content using a backend database. An example of such a site is a real estate listing service, offering such functions as:

- login and registration
- search by various criteria
- view search results
- details on property listings, including photo, text description, and e-mail links
- administrator's module for site owners to load content into database
- development time is three months
- approximately 500 property listing records in database

Table 4.2 Sample cost estimate: database-driven website

	% of year	Yearly salary	Loaded salary @ 25%	Project total	
PERSONNEL					
Project manager	25%	$90,000	$112,500	$28,125	
User interface designer	25%	$75,000	$93,750	$23,438	
Artist/HTML author	25%	$80,000	$100,000	$25,000	
Lead programmer	25%	$100,000	$125,000	$31,250	
Junior programmer #1	25%	$85,000	$106,250	$26,563	
Junior programmer #2	25%	$75,000	$93,750	$23,438	
Tester	25%	$50,000	$62,500	$15,625	
Data analyst and formatter	25%	$50,000	$62,500	$15,625	
Editorial (text content)	25%	$75,000	$93,750	$23,438	
Editorial assistant	25%	$45,000	$56,250	$14,063	
Personnel subtotal				**$226,563**	**$226,563**
SERVICES					
Site hosting for one year (dedicated server with database, includes backup and tech support)				$12,000	
Database software license (one year)				$5,000	
Image scanning (500 @ $5)				$2,500	
Services subtotal				**$19,500**	**$19,500**
EXTRA MATERIALS					
Hardware: Backup drives and data				$5,000	
Software: Miscellaneous development tools		$15,000		$15,000	
Materials subtotal				**$20,000**	**$20,000**
Project subtotal					**$266,063**
Safety factor (15%)					**$39,909**
TOTAL					**$305,972**

5

Analysis and the Project Plan

The goals of the analysis and planning phase are to:

- Analyze whether the project is a worthwhile endeavor.
- Determine the website requirements needed for a successful site.
- Create a workplan to accomplish the project.

This analysis is a crucial step. The success or failure of a website project often can be traced to this stage in development. Exploring and analyzing the proposed website in this phase can reveal many hidden issues you can address early, clearing the way for success.

WHY ANALYZE?

A good analysis will support and polish a good site idea and will reveal the flaws in a bad idea. In fact, if the analysis prevents a company from developing a poor website concept, the analysis must be judged successful. It has prevented the company from wasting precious resources, so they are available for more promising projects.

For example, a client proposed a website that was to be a directory for finding and hiring entertainers for elementary school presentations. The original concept was to include motion video, live booking of acts, and other data-intensive functions. Upon analysis we learned that most users had dial-up connections, which would not readily accommodate video over the Web, and that the costs of videotaping and digitizing so many performers would be a considerable investment. The live booking of acts would require communication with performers who often did not have e-mail, much less check it often enough to allow live bookings. Other features were also examined and found to be overly ambitious. We adjusted the site design to the new reality, reducing the estimated cost by

more than 75 percent. The client was able to build a satisfactory site at a very reasonable price and use the remainder of the budget for marketing the site, an aspect that was given lesser priority in the original concept. By examining the concept in this way, you can gain such benefits as:

- prioritizing and modifying features
- generating significant cost savings
- reducing risk
- increasing understanding of the target market

On the other hand, sometimes ideas that at first glance seem suspect turn out, after further investigation, to be ideal candidates for development. For example, offering users free e-mail would seem to be a losing proposition; however, Hotmail was able to achieve tremendous success with such a strategy. Consider other unusual websites and services such as online auctions and reverse auctions, free hit counters, and other Web-based services that have proven to be successful business models. Some of the most successful website businesses represent a conceptual shift from existing business models. Perhaps the most persuasive argument is the necessity of websites to keep up with business competition, or the greater efficiencies of communication and transactions permitted by utilizing Web technologies. Sometimes such benefits are hard to quantify but easy to appreciate from a qualitative and competitive perspective.

The most important consideration in evaluating the business case for building a website comes by establishing the main goals for the site. Websites can be justified in many ways. Ultimately, the decision is subjective, as is the decision of what to put on the website. What do you want out of the site? Is it to establish a Web presence? E-commerce? To establish an online community of customers (or users)?

Website plans often accumulate potential uses, and the main goals of the website lose focus. For example, if a small company is considering building its first website, the goal would most likely be to establish a Web presence and improve communications with customers. Such modest goals can be readily accomplished, and the benefits demonstrated. If an established company with an existing site wants to start offering products for sale online, it will represent a more significant investment to set up such capabilities; however, such a project is easily evaluated on a cost–benefit basis.

Another common way that companies evaluate the benefit of a marketing or training website is by comparison to other, more traditional delivery methods, such as product brochures, magazine advertisements, telemarketing efforts, or the use of live training instructors or video-based training. Budgets for websites are often compared to the budgets for these other activities and generally need to fall within the same ballpark. For example, if the company is accustomed to pay-

ing $20,000 to have a brochure designed, printed, and mailed, then a proposal for a $250,000 website could run into some stiff opposition, even if it is expected to be 10 times more effective. The company may simply be unaccustomed to paying such high sums for this kind of work. These budgetary parameters (resource factors) can have a significant effect on the kinds of websites that are developed and how they are implemented.

CRITERIA FOR SUCCESS

In addition to determining whether the project is worthwhile or not, one of the main goals of the analysis phase is to determine the criteria for success. These criteria can be quantitative or qualitative. Knowing how the success of the application will be measured will help you apply development efforts in that direction. If the criterion for success of an e-commerce site is that it break even within a year, then development expense and delivery dates are crucial, and all efforts should be focused in that direction. On the other hand, if the criteria for success are more qualitative, such as to support the current marketing strategy, then even a flawless site may be judged unsuccessful because the overall strategy fell short.

EVALUATING PROJECT IDEAS

Ideas for websites and new site features can originate from almost anywhere—customers, potential users, management, product development personnel, even family members of company staff. Evaluate all ideas objectively, regardless of the source. Product ideas tend to take on a life of their own, especially in the minds of their creators. Just because an idea originated with senior management does not mean it is a good idea (or a bad idea). Evaluate the idea as impartially as possible by determining an agreed-upon measure of its value. If the idea seems to have merit, start refining it into a usable concept for more thorough analysis and market testing.

The first step is to verify the potential market or, for an intranet site, the internal need. To be successful, a great concept must fulfill a need. Creating an online catalog of your company's product line is pointless if most of your customers do not have Web access on their computers. On the other hand, if your company is without e-commerce, and all of your competitors have it, it is probably worth considering. An important voice to listen to in the evaluation phase is the potential customer or user, no matter how enthusiastic the prospective developer may be.

If you are one of the project advocates, do not let your own enthusiasm for the project blind you to its real chances of success or failure. If the project is worth

doing, it will become apparent. If not, it is usually better not to do it at all than to proceed with a project that has little chance of ultimate success. If it becomes apparent that a project stands little chance of success, it should be abandoned as soon as possible, to avoid sapping company resources. Then you can get started on a new project with a better outlook.

If the initial analysis shows that the idea is good but not quite viable, it may be worth modifying the concept into one with a better chance of success—perhaps something that requires less investment or implementing the project in phases, so it will start paying back on the investment earlier. These situations usually involve changing the requirements and/or the design. Stay flexible. You may originally have estimated that the site will take six months to complete, but management wants it in four (which is only 66 percent as much time as you need). Or the project is cost estimated at $100,000, but management can afford only $50,000. Remember the three project factors of time, task, and resources. In most cases, the only room to maneuver is to change the design, so that the project can be finished faster, for less money, or both.

GATHERING USER REQUIREMENTS

In the analysis phase, you need to find out if, or how, the project can be a success. Communicate with stakeholders such as potential users, decision makers, and those responsible for marketing and selling the product. This effort is real work and requires time and personnel—and, hence, funding. If funds are not available to conduct the analysis, any funds approved for actual development are likely to be wasted. Examine desired functions and features as well as users' technical requirements, such as platforms, browser versions, and use of plug-ins.

Gather as much reliable, quality information about website features as you can. Talking with one person in the marketing department for 30 minutes about what features he or she would like in a proposed online catalog is not sufficient, even if that individual is the vice-president of marketing. On the other hand, holding a day-long brainstorming session with six people from the marketing, sales, and customer support departments can give you a pretty good start in formulating design requirements. Not only do you hear various viewpoints with this approach, but the participants themselves also often generate new ideas and may even arrive at a useful consensus regarding the priorities of various proposed features.

The most obvious place to start the analysis is with potential users. All manner of discussions and communications with them are valuable. Some of the most common methods are surveys (both mail and phone), focus groups, and individual interviews.

Surveys

Surveys by phone, mail, or e-mail are valuable for obtaining statistically significant amounts of data from a large prospective user base. With a survey, you can contact enough potential users to check the need and potential value to the user of the proposed site and establish the relative priorities of proposed site features. You can expect relatively low response rates from mailed surveys, sometimes only in the 2 to 5 percent range. The length of the survey form or phone interview must be limited to what can be completed by the subject in 15 to 20 minutes, and certainly no longer than 30 minutes. Beyond that, the response rate will drop off because completing a longer survey is too time-consuming. In addition, the information received from a longer survey may be less reliable, as the subject's concentration wanes. The ideal survey is two to three pages of easily answered questions. E-mail surveys should be shorter. It is also beneficial to provide some small compensation or incentive for the subject's efforts. The goal is to get valuable information quickly and let subjects go on their way.

Focus Groups

Focus groups are another effective way of obtaining feedback about a website idea. The traditional focus group is a highly structured affair run by a professional moderator, videotaped, and observed through one-way glass. You may not need to go to such lengths for your application, however, and if you cannot afford it, less controlled focus groups are still valuable. Even informal gatherings of potential users can elicit valuable information. For example, if you were to analyze a potential site aimed at the education market, it would probably be worthwhile to hold a discussion group (with coffee and doughnuts, of course) for teachers at a conference they happen to be attending. For a business-to-business application, you might invite a group of key customers at a trade show to your company hotel suite and get their thoughts on the feasibility of transacting business over the Internet. These informal discussion groups may not have the same reliability as a traditional, professionally moderated group, but they can provide an additional convenient, low-cost alternative with much value nevertheless. If you exercise a little foresight, focus groups can be a great source of information, and they are also helpful in finding individuals who might be worth calling back later for in-depth interviews. Focus groups should include potential users with a variety of responsibilities, in order to become aware of the various viewpoints and perspectives.

When holding a focus group, the key is to keep an open mind, which is easier said than done because you usually have a stake in the outcome. Your own expectations and assumptions can easily distort the discussion and the subsequent

interpretation of the results. If several observers are present, observations and impressions can be cross-checked later to minimize the potential for biased interpretation. In addition, you might prepare a short questionnaire to gather baseline data on the participants before the discussion. This questionnaire should solicit not only their vital information (i.e., name, organization, address) but also their personal histories and prerequisites. For example, if you were running a focus group of librarians and teachers for an educational site, you might want to know each participant's subject area specialty, number of years' experience, Web and research knowledge, and other pertinent information. This data is essential in interpreting the results of the discussion. Finally, it is often helpful to have some sort of prototype site or design concept to demonstrate.

Individual Interviews

Interviewing individuals in depth is an invaluable means of gaining a more complete understanding of users' needs and wants. Often, issues that are raised or identified through a survey or focus group cannot be explored in that context because of a lack of time. An individual interview lets you gain a fuller understanding of a particular issue. For example, a feature thought to be a big draw to the website may receive a lukewarm response on the survey. In this case, you might find it worthwhile to interview one or two of the individuals in depth to learn why the feature is not more appealing. A group of in-depth interviews might uncover a consensus from among such possible reasons as the following:

- The feature may simply not fit their needs.
- They may already use another resource to accomplish the same task more easily.
- Their network does not support or allow the feature because of bandwidth or security considerations.
- The feature may be on the right track but does not go far enough.
- The description of the feature on the survey was misleading.

Only by talking with a potential user in depth can you learn the real reason. Otherwise, you could easily make incorrect assumptions and either include something extraneous in the requirements or omit something essential.

Individual interviews offer other benefits as well. By interviewing people in depth, you can learn many details about the intended users and their environments that help you see things from their perspective and enable better decision making during the development process. Individual interviews can also be a good way to identify potential user advocates and enthusiasts for participation in the project, or to provide future marketing testimonials. A member of the target audience who is easy to communicate with can be invaluable during development when prototypes and interim versions of the site are user-tested, or to

help make other useful contacts in the industry. These people often simply appreciate the opportunity to become more involved in developing a website application.

ANALYZING THE COMPETITION

In addition to getting feedback from stakeholders and other interested parties, it is essential to analyze the competition. No product or service is sold or produced in a vacuum. Look for direct competition, such as another website that serves the same purpose, or indirect competition, such as a print catalog that addresses the same need as a proposed online catalog.

If your competition is direct, make sure you plan a site that is superior in some important way. Studying the competitive company itself, you can determine if your company has the marketing resources and expertise to compete in the open market. For example, other organizations have the ability to create online travel websites to compete with Expedia.com (owned by Microsoft), but how many of those companies can challenge Microsoft's depth of resources?

If the competition is indirect, in the form of non-website products that address the same need, then to be successful your product must provide the user with some compelling advantage to providing this service online. For example, simply converting a print catalog to an online catalog may not be worth doing if the site provides only the same information. In fact, such an application has an inherent disadvantage, in that it is expected to be always current (ongoing maintenance), and you need a computer to access it, unlike a print catalog. It will probably cost more to produce than a print catalog and have lower-quality photos because of the better resolution possible in print compared to computer displays. If your online catalog makes good use of the computer capabilities to do things that can't be done in print, however, such as running promotional banners and letting customers sort through massive amounts of product, it might be worth doing online because it would pay off in increased sales.

In summary, there must be a compelling reason to create a website, as opposed to accomplishing the same purpose in another more traditional medium, such as video or print. The creative design grows from that *raison d'être*.

You should strive to remain objective during the process of gathering user requirements. Regardless of how well things may seem to be going, you should take everything you hear with the proverbial grain of salt. Potential users are rarely experienced Web designers and often cannot accurately envision the site being described. Therefore, their responses may be clouded by wishful thinking or simple misunderstandings. Even experienced designers can have difficulty accurately envisioning a site design from a printed description. In addition, other factors may color subjects' responses, such as perceived benefits from positive responses or some other hidden agenda.

During the analysis, get input from as many interested parties as possible. When discussing the idea of designing a public website, it is essential to get input and support from those responsible for marketing. Likewise, you should provide some sort of technical support, the size of which will depend on the situation. You may need a full department of customer support personnel, or you may be able to simply designate an individual to reply to the occasional e-mail. If this support does not already exist, then the issue of how customers will obtain technical support will have to be decided early and weighed into the break-even equation.

REQUIREMENTS SPECIFICATION

A primary goal of the analysis phase is to identify and describe the application's crucial functions and features: what the website needs to be able to do. This discussion is embodied in a document that specifies the requirements that will be needed, which is often known as the requirements specification. This essentially sets the task factor of the project. For example, a particular website, to be successful, may need to include sections on products, personnel, store locations, and an online catalog that accepts credit card payments. In the requirements specification, all this would be described to a fine level of detail. The requirements specification is crucial to the success of the project because it is the starting point for the workplan and cost estimate, and later for the design itself.

Once you set the requirements, it becomes much easier to predict chances of ultimate success and to reexamine and perhaps modify the project to increase those chances. Imagine that a website is cost estimated at $500,000 based on an initial requirements specification. Will the site increase sales to this point over time, and how much time? Is the market for the product large enough to support such sales? If not, one way to change the break-even point is to lower development costs by lowering the requirements, allowing the project to be completed in less time or with fewer people. In this way, the feature requirements can have a major impact on the success of the application.

This reexamination and modification of desired features usually forces a fresh prioritizing of the requirements needed to achieve project success. Marginally useful functions and "nice to have" features accumulate rapidly on a requirements specification. These often superfluous features must be eliminated to avoid weighing the project down and decreasing the chances of successful development. Every additional feature increases real costs exponentially because each additional feature must be designed, integrated, and tested in combination with the other features. The requirements specification should identify and include only those features and functions necessary to the ultimate success of the product, not those with the most vocal or high-ranking internal advocates.

DEVELOPING THE WORKPLAN

Once the analysis has been performed, a requirements specification has been produced, and the project idea has been deemed worthwhile, the next step is to develop a workplan. A workplan is a document that essentially details the three factors of time, task, and resources for the particular project. The time factor is embodied in the project PERT and Gantt charts, milestones, and development schedules. The task (what needs to be done) is derived from the requirements specification. The resources are the estimates of people, equipment, materials, and outside services necessary to develop the product, and the associated costs.

Only by planning these three factors in detail can the full scope of the project come into focus. Envisioning the individual dimensions forces you to think through most of the issues, consider them from various perspectives, and anticipate the details and concerns that may arise (Figures 5.1 and 5.2).

The format and content of the workplan will differ greatly from one project to another, depending on the specifics and complexity of the project. The workplan may range from a single-page document (for a simple website like a three-page Web "home page" site) to a multivolume marketing, development, and implementation plan (for a large-scale dot-com business). The plan should be as complete as necessary without being too detailed. Although planning is necessary and important, you should not go overboard in writing the workplan. Remember that the goal is not to create the perfect workplan, but to plan out the

Number of (relatively equal) features

Figure 5.1 The cost to implement each successive feature increases exponentially, not linearly.

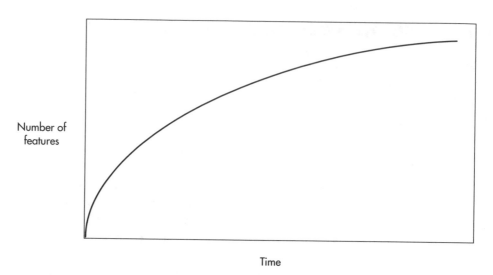

Figure 5.2 As the number of features increases, the time required to implement each successive feature becomes proportionately longer. The first few features can be implemented relatively quickly, but eventually, the time required to implement even one more significant feature takes inordinately longer because of the ripple effect.

project in enough detail to foresee significant issues and deal with them. At some point, the analysis must end, and the development must begin. In fact, sometimes perfecting the workplan can become an excuse for not starting development, or a way to actually procrastinate making a decision on the project itself.

While primarily the responsibility of the project manager, the workplan should be viewed as a jointly produced document that represents the consensus of the various decision makers on the project. The project manager will be in a much stronger position if all interested parties have had input into the workplan and agree with it beforehand, than if it is presented for approval without their prior input.

In fact, the process of developing the workplan helps achieve this consensus. Putting it all down on paper makes the assumptions and expectations more tangible, visible, and subject to much less interpretation and misunderstanding (compared to verbal descriptions). In this way, the workplan is actually a tool to help those involved develop a common understanding and agreement on what the site will look like, what it will do, and how development will be accomplished.

Time

The workplan should detail the time factor—in particular, the development schedule embodied in the PERT and Gantt charts, along with descriptions of the milestone tasks and completion dates.

The PERT and Gantt charts are crucial in compiling a development plan because not only do they force you to think about the different tasks and the workflow necessary, but they also allow this information to be shared and discussed, and they graphically depict how you expect the project to unfold. They also provide a way to document the project's complexity to those who may question the time and cost estimates.

The schedule is monitored according to milestone delivery dates, such as "Alpha version delivered." These dates provide a way to track progress objectively and to provide achievable intermediate goals for the development staff to work toward, rather than simply some distant final delivery date.

To make effective use of these milestone dates, they must be well defined. This action helps management understand in what stages the project will be developed and lets development staff focus on what needs to be accomplished to achieve those milestones. Including milestone dates and definitions in the workplan permits them to be examined, discussed, and modified if necessary and provides proof of the clear thinking that has gone into developing the workplan.

Task

When creating the workplan, the first step is to try to define the task in as much detail as possible. This means reviewing and expanding the details in the requirements specification. Identifying the task at this level of detail provides the basis for laying out the other factors. For example, the initial requirements specification may contain a target browser version along with its overall capabilities, a list of perhaps two dozen main features, along with one or two sentences describing each feature. These descriptions need to be expanded and detailed so that programmers, content producers, and data preparation staff can begin estimating the time and equipment needs to accomplish the task. For example, a feature on the initial requirements specification might appear as follows:

Online Catalog: An easily browsable catalog of our products

- Accessible from anyplace on the website
- Contains up to 2,000 products
- Searchable
- Order products online
- Easy to update

While this is a perfectly valid feature, it is not sufficiently detailed for a programmer to develop a valid time estimate. It lacks information about the features, such as how many screens, security technology, hosting plans, and so forth. Nevertheless, it provides a starting point for discussion. At this point, the

development staff usually starts asking questions (e.g., "searchable in what ways?"), which help define the project to the level of detail they need.

After reviewing this feature with those who have requested it, technical staff, and possibly with potential users, the description might be expanded as follows:

Online Catalog Module:

- Accessible from main navigation bar, active anyplace on the website
- Externally hosted on secure server
- Contains up to 2,000 products
- Product pages contain photos and text descriptions of most products
- Searchable by product function, word search, product number
- Shopping cart system lets users browse and flag products for potential purchase
- Lets users order products online through submission forms
- Automatic e-mail notification to users of order received
- Credit cards accepted for payment, with automatic verification and bank crediting
- Administrative functions to allow easy catalog maintenance (e.g., items, prices)
- Total estimated screens: 12 as follows
 1. Main catalog page, containing product categories
 2. Search page
 3. Search results page (with hotlinked results)
 4. Product detail page
 5. Shopping cart page
 6. Order information page
 7. Payment page
 8. Order verification page
 9. Order confirmation page
 10. Administrative menu
 11. Product maintenance page
 12. Order status page

The previous description helps clarify the "Online Catalog" feature and ensures that everyone agrees this is a suitable implementation that fulfills the requirements for the feature. It also provides enough detail for a programmer to start estimating the time required to develop the feature and integrate it into the site. The description also provides information to those involved in content development and data preparation that there will be 2,000 products, including descriptions, photos, product numbers, and other associated information, and the data will

need to be updated and maintained in an ongoing way. The target platform must be specified, as well as any restrictions or preferences regarding the Web development tools, graphical design, audience demographics, and other information pertinent to the overall task.

In summary, whatever you call it and whatever the form or format, you need a document describing in detail what it is that you are developing, to make it visible to others so they can understand and have something to approve.

Resources

The resources required to develop a project include the following:

- the people themselves (personnel)
- equipment
- outside services
- materials that will be consumed in the process

Determining the resources needed and planning for them requires careful examination of the tasks involved, what it will take to accomplish them, what resources will be available when, and how to obtain resources that would not otherwise be available.

The starting point is the requirements specification. This document can be used to estimate the personnel time required to implement each feature. You should consider all aspects for implementing each feature, including programming, data preparation, testing, and other pertinent tasks. The time estimates are best determined by having several individuals independently estimate the same tasks, for comparison's sake.

If large disparities occur, the estimates can be discussed in a group, if necessary, and a consensus achieved. You should be especially careful with time estimates cited by programmers because these people can be notoriously optimistic in their estimates. Project managers have been known to simply double a programmer's estimates as a matter of course. Although this reaction may seem extreme, more than one project has failed because the programming effort turned out to be an order of magnitude greater than originally estimated.

Personnel

Once the total time investment required for each feature has been determined, the estimates can be totaled for an initial view of the personnel requirements. This initial view is usually a rough approximation and does not include contingencies for unknowns and getting project personnel up to speed; however, it does help you start blocking out how many and what kinds of individuals will be required to develop the application, and for how long.

It is also helpful to consider whether these people will be existing internal staff assigned to the project, whether you will need to hire permanent staff, or whether you can use freelancers or contract personnel. Different kinds of personnel may require different approval processes. For example, reassigning permanent staff may require a commitment from management to make these people available. Hiring new permanent staff may require a lengthier approval process. Hiring consultants and freelancers may be more expedient, but the expertise they gain while doing the project will most likely disappear with them when they leave, after the project is finished.

Equipment

Different types of employees may require different types of equipment. If permanent company staff is assigned, they will presumably have their own existing equipment to use. If they are new staff hires, equipment for them to work on will most likely need to be purchased. If they are temporary personnel, it might make more sense to rent equipment.

You must also consider what kinds of supplementary equipment will be needed, including computers capable of digitizing video, additional peripherals such as hard drives and printers, and various other hardware the company may not currently possess.

Materials

Materials required will include everything from office and computer supplies, to software for people to use, to content that must be purchased. If you intend to use photographs that your company does not own, there will be licensing fees. If you need to obtain data, it will usually be at a cost. Even if content or data is publicly available, there may be a hefty service fee required to obtain it or to input it in a format you can use.

Outside Services

Like all other resources, the outside services needed depend on the specifics of the project. These kinds of services typically include hosting and backup, domain name acquisition, outside testing, service fees of all kinds, and other items that you may not have the capabilities or resources to do in-house, or that may simply be more cost-effective or expedient to contract out.

Assumptions

The workplan document should show any assumptions you have made. These assumptions may vary greatly depending on the nature of the project, including unresolved technical issues, staffing issues, and other items that may not be firmly rooted in certainty. The primary reasons to state these assumptions are to

make sure everyone is aware of them and to protect yourself later in case the assumptions change or prove incorrect.

For example, you might state your assumption that certain critical staff members will be available to work on the project by certain dates, and if they are not available, then the schedule may slip. If this actually happens during the project, you will be able to go back to the workplan and point out this assumption, to which everyone agreed and approved. It is worthwhile to try to identify as many important assumptions as you can, in order to gain agreement that they are valid assumptions and to make sure the risk is shared by all involved, rather than just yourself.

Executive Summary

Finally, it is often worthwhile to include an executive summary of the project analysis in the first few pages of the document. The full analysis usually contains several levels of detail more than an executive may want for an overview of the project. The executive summary should be concise and no longer than a page. A brief summary is much more likely to be read, and the workplan considered and acted upon.

Workplan Outline

Here is a boilerplate outline for a workplan:

 I. Overview
 A. Executive Summary (who, what, where, when, and how without jargon, in one page)
 B. Goals and Objectives
 C. Marketing Considerations
 D. Effect on Existing Business
 E. Maintainability
 F. Special Issues
 II. Task
 A Requirements Specification
 B. Design Specification
 C. Quantitative Evaluation
 1. Content to produce or purchase
 a. Photos
 b. Text
 c. Other (graphics, sound, video)
 2. Data to produce or purchase
 a. Databases

 b. Data files
 c. Other
 III. Time
 A. Milestones Defined
 B. Milestone Target Completion Schedule
 C. Gantt Chart
 D. PERT Chart
 IV. Resources Required
 A. Personnel
 1. Technical (roles and skills)
 2. Nontechnical (roles and skills)
 B. Equipment
 C. Software and Materials
 D. Outside Services
 E. Web Hosting
 F. Testing
 G. Special Technical Services
 V. Further Considerations
 A. Assumptions
 B. Risk Factors and Mitigating Them
 C. Technical Factors (new development considerations)
 D. Business Factors (competition, etc.)
 E. Others
 VI. Appendix
 Approval

Once the workplan is complete, the next step is to obtain official budgetary approval, which is sometimes easier said than done. The method of getting official approval to start (or continue) a project varies widely, depending on the organization and its sponsors within. A website production company, which is in the business of developing websites, may have a well-defined procedure for taking a project from idea to completion. On the other hand, a company with an unrelated core business may have no formal (or even informal) mechanism to approve such a project and may even allow it to move forward simply by not stopping it.

 Other companies may have ambiguous approval processes, such as a training company that provides instructor-led training but wants to start selling training over the Web. If the company does not have an established method of considering and approving such a product, approval could be delayed beyond reason, if not indefinitely, despite potential benefits to the company.

ROGUE PROJECTS

It may be tempting to "go it alone" on a project, without approval, using hours and resources allocated to officially approved projects, but doing so is an extremely risky proposition for the people involved, and the risks can outweigh the potential rewards. First, it is difficult to keep such a development effort quiet. Not only do coworkers notice what's going on, but it's difficult for most people to refrain from discussing interesting new projects they are working on. In keeping with Murphy's Law, such covert operations are usually discovered by senior management at the most inopportune moments, such as when management is investigating why an important deadline for another project was missed. If the rogue project actually makes it to a showable stage, then no matter how ingenious the site, management will certainly want to know why it was done without approval. Your own boss may even suspect you of attempting a power play. So if you start significant development work without approval, you not only risk the backlash of never getting the project approved, but you may also risk your own job.

While there are rare cases in which a project is developed "off the charts" (and usually after hours) and results in a great success, these projects usually have a champion within senior management to shield the project from scrutiny and provide a suitable context in which to unveil it. Usually, the best strategy is to be patient and get official approval before you start applying significant resources to a project.

BY THE WAY . . . IT'S ALREADY STARTED

During the analysis phase, you may be simultaneously focused on gaining approval to start the project; however, what may be less apparent is that regardless of forthcoming approval, the project has already begun. The time needed to conduct a proper analysis and requirements specification, including holding focus groups, working out budget estimates and break-even points, and prioritizing features, is significant. This start-up phase actually costs time and money, and while a project may not yet be officially approved, time and money are already being consumed during the analysis phase to prove or disprove the concept.

In summary, the analysis phase for a website is crucial. The site can be expensive not only to develop but also to maintain. Good planning must be employed to create a site that an organization is able to maintain with its own resources. In addition, there must be some compelling business case for creating a site. If the goals of the site are not clearly established, it can easily become a significant waste of time and money. Such goals can also be somewhat difficult to

establish, given the number of individuals from various departments who tend to get involved in the decision-making process, each of whom brings his or her own set of expectations.

The two fundamental questions to answer are: "What are we trying to accomplish with the site?" and "How much is it worth to accomplish such objectives, on a yearly basis?" Only by answering such questions in a quantitative manner can you expect to develop a successful corporate website. The answers to these questions determine the design of the site, the time frame in which it can be completed, and the cost.

The Web Development Team

Developing a website can be a complicated undertaking, requiring the efforts of multitalented individuals and those with specialized skills. How these people work together is an important consideration in the development process. Workflow in new product development tends to follow one of two paths:

1. Functional area approach
2. Team approach

While not mutually exclusive, one path or the other tends to dominate in most new product development processes.

Industrial manufacturing has historically favored the functional area approach, with the assembly line as the archetypal manifestation. In the functional area approach, the work product moves through functional areas or departments (in a supposedly "automatic" fashion), where specialists can apply their skills in the most time-efficient manner possible. For example, on the traditional auto assembly line, the workpiece (a car in the making) moves along from station to station, with specialists at each station applying their skills. The car stops in front of the windshield installer, then moves off to get its headlights installed, while the next car arrives to have a windshield installed.

The team approach is generally better suited to Web and software development. With this approach, a multidisciplinary team is responsible for taking a product from the beginning to the end of the development cycle. When building a car with the team approach, the car does not move down an assembly line. Instead, it stays in one place, and a stable team of multiskilled people works together to build the car. One person installs the windshield, then goes on to install the headlights, and then perhaps helps another team member maneuver the engine into the engine compartment.

A particular development process may incorporate elements of both approaches. After a team builds a car, the car may go to a testing shop. Because that

testing shop does nothing but test cars, it can be considered a functional area. Different product development and production situations favor different approaches, including hybrid processes—like a team approach that uses some assembly line elements, or vice versa.

WHEN TO USE EACH APPROACH

The functional area approach is well suited to a situation in which many similar or identical products need to be produced and a minimum of design work is needed. Each specialist can apply his or her trade as efficiently as possible, with a minimum of interaction among specialists.

The team approach is more appropriate when the organization develops a few distinctive skills, especially when a significant amount of design work is involved. For new products, in which a lot of interaction among specialists is required, a team approach is better suited. The more products and the more similar they are, the better suited is the assembly line. The fewer products and the more different they are, the better suited is the team approach. Website development usually benefits strongly from the team approach.

The team approach may seem counterintuitive to those previously experienced in producing other kinds of media, like video or print. Typically, a video production moves from the scriptwriter to the director to a shooting crew to a postproduction facility, all under the watchful eye of the producer, whose responsibility it is to make sure the project comes in within the budget and on schedule. Often the video is one of several (or many) similar videos being produced, perhaps as part of a video series or as an installment in an ongoing effort, such as a video magazine. A series of 20 videotapes can be produced by setting up an assembly line and then moving the work through the process in a steady stream. This type of product can move easily and efficiently through the functional area production process, because each step is well defined and the current product varies little in form and format from previous products.

Likewise, print publishing lends itself well to a functional area approach because the work must proceed by a well-defined linear path (i.e., writing, editing, copyediting, layout, proofing). Everyone is a specialist and can do his or her job in turn. In addition, the current product—whether book, magazine, or brochure—is usually similar in form to previous products.

Software in general, and a website in particular, is unlike other media in this respect. Generally, a website or software application is the only such project in development, or one of only a few unique projects. It usually requires a significant amount of design. Setting up an assembly line to produce it would result in loss of communication, inefficiencies, extra cost, and, most important, diminished

product quality. Developing a website requires a wide variety of skills, from art-work to programming to content writing and testing; it also requires that the people applying these skills be in almost constant communication. Therefore, most successful websites are developed by small teams of individuals, working almost full time on a given project: the team approach.

BENEFITS OF TEAM WEB DEVELOPMENT

Better Communication

To make appropriate decisions quickly during the development process, you need to keep a tremendous amount of detail in mind so you can evaluate the rip-ple effects of various decisions. For example, how will adding a particular feature affect other features? Site navigation? Data preparation? Testing? Will incorpo-rating a nifty new JavaScript function require users to have the newest version of the browser? To make intelligent decisions, you need to know a lot about the project in general and the design specifically. The team needs well-rounded rep-resentation of the various disciplines (e.g., programming, testing, design) and free and open communication.

If you try to produce a website with the functional area approach, people down the line need a huge amount of information about the work to be per-formed, and that information must move along with the work. In fact, the com-plexity of the required information will slow down the project. So many handoffs open up many opportunities for miscommunication and mistakes.

A website development project does move from an analysis phase through the design phase, prototyping, various production versions, testing, and is fi-nally posted and goes live. This apparent step-by-step process may tempt you to set up an assembly line approach and move the project along in linear fashion. In reality, however, these phases cannot be so cleanly separated. They are often in-terrelated, and they may need to be repeated in part or in full as new information or ideas emerge.

The product design greatly affects the programming and even the testing procedures. A software tester involved in the project from the beginning can start writing test specifications early, based on the design specification. Otherwise, the test specifications need to be written after the program has been coded, which is much more time-consuming. Likewise, a programmer who is involved early in the design phase can warn about proposed features that might be difficult to im-plement or inconvenience users, and then offer more viable alternatives. Involv-ing the programmer early also gives him or her a head start on technical design and implementation, perhaps even before the design is finalized, which can save

a tremendous amount of time. You should involve as many team members as possible from the beginning of the project.

Concurrent Tasks

The large number of concurrent tasks that can and must be performed to develop a website in a reasonable time frame also points to the team approach. Website development is more akin to synchronized swimming than the 400-meter freestyle relay. During the development process, all team members are working simultaneously on various aspects of the project and need to be in constant communication. If they are working on the project full time, it greatly facilitates this communication and team integration.

Commitment among Team Members

The success of a website is usually a function of inventiveness. A successful website offers distinctive content or somehow creates a more powerful or positive user experience than do other websites. Because most sites try to be different, they are, by definition, attempting something new. Invention is at the heart of the process, and invention is characterized by continuous problem solving, which takes time and dedicated people. People become dedicated to a project only if they feel ownership of it and a responsibility for its success, which usually happens when it is their full-time job, more or less—not just because they have been assigned to the project as part of an assembly line workflow. A full-time website development team will take ownership of the site and become committed to its success. They will view it as a direct manifestation of their efforts.

Programmers who are part of an assembly line process rarely become dedicated or committed to a given program. They may never have seen it before and will probably never see it again; however, as part of a development team, programmers are involved in a product through its development cycle and can actually become emotionally attached to it. They often work extra hours voluntarily to maintain high-quality standards and, more important, because the other members of the team are counting on them.

Not a manipulative or gratuitous "warm, fuzzy" approach, team-based Web development is simply a pragmatic and effective way to achieve one of the essential elements of success—the bonding among development staff. People depend on each other for mutual success and feel compelled to support each other in the effort. The team can take on a wide variety of tasks, and team members can apply their individual strengths and cover for each others' weaknesses. In this way, a team begins to identify with the successful completion of a project, and the team identity depends on such a success.

TEAM DYNAMICS

Each individual has a unique personality and identity to be respected as well as skills to be utilized. Creating teams is a delicate process. Although it is difficult to predict in advance which individuals will work well together, it is helpful if team members have some input into the composition of their group. On the other hand, it may not always be possible for the project manager to handpick team members.

One important consideration in team composition is a variety of personality types, which helps balance the team dynamics. One or two dominant personalities are fine, but not too many. A team without an empathetic, social person may have trouble developing a sense of camaraderie and cohesiveness. A thorough, hard worker encourages others to stay on task.

Genuine, cohesive, mutually supportive teams do not form instantly. It takes time for individuals to come together and start performing as a team. Both the psychological issues and the division of work and responsibilities need to be sorted out before a team can work together effectively. In fact, according to Bruce W. Tuckman, a psychologist who wrote in the 1970s, a team in the making typically passes through four stages before it becomes a unified team:

1. Form
2. Storm
3. Norm
4. Perform

Form, the formative stage, is the time during which team members are chosen and are starting their work together. Storm comes next, when they are sorting out issues of responsibility, dominance, and informal communication. The Norm period is when the team has settled down into a normal working pattern. The Perform phase is when that established working pattern has taken hold and been optimized, and the team is operating at peak capacity.

TEAM MEMBERS AND FUNCTIONS

Choosing the right team members and determining the right positions for the development project is essential in the team approach. What are the right positions for a Web project team? The answer naturally depends on the specifics of the site. A simple Web presence site may require only a Web artist with HTML authoring skills and a content/editorial expert. A large, database-driven site, with e-commerce and Java applets, may require a team composed of a dozen

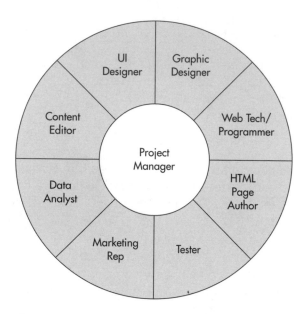

Figure 6.1 Team members and functions.

members working on it for six months or more. The roles depicted in Figure 6.1 must be covered, whether some individuals have responsibility for more than one role or work with others to fulfill a single responsibility.

Please note that the term *Webmaster* is not included in these descriptions because of the ambiguity in usage. It may refer to any of the following roles depending on the organization:

Content Editor
HTML Author/Designer
Technical Lead
Marketer

Team Leader/Project Manager

First and foremost on any website development team is the team leader, usually the project manager. This person has ultimate responsibility for the project outcome. Administrative responsibilities will vary, depending on the person's rank within the organization. Regardless, on a daily basis, this person must function as a first among equals, not strictly as a manager. Although the team leader coordinates the efforts of team members, he or she is often not the direct administrative manager of those on the team. Therefore, the team leader must gain the respect of

the team members through example, rather than by managing them by administrative decree.

Leading a project team differs greatly from managing. You can manage by decree but cannot lead by decree. Drawing from superior experience or knowledge, managers may give orders to subordinates. Leading a project is different—a leader needs others to create strategies and solve problems independently, then coordinates the efforts of self-motivated team members. On a truly self-motivated development team, the team leader wins team members' cooperation by gaining their respect, not by coercion, intimidation, threat, or pulling rank. You can be appointed project manager but can only truly lead a team when you gain their respect and trust.

Old-line managers may have a difficult time understanding or accepting such an approach. In many companies, management views employees as soldiers whose job is to execute the orders of their superiors. Unfortunately, the intelligent, innovative employee who voices concerns about established methods is often viewed as a troublemaker by management. A true team must develop a level of trust so that such voices can be heard. A team approach does not rely on the chain of command, but rather on the intelligence and internal motivation of the team members. When teams are at their best, members identify with their work, perform to the highest quality they can, and want to make suggestions that will be taken seriously.

The position of team leader or project manager requires a special person who is conversant in all areas of website development, from user interface design and programming to testing and even marketing. No one individual can be an expert in all of these fields, but the team leader needs enough background in each area to understand the issues involved. Otherwise, he or she will find it difficult to make intelligent decisions and will thereby lose the respect of the team members. No one likes to be led by someone who is perceived to be incompetent. The team leader sets the schedule, manages resources, and defines the tasks to be accomplished; however, effectiveness depends on the voluntary support of the other team members, so the team leader must cultivate good personal relationships with each team member. In addition to the necessary technical knowledge, one of the most important requirements for an effective team leader is good interpersonal skills.

User Interface Designer

The main responsibility of the user interface (UI) designer is to plan out the site navigation and any user interface controls for features. The interrelationship and flow of all of the screens, controls, buttons, and choices in a logical, intuitive manner are all the responsibility of the UI designer. Using a variety of tools, such as screen drawings, text descriptions, and flowcharts, the UI designer describes the

user interface so that other team members can understand it. The UI designer understands the constraint of the resources and time and designs accordingly.

The UI designer should be schooled in the appropriate communications design, depending on the application, including instructional design and/or graphic arts when necessary, as well as the appropriate psychological disciplines, such as ergonomics. The UI designer should also be able to use graphics programs and HTML authoring programs as needed, in order to convey ideas to other team members as well as to potential users and management decision makers. This person needs to be familiar with other websites and understand the prototyping process. He or she must be open to design changes from others on the team as well as changes based on focus groups and usability testing, which calls for a collaborative personality type.

The role of the UI designer is crucial in developing a high-quality website. The various screen layout changes, feature modifications, and shifting requirements make this role fundamental and often full time for a large-scale website project, especially when custom-programmed interactive features are present.

Graphic Artist

The role of the graphic artist is to create the visual elements specified by the UI designer or provide creative alternatives. These elements include screen layouts and designs, illustrations, button designs, and any other visual elements on the site. Graphic artists may create these elements in any number of ways, from hand-drawn illustrations to computer-generated artwork, and all manner of combinations. Therefore, the artist must be able to work proficiently with a variety of computer graphics and art programs. He or she must also have the technical ability to scan and digitize images, and manipulate them as necessary. The artist needs to be able to work in a visual style that is consistent with the website goals and in collaboration with the UI designer, presenting options from which to choose. This person must also be able to conform his or her personal style to the needs of the site.

Programmer/Software Engineer

The programmer is responsible for designing any software architecture and writing the code at the heart of the application. This may occur in many situations in Web development, from database-driven applications to interactive Java applets to backend server processing. The programmer's skills should correspond to the project needs. For example, a basic Web presence site may require little, if any, actual programming, so a programmer may not even be needed. On the other hand, a more complex site with the features described previously may require the efforts of several programmers working in different areas of specialty.

If programming is needed on a particular site, it will achieve the highest priority in the Web development process. The site usually cannot go live without the executable code working as desired. Imagine the Weather Channel site without functional programming. The whole site would break down. Included in programming are related tasks as needed, such as database management, server maintenance, and security considerations. Therefore, the programmer sits at the hub of the process and can be seen as the linchpin of the development process.

The programmer should have previous experience working in the project's development environment (e.g., NT vs. Unix, ASP vs. Cold Fusion, Java, JavaScript), if possible, since the learning curve on some of these technologies can be steep.

Programming requires the utmost concentration, which has ramifications for how the project is managed. It is beneficial to physically separate programmers from the rest of the development team—each in an individual office, if possible. The efficiency of a programmer who is subjected to frequent and uncontrolled visits by other team members will suffer greatly. Programmers must also be protected, to some extent, from the administrative and managerial demands of the project, because these also represent significant distractions. This does not mean that programmers should be treated either like prima donnas or "techno-slaves," but merely that it is wise to keep distractions to a minimum to allow them the needed concentration, so they can meet their deadlines and avoid making costly mistakes.

In addition, it is advantageous for the programmer to be included as early as possible in the development process and not simply tossed a website design specification and expected to build it. If included early in the process, the programmer may bring many useful insights and suggestions to the functional design and can help the team avoid many pitfalls while it is still early enough in the process to have a beneficial effect. The programmer can propose creative alternatives to solve design problems early and can even be actively working on the software architecture much earlier than is often imagined.

Data Analyst

Data preparation covers a wide variety of tasks, from graphics manipulation to image scanning, to text markup and file formatting. Therefore, the data analyst's required skillset depends on the project needs. The data analyst ensures that all content for the website (i.e., text, graphics, photos, and sound) is in the proper file format. Once prepared, the files are handed off to the programmer or HTML author to be incorporated into the site.

Data preparation is a two-step process:

1. The creation of original source material (commonly called "content")
2. The conversion of content (original or provided from another source) into the correct file format(s) for use on the website

Using text as an example, a word processing file has to be formatted into HTML, or archived in a database for later use by a programmer. Web projects often utilize content created for another purpose, such as a promotional video clip or print brochure. In such cases, the data analyst is mostly concerned with processing the existing data into the right file formats.

For example, in creating a database-driven Web-based catalog, you may simply extract text and photos from a print catalog, format them appropriately, and add them to the necessary database. Other common kinds of data preparation include HTML text conversion, picture file format conversion, and audio digitizing.

Another element of the data analyst's job is to control and oversee the data. He or she needs to archive data, follow and enforce file-naming conventions, and update new versions of data. On a large project, this responsibility can become a significant task and requires an individual with good organizational abilities, or even several individuals working as a subteam.

Referring to pictures and text as "content" and "data" may annoy some artists, producers, and writers, but these terms express the software-centric perspective of the development process that is essential. Although you may think in these terms to expedite the development process, in actual conversation with artists, writers, and so on, it may be more tactful to avoid using them out of respect to the creators.

Software Tester

Testing is crucial and can be a complex task. With exceptional attention to detail and a high level of creativity, testers find and isolate defects and errors that may be mysterious in their occurrence and effects; for instance, problems in one browser or not another, or in a certain version of a browser with features activated or turned off, at different screen resolutions, and so forth. If these problems are not discovered internally during the development process and corrected, they will be discovered by your users with unpleasant results.

Testing a website is best assigned to a single individual. Various team members may help perform testing, especially toward the end of the project, but a single, knowledgeable tester must coordinate their efforts and, usually, perform a sizable amount of testing. This person writes test plans (based on the design specifications) and implements them with the assistance of others on the project team or outside testing personnel. The lead tester is responsible for finding and documenting all errors, including both programmatic errors (defects) and data errors (incorrect content).

All websites must be tested, whether they are five-page static websites or complex business-to-business e-commerce sites. The larger and more complex the site, the more testing is required. It is often beneficial to involve several people in

the testing process. Different people tend to navigate through a site differently, and in so doing find different kinds of errors.

SHIFTING RESPONSIBILITIES

Team members may need to assume many other roles when appropriate to the project (Figure 6.2). For example, a marketing person is often needed to coordinate development activities with marketing needs and to protect the interests of the marketing department. Other areas of expertise that are often useful are sales and customer support.

The team members and their roles described previously are general guidelines, which are meant to be adapted to the needs of the particular website. Be assured we are not recommending you use exactly seven people, in exactly those roles described, on every Web project you do. Websites can require the efforts of anywhere from a single person to dozens of people organized into teams and subteams. In addition, because the work is done over time as part of an ever-changing process, the workload and type of work for a particular team member fluctuates, so it is key for team members to have overlapping skills and be easily

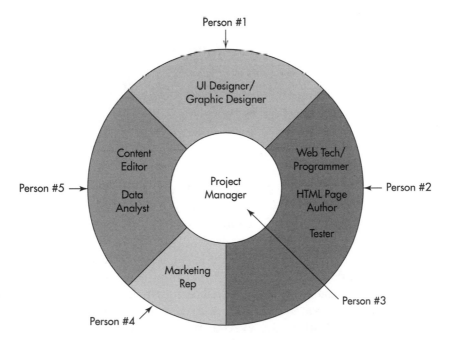

Figure 6.2 Team members and functions: Several job roles accomplished by fewer individuals.

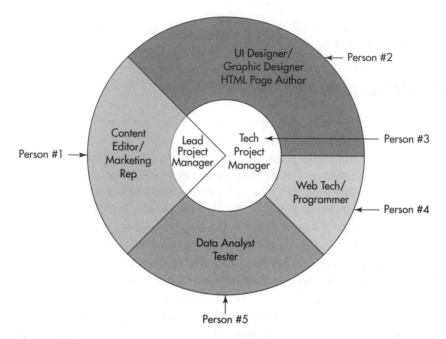

Figure 6.3 Team members and functions: Project management function divided between technical and nontechnical areas of expertise.

trainable. If so, they will be able to help each other and smooth out the variations as the workload ebbs and flows among different specialties (Figure 6.3).

When team members can work on various aspects of the site, they develop a more well-rounded perspective and better communication with their colleagues. Together, these two benefits translate into advantages that can raise overall team performance to a higher level. The result is relatively shorter development time and better quality.

Another benefit of having people work in areas outside their specialties is that it maintains their interest level by letting them work on new tasks and develop new skills. Not only do they remain mentally tuned-in to the project, but they also develop a wider repertoire of skills.

For example, during a temporary lull in the testing phase, a software tester may need to assist in data preparation. This overlap is beneficial. In performing data preparation, the tester may learn valuable information about this area specifically and the site in general, which will ultimately help in testing and benefit the team as a whole. In addition, the overlap necessitates interaction between the tester and the data preparation staff, ideally promoting communication between the two. Finally, cross-functionality gives the tester the opportunity to support another party on the team, increasing the bonding among team members.

7

Contractors and Clients

Websites can be developed in-house (internally), out-of-house (externally), or using both. With in-house development, a company designs and builds a website using primarily its internal staff. Out-of-house development is when a company goes outside and commissions another company to build its website, in a client–vendor relationship.

A fundamental factor in the management of a website development project is the business or employment relationship among the players. In the interest of tax collection, the Internal Revenue Service (IRS) has gone to great lengths to distinguish between an independent contractor and an employee. The distinction can be ambiguous in some situations, so the IRS has established a list of checkpoints that swing the balance one way or another. The guidelines specify that a contractor is responsible for the output and is not supervised or trained in how exactly to proceed toward that outcome. This is an illustration of how rules and customs governing interpersonal relations differ depending on whether the person is an outside contractor you've hired, a coworker from another department in your company, a direct report, or a peer. In short, an in-house project manager does not have the same control over a contractor that he or she is likely to have over an employee.

Most of the time, Web projects involve a mix of in-house personnel and contractors. Certainly large projects do. So many skills are involved in putting together the pieces (e.g., writing, programming, graphic design, and network administration) that a company usually goes outside for some services. Even though the corporate website now has an undeniable place in the communications and commercial mix, a company's information technology or marketing departments are often too busy with other duties to build and maintain a site. Even many intranet sites running on large corporate networks are built and maintained by an outside developer.

Successful project management depends on communication. Your perception of a given project may vary greatly, depending on whether you are in the

client company or the outside developer. Whether your position is as a project manager in a full-service Web development agency or an inside team leader who hires the outside firm, you have an interest in how the project is managed. If you're the in-house team leader hiring an outside project manager, you will still manage facets of the project that only an in-house person can, such as executing the agreement, gathering content, and shepherding deliverables through the approval process.

Coordination is always an issue in project management, and it is likely to involve both contractors and employees. In this chapter, we look at how contractors and clients can align individual interests for the common goal of a successful website project. To search out this common ground, contractors and clients can benefit from understanding one another's perceptions and motivations regarding the website project. This chapter explores both perspectives.

CONSIDERATIONS IN THE INSIDE-OUTSIDE MIX

The decision about whether to produce a project internally or externally is an important one that merits thorough consideration of many issues. A sound place to begin is with the three dimensions of project management—time, task, and resources. The project needs within the context of the organization's overriding Web strategy should guide the decision.

A company getting ready to launch its first website will probably opt for a significant amount of assistance from an outside development firm. Once the site is up and running, maintenance duties can usually transfer to the client (often with the ongoing assistance of the original development firm). Internal personnel often maintain and develop intranet websites, which run on a company's private network, but this function can also be outsourced. Most commonly, a hybrid approach is used, in which some aspects are handled by the client, some by the developer, and some cooperatively, as shown in Figure 7.1.

We'll compare inside versus outside development in the following areas:

- Expertise
- Cost
- Control
- Teamwork
- Time and scheduling
- Investment and core functions

Table 7.1 provides a quick overview of the strengths and weaknesses of the two different approaches.

Hybrid Development Strategy

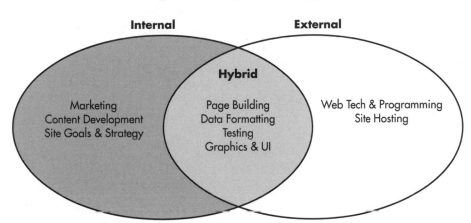

Figure 7.1 Internal/external/hybrid development tasks, a commonly used strategy.

Expertise

In-house development may not be an option. The first question the project manager must ask is: "Does the necessary expertise for meeting the project's goals lie within the organization?" If the appropriate staff does not exist internally and a website is attempted anyway, the results can be disastrous.

If an organization lacks internal expertise but does have talented people who could potentially develop the necessary skills, should it use the project as an opportunity to do so? It is feasible for internal people to learn some tasks on the

Table 7.1 Internal versus external development—comparison of strengths and weaknesses. (Note: The project cost depends on many factors, including site design, technology, available resources, and accounting methods within a company.)

	Internal development	*External development*
Expertise		X
Cost (depends on project specs)	?	?
Control	X	
Teamwork	X	
Speed of development		X
Investment in future	X	

job, such as basic software testing or documenting design changes. Other tasks, such as Java programming or Web server maintenance, are not so easily learned in a short time. Nonetheless, a certain amount of in-house Web expertise is a real asset in today's business environment. The work experience gained by participating in the development of a website, even an intranet site, is often applicable to other tasks within a company and could be of great use in the future. Again, the question of resource allocation arises. What aren't the organization's people doing during the time they're developing the website? What skills are critical to the firm's success? The glamour of website development may seduce staff away from more mundane, yet mission-critical, tasks.

When working with an experienced outside developer, the client company gets the benefit of that vendor's experience and knowledge gained on other projects, potentially similar ones. The value of this experience is a prime motivation in using an outside developer and why it can be much less expensive in the long run to do so. If a project has a high risk factor and must be completed on time, the best bet is probably an external developer with a proven track record of producing such websites, rather than trying to do the work internally and learning along the way. An external developer is a specialist and can often do the work much faster and with fewer errors than in-house personnel. This efficiency greatly benefits the project and those associated with it. For example, if a company needs a database-driven website right away, but has never developed or managed a Web database, it's a good idea to use an external website developer. Ideally, internal people will be involved as much as possible in the development process, so they'll be prepared to take on a more active role in the future.

Cost

A common misconception is that developing a website internally is cheaper than going outside. Theoretically, a project requires the same resources whether it's developed internally or externally. Therefore, given overhead and internal billing rates, costs should be comparable.

Arguably, with all else being equal, the development cost actually would be lower for in-house development because only "true" development costs would be charged, with presumably no profit margin added. Although the accounting practices of the company may require transfer payment between departments involved in development of the site, these costs would be lower than what an outside developer would charge.

Of course, all else is never equal. An organization's overhead charges may, in fact, exceed what an efficient outside developer builds in as a profit margin. In-house skillsets may not match those available outside. Normal job responsibilities of staff may make them efficient with certain tasks of the website development project. For example, if a project requires data preparation using internal com-

pany source files, internal personnel will probably be faster and more experienced at working with the data than an external developer (who would be working with the data for the first time). Conversely, a key skill for the project, such as Java programming, may not be available internally.

Outside developers' quotes that are not fixed bids should be closely managed. Enhancements or other changes can quickly escalate costs. Another issue is future updates. The most convenient way to produce an update is to go back to the original developer.

On the other hand, external developers can be much less expensive in some situations. Internal managers must consider the big picture. When time is crucial or when internal personnel do not have the skill or experience to do the job efficiently, external development may cost less. In addition, an internal project manager can often apply pressure on an external developer more effectively than on internal staff, especially when that staff is located in another manager's department (such as the internal Information Technology department), which brings up the issue of control.

Control

Developing the website in-house lends the maximum control over how the project is executed. The development personnel are company employees and can be monitored closely, if necessary. The project manager has great flexibility in how resources are applied. In addition, if the development is done in-house, then presumably the maintenance can be done in-house as well. In a situation in which the Web project has great strategic importance and qualified technical personnel are on staff, in-house maintenance is the safest method. Also, if the team is composed of company employees, the project manager can better encourage and reward the commitment and loyalty of the development team. The issue of control, however, is not always cut and dry.

When working with an external developer, a company relinquishes some degree of control over the project. An external developer usually works off site and is therefore a more independent entity. In an external development arrangement, the resources are essentially guaranteed by the developer. When project milestones trigger payments, the developer is motivated to deliver, and the client has the leverage of withholding payment. Because many small developers run their businesses virtually from payment to payment, withholding a payment pending milestone approval usually provides sufficient motivation to meet the milestone dates and specifications (to the best of the developer's abilities).

An internal project will also be more vulnerable to internal political maneuvering. When authority is unclear in an organization or when the project involves people from different departments, as is often the case with website development, in-house production does not lend the amount of control one might expect.

The project manager working with an in-house production staff needs to respect their time and other priorities. From the perspective of the in-house developers, internal clients can be the toughest customers. Project managers using in-house development sometimes feel free to make changes to the design at the last minute. They make demands of internal staff that they wouldn't think of asking from a developer. Although internal development may give the project manager the control to do that, those actions still carry a cost in resource use and time.

Teamwork

If a company chooses to hire people for internal development of the website, a commitment has been made to keep them busy after the site is completed. Therefore, additional hiring for website development can only be undertaken in the larger context of organizational workflow. Even when using freelancers or hiring temporary employees on a project basis, a subconscious commitment to giving them work develops. Relationships naturally form when working closely with a person for a length of time and participating in the trials and tribulations of project development. Budgetary problems caused by excess staffing may ensue. Using an external developer helps avoid such situations.

A trend in corporations is to use cross-functional teams for special projects, like developing a website. A potential problem for the project manager, however, is that although development is in-house, individuals are "on loan" from other departments. Usually, these individuals retain at least some of their existing responsibilities in those departments while working on the project part time. For example, suppose a new section of the website needs to be developed to correspond to an upcoming tradeshow promotion, and the project manager intends to use existing company development resources. Perhaps the programmer is from the IT department and, although assigned to help on the project, may still retain some of his or her usual responsibilities. Work on the project may suffer, and development time can evaporate quickly in such a situation. To avoid problems with this situation, the project manager must seek clear guidelines from upper management on priorities and the level of commitment that can be expected from staff with multiple assignments.

No matter where in the company the internal development team comes from, they may be more difficult to motivate than an outside developer. They will get a paycheck anyway, regardless of when the product is finished. In this sense, project management is no different than any type of management position. When you manage a website project, you also manage people. Communication is one of your tools and one way you motivate, inside and outside the organization.

Virtually everyone wants to take satisfaction in a job well done, and this is especially true for those in the product development arena. By allowing internal

staff to work on a website, managers give them the opportunity to take part in interesting work that can broaden their skills and to gain a sense of accomplishment when the project is completed. Not only does this situation benefit the individual, but it also benefits the company, by raising the interest level. This effect can be beneficial to morale, with a ripple effect even among those not participating directly in the project.

In-house website development is an opportunity to offer interesting work and shared glory to staff in various departments of the company. For example, internal art and design personnel may prepare graphics for the website. In doing so, they increase their visibility within the company, which in turn may help them justify increased staff and equipment to perform the work. Because websites may be perceived as hip, cool, or trendy, most staff will happily accept Web assignments. The shared experience can also increase the sense of teamwork among departments, which benefits the company as a whole and future projects of all types.

With reasonable foresight and political sensitivity, website projects can be developed internally with significant efficiency. Developing a website in-house can be a rewarding experience, both in terms of job satisfaction and career advancement. If you get the opportunity to develop a website in-house, make the most of it!

Time and Schedules

Internal company pressures may slow down the development process, relative to using an external developer, working outside the corporate environment. Even when fully staffed, a company must juggle many priorities. The website may be the ball that gets dropped. The choice between external and internal development often boils down to expediency.

Sometimes an external developer can offer the in-house manager a great deal of flexibility, letting a manager speed up and slow down the project at will (depending on contractual arrangements). If the work is being done on an hourly basis, the manager can request as much or as little work done as needed. An external developer can typically get projects started (and stopped, if necessary) faster and can often change directions faster during the project as well; however, in-house managers sometimes make the mistaken assumption that working with an outside company will somehow relieve them of all project management responsibilities. After all, isn't that why the developer was hired? Outside developers can require just as much management supervision as internal staff, if not more, and the notion of a truly "turnkey" website developer is somewhat unrealistic. Usually, the many internal decisions, discussions, and judgment calls preclude giving an outside developer complete autonomy.

Investment and Core Functions

Matters of expediency tend to point toward outside website development. There is much less administrative work, in the form of reports, meetings, approvals, performance reviews, job descriptions to justify new staff, and so on. The main problem in developing a site internally occurs when it grows beyond the normal workflow capacity and staff responsibilities. New staff must be recruited, hired, and managed. Equipment, working space, software tools, and communications infrastructure (including Web and server access) must be arranged. These resource and logistical issues can consume a great deal of managerial, administrative, and technical support time that, while not directly related to running the project itself, drives up general operating expenses for the company and delays development progress.

The external developer can simply "do the work" and manage its own personnel. The equipment, communications, and staffing issues are generally the responsibility of the external developer; in-house managers do not have to arrange for rental computers or write up endless justifications and paperwork to purchase equipment. Instead, they can adopt the much more convenient role of consumer, purchasing development services as needed, rather than dealing with the time-consuming logistics and details required to directly manage a large (and perhaps temporary) staff.

In-house website development is full of hidden expenses. It is expensive in terms of indirect costs or opportunity costs that don't find their way to the project development budget; however, an organization's strategy may dictate that it is essential to grow an in-house capability for developing websites. An executive could argue that a marketing department that understands the company's message and products should be able to create a website as well as it might implement a publicity campaign. From that perspective, the indirect costs of developing the website represent an investment in the company's future.

One management philosophy is to crystallize the many activities of a company down to its core functions. Anything that is not a core function can be outsourced. Whatever is a core function should be performed or developed in-house.

The scope of the project is also an issue. How much does the executive want its marketing department to know? Should they be able to develop a database? Or is understanding message design and content enough?

TYPICAL PITFALLS

In order to establish and maintain a good working relationship between client companies and the external developer, it is helpful to know about some common sources of conflict.

Compatibility

One of the most common sources of problems between a client and developer is incompatibility. In these cases, the first mistake was agreeing to work together at all. A working relationship may be doomed from the start. Independent developers and outsourcing managers alike must learn to recognize trouble before they sign the agreement. The close working relationship necessary between the client and developer will flush out even the smallest incompatibilities before long. Incompatibility may be in the form of a developer's lack of experience with developing a type of website or with using required tools. The client may have chosen the developer based solely on price or on marketing image. Here the importance for clear communication on requirements and needs of the website is evident.

Sometimes the problem is a simple clash of cultures. Every company has its own procedures, attitudes, and codes of behavior and dress, collectively referred to as the "corporate culture." Small website developers also have their own culture. Differences may be so pronounced that they seriously impair the working relationship. Imagine the conservative banking institution that hires an offbeat Web developer partial to body piercing. This extreme example of drastically conflicting fashion may seem trivial; however, difference in styles, whether in dress or work habits, can easily overpower the basic communications about the project and lead to misunderstandings.

The clash does not have to be as monolithic as corporate cultures. Rapport among the key representatives of the client and developer teams is also important. Personality and chemistry is worth paying attention to during the selection process.

Desire for Control

Another common reason for client–developer problems is the desire of either party to exclusively control the project. If the client treats the developer as a true partner with valid ideas and valuable knowledge, the independent developer often puts forth effort beyond expectations. The developer who tries to control the project often causes more problems than are solved. The client is the customer and has every right to call some shots. Many so-called personality conflicts are actually battles over control of a project or an aspect of it. When both parties can focus on results, the value of respecting each other's expertise will be clear.

Design Changes

Another potential trouble spot is when the client insists on making significant design changes throughout the development process, especially in the later stages.

This is a major source of conflict because of both frequency and the severe problems it causes in development, often impairing the developer's ability to finish the project on schedule.

Design changes can happen for many reasons: the client may be unable to envision the final website until it is up and running, at which time they may want to change the design; or the requirements themselves may change during the project because of competitive issues or new ideas. Whatever the reason, requesting significant design changes in the later stages of development can create a massive amount of additional work for the developer, along with the resulting schedule and workflow problems. A competent and realistic developer will request more time and money to implement such changes, and clients are rarely pleased when this happens.

Such an impasse is difficult to work through. The problem of ongoing design changes is best addressed through prevention. The workplan document developed in the analysis and planning stage is critical and should be the reference point for everyone involved. Project managers should continually coach the clients, whether internal or external, on the value of upfront planning. Companies may resist spending money for such creative development, especially when there are no tangible outcomes. The outside developer who creates a plan without client input or approval is asking for changes down the line. It's also best to seek user input as early as possible in the process. When the client suggests a change down the line, you can gently remind them that the current version has been approved by users.

Relations between Contractor and Client

The importance of compatibility may be reminiscent of matchmakers and marriage. The developer–client relationship, like marriage, requires commitment, hard work, and dedication in order to survive the inevitable spats and conflicts. A long-term relationship can bring benefits to both parties that would be unachievable in working alone. If you look at the common pitfalls described previously, you can see that better communication could solve each one.

The first step to successful collaboration is to recognize and respect your different perspectives and motivations. In the most basic arrangement, where the developer is doing the project as a work-for-hire and is due fixed lump sum payments based on milestones, the objectives of client and vendor are fundamentally opposed. The client wants as much design flexibility, functionality, and quick development as possible. On the other hand, the developer wants to fix the design specifications "in concrete," to avoid the data rework, revisions, "feature creep," and technical problems that result in cost overruns. Documents like the workplan, proposals, and the agreement articulate a common ground between these conflicting motivations; however, no agreement can cover every possible situation, and those that attempt to do so often strain the relationship by spelling

everything out. A sense of trust should underlie agreements that clearly define expectations, obligations, and respective roles in the project.

Some situations present even more hidden and conflicting agendas. Developers have been known to work on websites for unrealistically low fees (or for free) simply to "hook" a client. Such sites often have quality problems, because of the lack of resources invested, and may never get finished at all. On the other hand, client companies are sometimes guilty of "stringing along" small developers with promises of work to keep their options open and sometimes even to get *de facto* free consulting services from an eager independent developer. Both of these situations raise ethical questions. Open communication and integrity always produce the best results.

Dancing with Elephants

Although the Web development business is establishing quickly, and large, well-financed operations are emerging, the industry is still dominated by small, independent development shops. Project managers working in small website development companies should understand some important concepts involved in working with large corporate clients.

First, large companies can move very slowly. Usually, the larger the company, the slower it moves. In a small website development shop, the environment is completely different: decisions can often be made by one or two individuals and implemented almost immediately. By contrast, a large company may require several levels of approval, each of which is harder to obtain than the last. The chain of command, approvals, and buy-in decisions can be difficult to understand, even for those within the company, much less for a small, independent website developer who is waiting for a decision on a project. Your in-house contact may have little or no decision-making authority, or even input into the approval process.

Large companies often operate in the "hurry up and wait" mode. They may require a developer to perform a large amount of work in a hurry (such as to write a proposal by the end of the week), then wait an indeterminate length of time for a complicated approval process to grind to completion before receiving an answer. By the time the project is finally approved (assuming it does get approved), there may not be enough time left in the schedule to actually develop the website as described in the proposal. Often the best thing a small developer can do is be politely persistent, perhaps by checking in by telephone or e-mail once a week, while looking for other project opportunities in case the project under discussion does not materialize or is delayed.

Most important, when awaiting project approval, do not assume that large companies are rational, logical entities; they often are not. They sometimes pursue courses of action that appear to be (and actually may be) counterproductive and even self-destructive to their apparent business interests.

Decision Makers or Indecisive Companies

Project managers should identify the internal decision makers for their website project. The larger the company, the more likely the decision maker is not to be the developer's primary contact. The internal manager and developer should discuss how decisions and approvals are executed inside the company. Not only do such communications avoid misunderstandings down the line, but they also help in project scheduling.

One of the most frustrating situations for the outside developer involves overly bureaucratic companies in which people cannot make even the smallest decision without endless meetings, committees, and layer upon layer of approvals. This means that few individuals are empowered to actually make real decisions, and the company must reach a consensus for any decision of significance, including the decision to actually sign a website development contract. If you start feeling that the decision-making process is taking much too long (and assuming there are no outstanding invoices), it may be time to look for other work opportunities while the client sorts things out internally. Check back by phone once every week or two to see how things are going. Patient persistence can be effective.

Here is an example of a compatibility issue. If you are a small developer who can work on only one project at a time, you may have to walk away from an opportunity to develop for the large bureaucratic company. The decision-making process may put you into unproductive downtime. Not all companies are overly bureaucratic, however. Don't evaluate potential clients on size alone. Early negotiations provide a sample of what lies ahead. If you experience long delays in accepting your proposal, you can expect the same for approval of various project milestones unless something changes. If you're concerned about future approvals, you should raise the issue with your contact person.

Long-Term Relationship

Once a website has been developed, the natural course of events is for the original developer to handle revisions of the site. The original developer already understands the development tools, data, and programming for the site and, therefore, is best able to efficiently make necessary changes. Although internal staff may handle modest content changes to the site, original developers tend to maintain websites into the future. Conflicts such as personality clashes, business concerns, and miscommunication can strain the relationship. This "uneasy marriage" creates a situation with significant potential for built-in conflict. Sometimes a client might feel they are in an inescapable relationship with a developer. Or a developer may feel underpaid or unappreciated for their creative efforts. If a mutually beneficial, "win-win" relationship is cultivated from the beginning, a project will have a much better chance of long-term success.

In an external development situation, the client often provides content and conceptual design input, with the vendor detailing the design and producing the site, including programming and hammering out technical issues. Various other aspects, such as data formatting, graphic artwork, and testing, may be performed internally or contracted out, as appropriate. This mixed approach is probably the healthiest method because it keeps vendors competitive, helps educate internal staff, and gives the company a wider choice of production alternatives. The larger the project, however, the more internal project management time is needed to coordinate the workflow and communication between internal and external personnel. Whether you are on the vendor or the client side, make sure the other party is creditworthy, and that the relationship can be managed toward mutual benefit.

SELECTION PROCESS

Carrying forward the marriage metaphor, it should be obvious by now that special care should be taken during the courting process to ensure that yours is truly a match made in heaven. A thorough discussion of vendor selection and negotiation is beyond the scope of this book; however, some basic points can keep vendors and developers out of a bad relationship.

The first step for the in-house manager seeking a developer is to call around and get recommendations. That's not to say you should hire your buddy's college-age son who's "fantastic with this Web stuff." Those days are long past, if they ever existed. Look for referrals of companies with experience in building the type of site you're planning. They don't necessarily need experience in the same industry. More important is the technology underlying the site. The nuances of various industries play out in the area of content, which generally comes from the client anyway. As an example, the sort of experience you might look for is development of an e-commerce site running on a UNIX server, with an Oracle database and Cold Fusion as the development tool.

Second, beware of exceedingly low cost estimates. Although developers who want your business will attempt to quote a competitive price, some unscrupulous developers have been known to quote extremely low prices simply to get the job, believing that once the website is sufficiently underway, they can ask for more money as it proceeds. This scenario does not lend itself to high-quality site development, nor does it encourage a good working relationship with that vendor in the long run.

One old method of selection when cost is truly the most important factor is to get three bids and pick the middle bid. The reasoning behind this approach is that the lowest bid is a lowball or low-quality bid, the highest is the one with the most built-in profit, and by default the middle bid is probably best. This arbitrary approach is little more than a human tendency to gravitate toward the middle.

Though much better than automatically picking the lowest bid, its assumptions are probably false. With all the complexities and choices involved in website development, variations are just as likely to be caused by different approaches as by different profit margins. It's not the same as installing a muffler.

A better tactic than simply comparing bids based on price is to request a detailed analysis of how the firm will accomplish the task in a prospective developer's proposal, including tools, personnel, equipment, and testing. It may even be appropriate to pay the developer a small sum to help defray the costs of developing such a detailed proposal. Generally, the better and more well thought out the proposal, the higher the quality of the developer and the more seriously he or she will take the website project.

One real aspect to consider in choosing a developer is geographical location. Theoretically, an external developer may be located across the country, sometimes even in a foreign country, and still get the job done. In such a situation, however, it is difficult to hold face-to-face meetings, which are generally an important way to build and maintain rapport among team members. Distance can also become a significant inconvenience because of time zone changes. Given the large number of development houses located on the West Coast, this time zone change can make a big difference for companies located in Eastern states. The three-hour time difference shortens the available time for telephone conferences. Although this communication gap can be eased with e-mail and voice mail, it still does not replace the rapport gained in face-to-face meetings.

Once a manager has narrowed the field to a few developers he or she would be satisfied working with, it's worth taking a closer look before making the commitment.

View Previous Work

The best way to assess the capabilities of a developer is to view samples of previous work. A reasonably well-qualified developer should have at least a few sample sites to show, ideally of the same type as yours. If the sample is for a different kind of website or isn't of high quality, there is little need to continue the discussion. If the work looks good, try to find out what parts of the site (e.g., graphics, programming, page layout) this developer did, since most Web projects are a collaborative effort.

Contact References

Another way to check out the developer is to talk with previous clients. Any reputable developer will let you contact satisfied clients (unless a project was done under nondisclosure for some reason). If a developer has no satisfied clients as references, let that be a warning.

Visit the Company

There is no substitute for actually visiting the developer's worksite. First impressions may not be 100 percent accurate, but they are often more correct than not. The layout of the offices, cleanliness of the environment, disposition of the employees, technical resources, decorative taste, and company rules and policies can all contribute to a more well-rounded impression of the developer.

Meet the Principals

One of the best ways to assess the quality and character of the development company is to meet the individual(s) who runs or owns the company. A company's tone is set at the top, and meeting the people who run and own the company can provide an important insight into the company's work mode and ethic. This is especially true with website developers because they tend to be smaller companies in which the owners run the company hands-on and are closely involved in the work. In fact, the company is often a direct reflection of the owner. If the owner seems to have a strong work ethic and is flexible, accommodating, and technically knowledgeable, this is a good sign. An owner who turns out to be an investor with more interest in fancy dining and expensive cars than in technology might not be viewed as favorably.

Size of Developer

The size of the independent website developer you choose should be appropriate to the size of the project. Generally, the larger the project, the larger the developer needed. The developer should be large enough to absorb fluctuations in the workload but not so large as to be too expensive or unresponsive to your needs. A single individual working as a freelance developer might be fine for a small project, such as a simple "home page" Web presence site. For a database-driven e-commerce site, however, a larger development house with other such projects and clients might be more suitable. Such a developer can absorb your workload fluctuations, and the other jobs provide the developer with a depth of experience that can also benefit your project; however, a developer who is too large for your project may not be as responsive as a smaller one. If a large developer falls behind schedule on someone else's multimillion-dollar job, while yours is only a $15,000 Web presence site, the manager may be tempted to pull resources off your project to get the larger one back on track.

Make Valid Comparisons

When comparing developers and development proposals, try to make sure you compare them fairly and are not comparing "apples to oranges." One developer's

$50,000 bid may be very different from another's. One developer may be willing to build the site using the technology of your choice, or may include full browser version testing, graphic design, or even Web hosting in the bid, whereas another may not. These are real costs that can make a huge difference in the final project and maintenance expense.

Limit the Number of Vendors

If a project is being done out-of-house, work with the minimum number of external developers and vendors. When a lot of work is to be done externally, it is tempting to want to spread it around to several different developers. On the face of it this practice seems fair, and even a means of comparing the performance of different developers; however, each external developer requires a significant amount of internal project management time and coordination. As the number of vendors increases linearly, the effort to keep them all working together in sync increases exponentially. Conflicts inevitably arise among different external developers working on the same project: finger-pointing starts for missed deadlines, software defects, and the like; jealousy emerges over the amount of business being done with one or the other; fee comparisons are made; and issues of confidentiality exist among potential competitors. In addition, it takes time and effort to develop a good working relationship with a developer, to the point that the external firm understands your company (i.e., expectations, priorities, structure) and you understand theirs. It is often wise to focus more work on fewer developers than to give more developers smaller pieces.

BUDGETS AND BIDS

The In-House Development Budget

The motivation for in-house development is often a desire to save money. The false assumption is that the work can be done internally at a fraction of the cost. Often, a project bid received from an external developer is significantly higher than expected. At this point, individuals in the production department may start to imagine that they can do the work internally for the amount originally envisioned. Starting a large project based on this assumption can be a recipe for disaster. A better reaction to this scenario would be to reexamine the original estimate and interview the developer to better understand where the production costs lie. What often happens is that the purportedly high bid sways management to approve internal production for a project that is underbudgeted. Three months later, instead of going live, the site is still being tested and debugged with another three months estimated to completion, and management starts to realize its mistake. This situation benefits no one, least of all the production personnel who may have lobbied to do the work internally.

If you start a project without adequate resources being budgeted, it will require additional unbudgeted resources later. The project reels out of control, quickly escalating toward serious problems. Therefore, you should be especially careful that internal projects carry adequate budgets. Err on the side of overestimating for safety's sake.

Realistic Expectations

Clients often underestimate the cost and effort of developing a website, sometimes drastically. Inexperienced clients naturally compare website development to more familiar media, like video and print, when in fact software development is the better analog. To further confuse matters, website development costs tend to vary wildly. Some companies are offering website deals as a come on, angling for other businesses. Some college students will make a site for a pittance. The quality is often atrocious, but the low cost can set unrealistic expectations.

While sensitive to this tendency of clients to underestimate costs, developers must nonetheless be realistic regarding the true cost of development or risk working themselves out of business. Factors encouraging an unrealistic quote include:

- sheer optimism
- pressure by the client
- minimizing the inherent unknowns in doing a software development project

In addition to the risk of losing money on a project, a low price can set an unfortunate precedent that could inhibit you from billing the client at more reasonable rates in the future.

Smart Proposals

The dialog around budget and bids can easily become a cat-and-mouse game, which is a disservice to both parties. It is perfectly reasonable for developers to ask clients what the budget for a project is. The client might fear that revealing the budget is no more than an invitation for the developer to use it all up in the bid. As discussed, it is not unlikely that the client will come in with gourmet tastes and a fast-food budget. Clear, open communications about the budget make for an early reality check on the project and ultimately foster proposals best suited to the client's needs. Developers can help clients along by delineating various levels of solutions around specific components of the site. Then clients can see exactly what they're getting for their money.

Clients may want to protect themselves by seeking a flat fee for development. A better arrangement for the developer is to quote by time and materials,

with estimates for both, especially when working with a company for the first time. Website development is both a creative process and technical software development. The many unknowns around these processes make accurate time estimates difficult, and sometimes impossible. After quoting the project on a flat fee, the developer will have a difficult time coming out ahead when a client starts requesting design changes just before release. A client who has to pay incrementally for those changes becomes sensitized to the costs involved in changing the specifications. This awareness can be helpful in setting a precedent for future work, as long as the client doesn't perceive that it is being "nickeled-and-dimed" for little things at the end of the project. No matter what the arrangement, it's a good practice for contractors to always track their hours.

Ideally, even in a new relationship, clients will trust developers enough to work on a time and material basis. Both client and developer should want a quality project. The developer's obligation is to keep the client informed of production costs along the way. Rather than automatically proceeding to work on every change request (knowing that the meter is ticking), the developer can discuss the cost ramification of new changes and explore alternatives, if appropriate.

Among the components of a proposal are the following:

- executive summary
- creative, strategic, and technical objectives
- description of the project scope, including a rough sketch of the structure and navigation scheme of the site, scheduling in rough time frames around development stages and milestones
- list and details of major features and functions
- development tools and technical features of the site
- summary of fees, services, and exclusions
- payment terms
- delineation of responsibilities
- staffing and personnel assumptions
- any assumptions made when preparing the proposal

The developer's goal after submitting the proposal should be to obtain a face-to-face meeting with the client company and make a presentation of the proposal.

AGREEMENTS

A written agreement defining the work to be performed and the amount and terms of compensation should govern the website development relationship. Where contractor and client are familiar with each other, doing business on a

handshake may be convenient and appealing; however, the flexible and ever-changing nature of software development make undertaking any significant website project without a written agreement an extremely risky proposition. This written agreement might range from a simple, single-page letter of agreement to a full-blown software development contract. The specifics of the agreement depend on the situation and parties involved.

Without such an agreement, both parties put themselves at significant risk, proportional to the amount of time and effort that will be invested. A developer working without a contract is like a tightrope walker working without a net. When expected payments are delayed by bureaucratic tardiness or withheld on minor pretenses, the developer is left without legal recourse. A client who asks for work to be performed without a contract risks not only investing significant time and energy without a guarantee of product delivery but also litigation if disagreement arises.

For projects of smaller scope and shorter duration, usually done as a simple work-for-hire at an hourly rate, a basic letter of agreement often suffices. Such a letter generally includes a description of the work to be performed, intended delivery dates, hourly rate/compensation, and so on. This can even be a single-page document signed by both parties.

For larger jobs, a software development contract may be necessary, a subject that is too large to be treated fully in this chapter. Development contracts come in many different styles, but all attempt to detail the working relationship between the two parties. They describe which party is responsible for what elements of the development, including the following:

- payments
- deliverables with schedules
- rights of ownership
- warranties and indemnities
- hosting arrangements
- maintenance, support, and training issues
- conditions of termination

Typically, tight schedules constrain website development, and the time spent negotiating the development agreement and obtaining approvals can eat up available time. The developer cannot afford to be put in the position of starting later but nevertheless being held to the same completion deadline. One way to address this situation while avoiding working without a contract is to start with a simple letter of agreement, which gives the go-ahead to start work, possibly defining certain steps in the analysis and planning stage. The letter of agreement is later superseded by the full development contract.

SCHEDULING AND DELIVERABLES

Contract Milestones

Many agreements are structured so that the developer is paid a predetermined sum by the client at specific milestones, such as delivery of the design specification, the Alpha version, the Beta version, and the final version. The contract defines deliverables with specific, objective criteria on how the milestone is determined to have been met. Nonetheless, as often as not, some disagreement about this occurs between the parties, such as whether a version submitted as Beta by the developer is accepted as Beta by the client.

Obviously, the definition of the deliverables is an important section of the contract. An unfortunate but unavoidable situation for the developer is that the client decides when the milestone has been reached. The unscrupulous client may manipulate the process and improve cashflow by delaying approvals. The developer's best legal protection is the language of the contract. The truth is that the developer has no real recourse against slow payment because legal action itself is slow and therefore more appropriate in collecting when payment is refused. The client who makes a custom of such chicanery may have a hard time attracting quality developers to future projects.

Delays are not necessarily foul play, however. More often, they are simple realities of organizational life. Administrative mix-ups, lost invoices, and corporate policies regarding payment cycles all can contribute to late payment. For the small developer facing financial hardships, understandable excuses offer small comfort. The time to ask about the approval process, both in terms of milestones and invoice processing, is when you are creating the initial schedule.

Late Content

In many projects, the developer relies on content from the client to create the website. It's not unusual for a client to push an aggressive schedule, then drop the ball from the onset by not delivering content. The delay can increase development costs and postpone milestone payments, through no fault of the developer.

The developer's project manager needs to stay out in front of this process and either obtain the necessary materials in time from the client or make sure the client is well informed of the effects of delivering content late. Schedules should be conditional upon timely delivery of necessary content from the client. When problems arise, developers can sometimes help with simple matters, such as getting photos digitized or text input—with compensation, of course.

As a protection, some developers charge an overtime fee if the client's late delivery of content forces extra or unusual hours. Not only does the developer benefit from this overtime rate, but its existence also sensitizes the client to deadlines.

PAYMENT

Clients should do their best to see that developers are paid on a timely basis. Developers, for their part, should understand that slow payment is an unfortunate fact of life and make their effort to plan for it.

For example, imagine that a developer is scheduled to deliver the Alpha version of the website on January 1, with a term of 30 days for the payment. The developer, assuming that the payment will take two weeks to process (which is how long it might take in a small company), expects and plans to receive payment in mid-January. In this case, though, the client takes one week to evaluate the Alpha version and determines that it does not qualify as Alpha. The developer takes two weeks to correct it, by which time it is the end of January. The milestone is approved a few days later, and the invoice is submitted for payment. It takes one week to amass the correct signatures, and the invoice finally arrives in the accounting department in mid-February. The accounting department holds the invoice for several weeks, according to an unwritten policy. The developer finally receives payment in mid-March, two months later than planned.

Small developers usually depend heavily on their individual clients. If a corporation withholds or delays payment, intentionally or inadvertently, it can have a serious and magnified effect on a small developer. This impact is sometimes difficult to appreciate by those within the corporate confines. A single delayed payment of sufficient size could cause a small developer problems with staff morale, credit, and making payroll. It may even result in the temporary or permanent layoff of staff. Short of such a dire outcome, slow payment at the least can brew resentments that are counterproductive to the project under development.

Unfortunately, ensuring that payments to a developer are made in a timely fashion may be a project all its own for the project manager in a large company. Many companies routinely hold invoices until the very last moment for payment, sometimes even longer, for good measure. Invoices can easily get lost on the desks of busy executives whose signatures are required for approval, or they can get lost in the accounting department while being processed for payment. Sometimes the approval process even gets changed while the invoice is in process, requiring it to start through the process anew. Meanwhile, the developer is anxiously awaiting payment and wondering whether to continue investing time and resources in the project. In-house managers and their counterparts in the development firm should both be motivated to work through this conundrum.

Discounts for Quick Payment

The converse of the standard penalty for late payment that is so often ignored, discounts for quick payment reward rather than punish. Offering a discount for quick payment may get the attention and motivation of a corporate accounting

department. Many otherwise lethargic accounting departments jump through hoops to get the check out if the invoice shows a clear notice that the company is allowed, say, a 2% discount for payment within 10 days.

Early Invoicing (or the Old "Stash-the-Payment" Trick)

In the event that a more officially sanctioned method is not available, a corporate maneuver can minimize the payment delay problem. The project manager instructs the developer to submit the invoice for payment at the earliest appropriate date. The project manager then approves the invoice and submits it for approval and payment, regardless of whether the deliverable has actually been approved, with one qualification: *the check is to be routed to the project manager* rather than automatically mailed to the developer. Then the project manager can hold the check and send it out immediately upon approval of the milestone for payment. This allows plenty of time for the invoice to be processed, and it lets the project manager pay the developer immediately upon approval. When using this method, you should be discreet. Your accounting department probably does not approve of it. Likewise, a developer who knows the check has been cut already and is in your top desk drawer may perceive that payment is being deliberately withheld and may become insistent that payment be made immediately (regardless of whether the deliverable has been approved). Note that these sorts of actions could come back to bite you in a few different ways. Deceiving your in-house colleagues is a high price to pay for accelerating payment. A better way of addressing the problem may be to study the flow of invoices and approvals and seek out legitimate shortcuts to the process.

Talking Directly with Accounting

Finally, if all else fails, and the in-house manager laments that the invoice is "stuck in accounting," the developer may want to talk directly with accounts payable. A polite, fact-finding conversation can sometimes reveal where the responsibility for late payment lies. The developer may learn useful information about internal corporate procedures. Trivial items, such as including your corporate identification number or social security number directly on the invoice, may make a significant difference. Before contacting the accounting department directly, developers should discuss this approach with the in-house contact and obtain consent. Otherwise, the developer risks alienating the client contact, if it is perceived that the developer is going around the contact, directly to the accounting department.

WIN-WIN

The focus of this chapter has been relations between client organizations and development firms. It is important to remember that the principles of project management apply in both settings. Business gurus have used the phrase "internal customers" to describe relations within an organization. If you are managing an in-house development project, you should treat colleagues commissioning the project like customers. If you are an internal team leader who is working with an outside development company, remember that you have not absolved yourself of project management responsibilities, but rather delegated the bulk of the details. Issues such as agreements, schedules, budgets, approvals, and payments still demand your time and attention.

Project managers in development firms often find themselves on both sides of the contractor–client relationship. Portions of the website development, such as graphic design or writing, may very well be farmed out to freelancers. The golden rule still applies. Treat the other party as you would like to be treated. For a win-win partnership, dedicate yourself to clear communication, respect your partners, and act with integrity.

8

Designing and Prototyping

Website development is an iterative process. Imagine yourself in a valley, gazing at the majestic peak of a nearby mountain that represents the successful completion of your website project. The distance might be only one mile as the crow flies. You may envision yourself steadily marching in workmanlike fashion right up to the top; however, once you start, you find that this is impossible, the angle is too steep, and no trails take such a route. Instead, the only way to the top is a winding trail 10 miles long that has many switchbacks. Although the trail steadily rises in elevation, sometimes you actually walk downhill. Eventually, however, you reach the top, but it takes longer than you thought.

So goes website development. If you could build the site exactly perfectly the first time, without any rework or modifications, it might only be a month-long project, but such a path does not exist. Multiple options, decisions, meetings, compromises, prototyping and reworking, changes in methods and production, testing and debugging, and more all intervene. The path you must take is not a straight line, but it is the only route. You need six months to reach the top, much longer than the one-month journey it appeared to be.

Advance planning is crucial; however, you should realize that you will need to make many decisions about how to reach the mountaintop when you're on the trail. Sitting in the valley cannot lend the perspective you will need to make those decisions. You should resist the temptation to overplan. No amount of planning will build the website for you. Do not attempt to outline every contingency. Rather, consider the plan to always be a work in progress. Be steadfast about your desired outcomes, but fluid in how you achieve them. Keep your plan at your side. Let it guide you, but modify it when it's sensible to do so.

In website development, you and your team have before you many options. You will discuss, debate, and decide upon each one. At a certain point, you will pause again and consider options on another decision. As you progress in building the site, you will make increasingly detailed and functional revisions to the plan. While a pattern of second-guessing yourself is never advisable, you may

want to reconsider a direction when it leads to significant obstacles. You minimize the cost of backtracking by quickly developing prototypes to test your decisions. Such practice is what makes website development an iterative process.

In Chapter 5, we looked at the initial analysis and planning of the website. The process continues with design and prototyping, which is addressed in this chapter, onto the topics of subsequent chapters, including production, or "build-out," testing, and finally going live. Web development is a continuous process. Although the processes described here are somewhat sequential, they should not be viewed as discrete steps. Parts of the process happen simultaneously.

As an iterative process, website development is circular in parts, with built-in feedback loops designed to lead you to previous steps for revising and refining (Figures 8.1 and 8.2). The process goes something as follows:

1. You create a design.
2. Through inspection, reviewing, and testing, you identify gaps or problems.
3. You may throw out the design and start over, or make revisions.
4. The cycle repeats.

By way of these switchbacks, you move up the mountainside. It is a fact of Web development that this is the only way to get a final and acceptable result. If you ignore this fact and try to develop a site in one shot with no revisions, you will probably spend your budget in a first cycle that leaves you dissatisfied and without the resources for the revisions you desire.

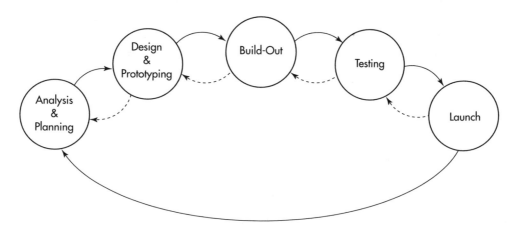

Figure 8.1 Iterative development process with feedback loops.

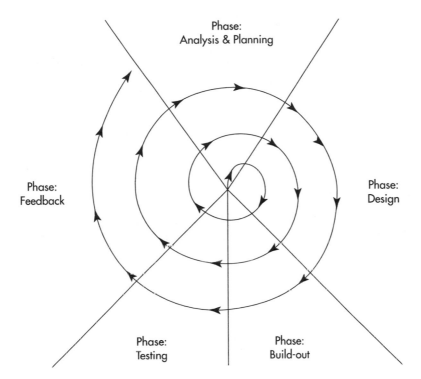

Figure 8.2 Iterative design process, alternative visualization. Notice how each version moves through each phase of the development process, taking longer each time, as the site becomes larger and more complex with features. Having made three full circuits, this project would have gone through three versions (i.e., prototype, Beta, and final).

This chapter describes the following three phases of design development:

1. Menu-tree diagram
2. Skeleton framework
3. Home page and motif

WHAT IS DESIGN?

Be careful about the word *design*, as used in website development. Upon hearing the word, clients may conjure the image of the artist or graphic designer at work, creating computer graphics, rich background textures, and animated buttons; namely the visual design and layout. The look and feel of your site is essential in

achieving your goal; however, the visual design is only one aspect of the website design, and although important, could also be called the finishing touches. Visual design communicates your concept, but it doesn't make your website work.

A more representative image of design in the context of the Web is the architect. In fact, the title "information architect" is being increasingly used in Web development organizations. The architect is both artist and engineer. He or she is sensitive to how people use the building, moving from room to room within it. The architect considers both form and function, envisioning what makes sense in the lives and practices of the people who will move within. He or she also looks at the mechanical systems of the building and its structural integrity.

Visual design is what you see upfront, and it may be all your client sees. You can help them look further, considering the following three components of website design:

- Functional design
- Technical design
- User interface and visual design

Consider the "stretch-to-fit" analogy of a wedding present for your second cousin, Joe. What you remember most from your recent visit to Joe's house is the smell of burnt toast. So you decide to buy him a new toaster.

You are choosing a gift that will make Joe and his fiancée happy, as well as be a practical tool for their kitchen. *(Functional Design)*

You now face additional decisions. What kind of toaster shall you buy? How many slices does it need to handle? What features are important? What about a toaster-oven? *(Technical Design)*

You are also thinking about your style of presentation to Joe and the bride. What sort of card would be right? What will you write in it? Should you wrap the gift in newspaper, use leftover holiday paper, or go to the store and buy wedding paper? *(User Interface and Visual Design)*

THREE BASIC QUESTIONS

Design and prototyping is an extension of the analysis and planning process you have completed. In that stage, you identified the objectives of the site with a customer-focused perspective. Now is the time to roll up your sleeves and get to work. Before you jump in, however, you should be certain that you can answer three basic questions. Your answers should be clear and succinct. Imagine yourself answering these questions to a senior executive in your company or with a client. Because senior executives are busy people with much on their minds and

many things to do, you only have 90 seconds, leaving no time for hemming and hawing. You must paint a compelling, big picture that hooks their interest.

1. *What do you want your site to do for users?* Through analysis and planning, you now have a clear idea of who your users or customers are. You understand what kinds of problems they have and what kinds of solutions your company might offer. Websites offer a new channel for communication with customers and to deliver products and services, some of which may not have been possible previously. A single website project is unlikely to do it all, so you must focus on the specific results you seek. What do you want your site to do for users? In the answer to that question are the seeds of your functional design documents.

2. *How will your site perform that function?* Chances are, your website is not starting on a blank slate. Certain technologies are in place—Web servers, server software, and Web development tools. You have assembled a team of people who have competencies with certain tools. It's likely they can learn others, but this process takes time. You can go to outside developers for certain functions, but depending on how much you've worked with them in the past, if at all, there are risks involved. Technologically, you always have options as to how a task is accomplished. Past decisions limit your options and suggest certain directions and methods. Nonetheless, you have choices. How will your site accomplish the functionality you're planning? In your answer are the seeds of your technical design documentation.

3. *How will your site look and feel?* Style counts. First impressions mean a lot. Your creative people set a tone for the site. Graphic designers and copywriters will work in tandem to give your site personality. As the project manager, you will review other communications from the organization. You wish to design a site that is appealing to your target audience and consistent with the marketing message of the organization. You may wish to use the Web medium to explore a new design direction, but even so, you will not want to stray far from existing brands and logos. In your answer are the seeds of your creative design documentation.

DEVELOPING THE CONCEPT

Specialists on both the technology and creative end will work simultaneously on the project. The project manager must coordinate the efforts. In the early planning stages, the project manager has identified strategic objectives for the site with key stakeholders. In order to answer the basic three questions outlined previously, the project manager has gathered information from others around the

organization, including team members for the project. Moving beyond the 90-second executive briefing, the project manager will probably want to bring together the team to further develop the concept.

The project document developed in Chapter 3 makes a good starting point for bringing people together. As explained later, suggested documents for both functional design and technological design include a brief and a specification, which is more refined. You will also prepare a creative brief for designers and writers. They will not be able to dig into their work until some functional and technological questions have been answered. For instance, graphic designers may brainstorm and identify graphics for a site, but they cannot design a navigation bar until the navigational structure is in place. Bring the team together and present your 90-second answers to the three basic questions. Share written documentation that is available, such as briefs. Then brainstorm, discuss, and debate. Strive for consensus and make decisions, even if these decisions are subject to change.

Your challenge here is to be as open-minded as possible. Your client may have delivered a navigational structure for the site with the initial request for proposal or project description document. Perhaps you have drawn up your own plan. At no other stage in development will changes be more doable than now. Do your best to shed preconceptions and allow for the perspective and insight of others.

Phase 1: Menu-Tree Diagram

When developing the concept and working with the initial layout of the site, you will probably want to create a menu-tree diagram or schematic. A menu-tree diagram is basically a page-by-page layout of the site, with the top-level menu (the home page) at the top of the page, divided into submenus, each of which is broken down into its component pages. Consider the following menu-tree diagram for the fictional company Campus Posters, Inc. (Figure 8.3).

As a bird's-eye view of the various sections and subsections, the menu-tree diagram clearly shows the relative sizes and relationships among the different sections. It reveals the complexity of the site, its richness, and its potential pitfalls.

The menu-tree diagram is a useful visual aid for a brainstorming or concept development meeting. The diagram helps everybody visualize the site and presents talking points for design and structure. You may want to use self-adhesive notes on posterboard, so "pages" can easily be moved around. Some developers cover whole walls with index cards, pushpins, and thread.

The menu-tree diagram shows pages, links, and some description of content. As your site plans develop, you can fill in specific details on content types, such as images, video, and copy. The menu-tree diagram helps the team members understand what is on the page. Designers will see both the big picture and

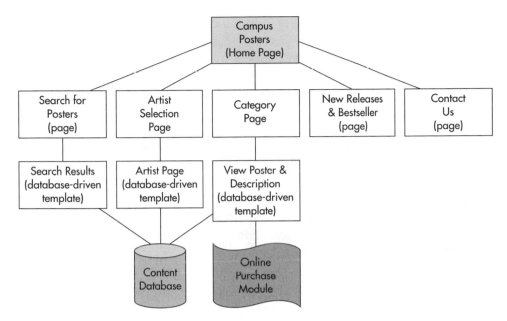

Figure 8.3 Example menu-tree diagram, showing the relationships among the following pages: Campus Posters Home page, Search for Posters (page), Search Results (database generated), Artist Selection Page, Artist Page (database generated), Category Page, View Poster & Description (database generated), New Releases & Bestsellers (page), Contact Us (page) (Note: the database serves multiple functions, and e-commerce is provided by a separate online Purchase module.)

all the elements that must be fit onto individual pages. If there are too many pages, this issue can be raised and addressed during concept development. Later on in production, it can help people track the content assets.

Design teams use a variety of software products to create diagrams. Adobe Illustrator or Microsoft Visio work well. You can also use Microsoft Word. The menu-tree diagram can also be created in outline format if you feel more comfortable. An outline consists of the same information as the schematic. Shortcomings of this approach are that it is more difficult to show linking and that it is not as effective in illustrating site structure as a visual diagram.

Functional Design

The functional design is a definition of what the website will enable users to do. *What are you building?* Answering this question is the starting point for any design work. You need to clearly determine what the website will do before you can plan how to accomplish it, what the site will look like, or what it will cost. The *functional brief* answers that question. Execution is not described in the functional brief. How a site will execute a particular function is a matter of technical design.

We were recently approached to build a website for a small floral business. The owner said he realized that he needed a "home page." His first question was, "How much will it cost?"

"What do you want it to do?" we replied. "Let people get in touch with you? Take orders? Show products online? Search for delivery locations and rates?"

"Yes," he said, "all that stuff."

"It could cost a quarter of a million dollars."

"I thought I could get a home page for a thousand dollars," he said.

Clearly, the functional design was the starting point for this project. In the end, we built him a nice little site for $2,500 that serves his real needs. He's even planning to get an e-mail account.

The functional specification is a continuation of the brief, delving into greater details, such as specific features, content topics, and user interactivity. The functional specifications also describe the organization of content and the site's navigational structure.

Examples of items in the functional design documents for Campus Posters, Inc. might include the following:

- The Campus Poster website will allow customers to search the database of approximately 1,000 posters stocked at the downtown store and thousands more that the store can special order from suppliers.
- Search will be on artist or source of poster, a short description of the poster, and broad categories such as music, sports, nature, and fine arts.
- Users will be able to browse categories for in-stock items.
- Search results will indicate whether the item is stocked or special order.
- Thumbnail photos will show up with search results, and a larger image will appear on the product listing page.
- A section of the site will be dedicated to special promotions and new releases.
- An e-commerce module will allow users to purchase posters online.

Technical Design

Ideally, you will have involved some members of the technical team in development of your concept. By participating in the process, they will have had the opportunity to raise any concerns about implementing the site's functions as described. In the technical design process, programmers, software engineers, database administrators, or other technical personnel decide how to implement technologies that will realize the goals of the functional design.

The *technical brief* starts with the technologies you can anticipate on the client side (that is, on your users' computers). The sorts of questions you should be asking include the following:

1. What kind of computers and browser software will they be using?
2. What browser software and versions are common?
3. Will they be using dial-up access or a high-bandwidth connection?
4. Do they use plug-ins and are they able to install them?

Server logs or specialized software can collect some of this information. Other data you might extrapolate from market research or contact with your own customers.

For example, one of our clients is a major airline, with an intranet for which they specify a common browser, screen resolution, and plug-ins for all computers in the company. This situation simplifies development because the browser is a known quantity. We can therefore incorporate a wide range of functionality on the client side because we know exactly what resources the user has. Other sites are made for viewing over the World Wide Web, where users might have virtually any type and version of browser, and little to no ability to install plug-ins themselves. A website developed for such a site should be kept simple and flexible in its design.

The technical team should look at the functional specification from a strategic point of view. For example, depending on the complexity of the site and the business objectives, a sensible strategy may be to plan for some enhancements after the launch. Regardless, the nature of websites is that they require updating. What distinguishes a Web project from media like print publishing or video production is that there is virtually no end to the product development cycle. The time to consider maintenance issues for the site is early on, in the technical planning phase, not after the site is launched. For instance, when planning a database-driven site, you may want to develop "administrator" tools that will make it easier for nontechnical people to import new content into the database.

The technical specification speaks to the techies and engineers developing the site and documents their planning. The first decision is what platform and server software to use for the site. The development of the site from prototype on out should take place on a Web server with the same operating system and server software as the final live site. The server should be accessible to members of the development team but not to the general public. This server is referred to as the *development environment*. The server that hosts the live site is called the *production environment*.

The technological specification addresses what technologies to use for delivering the functional requirements, such as Java, Perl, Active Server Pages, Cold Fusion, or digital certificates, and how they will work. For example, in a database-driven site, the technical team may decide that since the site will be hosted on a Windows 2000 server, the appropriate database technology to use is Microsoft SQL-Server with Active Server Pages. To implement this technology, they will

need to design the database(s) and query functions appropriately. Depending on the complexity of the technology and the various software applications involved, the technical team may need to get up to speed on the application programming interfaces (APIs) necessary to integrate functions. They may plan some feasibility testing to determine if desired features are doable within the budget and available technology.

To continue with the example of Campus Posters, Inc., the technical specification might include such items as the following:

- A large portion of the customer base, on-campus students, will be accessing the site using smaller monitors from laptops or iMacs in the library or student center.
- The host server will run on a Windows 2000 platform.
- The Web server will be Microsoft IIS.
- The database will be Microsoft SQL-Server.
- The e-commerce module will be Microsoft 2000 Commerce server.
- Credit card verification will be done online.

Technical specifications are likely to change during the development process. More details would be added to specify how it is all supposed to work. As a project manager, you should encourage the development of detailed technical specifications throughout the process. If the project suffers a change of personnel in midstream, your new engineers will benefit greatly from a current and detailed technical specification.

User Interface and Visual Design

Once you know what you are building, and how you are going to build it, you can start designing what it will look like and how the user interacts with the various features on the website. As project manager, you will communicate to the graphic designers and user interface designers who the audience is—their attitudes, expectations, and motivations. Most of all, designers need a clear idea of what action the organization expects users to take on the website.

User interface design and visual design work hand-in-hand to create the user experience but are not the same thing. User interface design is a unique discipline that draws on design theory and cognitive psychology. The user interface design basically describes what the user needs to do to make use of the site and operate the site features.

The information architect, if a team has one, works closely with designers on the user interface design. Regardless of what positions constitute the team, to execute a well-designed user interface, the designer must be intimately familiar with the functional specifications. The user interface defines the way users will get around the site, as well as the specific mechanics of interacting with elements

such as buttons, text fields, and the like. Consider a site with five main sections, each containing subsections. The designer must decide whether a static navigation bar on the top of the screen will suffice, or if the site is deep enough to warrant an expandable tree on the left, showing the subsections for each main section.

The user interface design questions around the search feature for Campus Posters, Inc., include the following:

1. How will customers find their way to the search field?
2. What sorts of tips or guidance should be offered?
3. If there are no hits, what will the page look like?
4. How will the customer get back to the search field to try again?

Any labels or instructions on the site are part of the user interface design, as are the messages in dialog boxes.

User interface design is critical to a site's success. It's easy to see how this aspect might become the weak link that would make all of the other work on the site fruitless. A rich, robust, full-featured site serves nobody if only the programmer can figure out how to operate it.

The visual design refers to the artwork itself, such as graphics, logos, colors, and fonts. An aesthetic element of the site, the graphics convey a mood or motif. All the elements of artistic aesthetics—color, texture, illustrations, and photographics—can contribute to the ultimate goals of the website. Good graphic design also supports the usability of the site. Consistent, purposeful use of color, shape, layout, and other elements of design can subtly orient users to the site's structure. The best design is subtle in that it doesn't call attention to itself, but powerful in that it clearly communicates more than words ever could. Your users may or may not read the text on your site; most users, in fact, don't. There's no escaping your visual message, though. At first blush, the graphics are a decorative element; however, they must be called upon to do more. Otherwise, they are merely gratuitous eye candy.

Unfortunately, novices tend to start their website development projects with graphics because that is what they see and notice about other sites. Flashy as the visual design might be, it nevertheless plays a supporting role to function in website development. Creating graphics is extremely time-consuming. Final artwork need not be prepared until other design phases have been completed.

Communication

Communication always plays a critical role in project management. In this stage, the project manager coordinates the three efforts of functional design, technical design, and visual and user interface design. The three initiatives are somewhat sequential, but there is overlap. Although functional design necessarily leads the

charge, the creative and technical teams work in parallel. Each of these three efforts involves some documentation. In this chapter, we talked about briefs and specifications. They do not necessarily need to be separate documents. Briefs lend themselves to sharing across the functions. Specifications generally give more detail than people outside the function need to know. Project managers can decide for themselves how best to document the projects for their team. What is critical is that you get it in writing.

The World Wide Web had its beginnings as a collaborative tool for physicists. Naturally, the Web development team can use the Web to collaborate on the website development project. Project managers can use a project site to communicate a calendar, up-to-date schedules, menu-tree diagrams, meeting agendas and minutes, progress reports, and more.

A favorite communication tool of most Web project managers is a simple one—e-mail. Communications are easily shared within the group. E-mail client software usually supports some sort of personal organization system or, at minimum, organization and archiving of both incoming and outgoing messages.

The project manager also must communicate with the client. These communications can be delicate at times. From the onset, the client, whether internal or external, needs to understand the development process. You should be clear that Web development is an iterative process. Some clients might have different expectations. Some may be looking to save money by avoiding revisions. "If you do it right the first time, you don't have to make revisions or fixes," they say. Revisions are a vital component of the process, however, not a discretionary add-on. You have two choices in this situation. You can inform people of the truth and sell them on it to gain agreement. The other option is to obscure the fact that revisions are being made, manipulating the reality to conform to their expectations. The second path is risky and probably unnecessary. Usually, such clients forget the "no revisions" rule anyway, once they have a wish list of their own pet features to add. It's best to consider their changes at the same time you negotiate feedback from within the team.

Because website development is an iterative process, it lends itself to various checkpoints with clients. You will probably want a formal signoff of the functional and technical specifications before the work begins. Throughout the process, the project manager's diplomacy and acumen in knowing when to consult with the client is helpful. Rooted in personality and organizational culture, the needs for communication vary from client to client. Striking a delicate balance, the project manager must delegate decision making to the people closest to the work but also know when it is time to draw the client into the process.

Testing the Concept with Prototypes

Sometimes the play doesn't go exactly according to script. The process of building, inspecting, and rebuilding is called prototyping. The word *prototype* means

many things to many people, but it usually refers to the first proof-of-concept version of the product. A starting point for subsequent development, the prototype tests your design hypotheses, flushes out problems early, and reveals the inevitable unanticipated issues sooner rather than later. Therefore, prototyping is an integral part of the development process.

For a website, a prototype is a first attempt to express or demonstrate the functional design through one of the other design phases. Following are a few examples of prototypes:

- The *navigational prototype* is usually a layout of the navigational structure of the site, also called the site skeleton or framework. Without implementing actual features, this prototype shows only the overall navigation structure. It uses plain links and blank pages, or pages with sample data.
- The *technical prototype* is a raw demonstration of the features required by functional design. It may be a programmatic interface to a database, which shows how you can search a particular database by various parameters.
- The *visual prototype* could take the form of a simple graphic file (not even a real HTML page) showing an "artist concept" of the home page. This is often called a "treatment" or graphic approach.

What all of these prototypes have in common is that they provide the first "support beams" for the website, a starting point from which the design can proceed. As the various prototypes are refined and accepted, they are combined to build a first version of the website, which may also be called a prototype. Design proceeds in modular fashion where possible. If you must discard your work, which is expected, it's best if you can do so in removable chunks.

Phase 2: Skeleton Framework

Phase 1 developed the concept through creation of the menu-tree diagram. From that document, planning work for the functional, technical, and creative efforts ensued. The next step is to prototype the website by developing skeleton Web pages representing the pages on the menu-tree diagram (Figures 8.4 through 8.6). These pages are "empty," consisting only of the minimal HTML tags and content for the page title and navigation links. It's best to work without content or graphics at this stage. If, for some reason, you find it useful, dummy content should suffice. In this manner, you can quickly prototype the whole site. As you click your way around the site, design flaws will be readily apparent. In this bare bones environment, nothing can hide the navigational structure. An ideal iterative environment, the skeletal framework takes only a few minutes to build or change. You can test-drive concept and structure and easily experiment with modifications.

Figure 8.4 Example of skeleton framework: Home page. (School Assembly Guide page <www.schoolassemblyguide.com>. Reprinted with permission of American Eagle, Inc.)

Once approved, a skeleton framework also forms a great basis from which the rest of the development team can begin production. For example, using the skeleton pages as a shell, the graphic designer can create "real Web pages" with graphics and layout. The skeleton framework also shows where content is needed and gives the programmers a context for how more advanced features are intended to be integrated into the site.

Figure 8.5 Example of skeleton framework: Category page. (School Assembly Guide page <www.schoolassemblyguide.com>. Reprinted with permission of American Eagle, Inc.)

Phase 3: Home Page and Motif

With the skeleton framework in place, the graphic artist has enough information to sketch out a visual design approach, or motif, for the site. The work generally begins in a graphics program such as Photoshop. Drawing from the creative brief and samples of the client's existing images, the artist works up a few alternative designs and approaches for client review. Based on feedback from the client, the artist revises the home page design until client approval is gained. Once approved, the motif can be applied to the rest of the pages in the site, keeping the site style consistent (Figures 8.7 through 8.9).

Figure 8.6 Example of skeleton framework: Detail page. (School Assembly Guide page <www.schoolassemblyguide.com>. Reprinted with permission of American Eagle, Inc.)

Ideally, your artist will also have Web-authoring skills so that the graphic designs are more easily converted to Web pages. Designing for the Web raises many issues that people working in the more controlled environment of print may not be aware of. The nuances of designing with ambiguity concerning output include table layouts, different browser display methods, graphic colors and variations in fonts depending on user settings, various screen sizes, and more. Graphic artists must design a Web page that functions in real-world situations, where these factors can come into play.

For example, we were privy to the development of a site for a print graphic design company, with no prior Web development experience. They insisted on designing the pages themselves, and promptly worked up a set of beautiful, richly textured pages with layers of lavish graphics, photo images, and unusual fonts. The design, beautiful as it was, could not be converted into standard HTML

Figure 8.7 Example of final site design: Home page. (School Assembly Guide page <www.schoolassemblyguide.com>. Design by JMC Studios <www.jmcstudios.com>. Reprinted with permission of American Eagle, Inc.)

pages because of their insistence that the page be presented exactly as designed, on every browser and screen resolution. The only way to accomplish this was to simply display the whole page as one large bitmap graphic, which turned out to be more than 500k in file size. When they saw how long it took to download, they became much more receptive to a more flexible HTML-based design.

Once the general motif has been approved, and an HTML home page built, you are ready to proceed to build out the website.

INVOLVING USERS

Underlying all of the design and prototyping efforts described in this chapter is an unwavering focus on the user or customer. In Chapter 5, we discussed

Figure 8.8 Example of final site design: Category page. (School Assembly Guide page <www.schoolassemblyguide.com>. Design by JMC Studios <www.jmcstudios.com>. Reprinted with permission of American Eagle, Inc.)

gathering user information as part of the preplanning of your website. In the next chapter, we look at formal user testing of your website when it's in production. User testing is a vital step in the development process, but it is not cheap. The sort of early prototypes discussed in this chapter do not lend themselves to user testing. There is simply not enough there for average users to evaluate. The insiders on your development team, on the other hand, are able to understand the rudimentary nature of the skeleton framework for what it is. Average users would be thrown off by viewing pages without content.

Nonetheless, project managers need to think of ways to elicit user feedback as early as possible. You should be on the watch for less formal checks on the design from users. Be willing to share these early prototypes beyond the development team and the client. Take advantage of any opportunities that arise to get feedback from customers or typical users. If you know somebody who loves to

Figure 8.9 Example of final site design: Detail page. (School Assembly Guide page <www.schoolassemblyguide.com>. Design by JMC Studios <www.jmcstudios.com>. Reprinted with permission of American Eagle, Inc.)

shop on the Web and owns more posters than they have places to hang them, maybe you want to share the skeletal framework of Campus Posters, Inc.

CONTENT MANAGEMENT

Now you have everything in place to begin production. Building on the strategic objectives of the website, you have developed the functional design, technical design, and user interface and visual design. You have developed a couple of prototypes that lay the foundation for build-out. Before actual production begins, it is worthwhile to consider the content gathering and creation process.

Your site probably uses some existing content. Chances are the content is not all in one place. More than likely, text and graphics are in multiple formats

and have not yet been converted to browser-readable form. In addition, new content is being created for the Web, some by your development team, some by the client. You can see the project management challenge that lies before you. To make matters worse, you may even be depending on the client for the bulk of your content. Therefore, you don't have as much control over gathering it as you might like. Your contact person with the client has logged much time in the early planning of the site. She has made herself available to you through negotiating and gaining approvals for the agreement. She breathed a sigh of relief once the project was outsourced, happy to move on to other priorities. Nonetheless, she's reviewed the documentation discussed in this chapter. Has she been at work preparing content while your team developed its specs and plans? Maybe not. Especially if you haven't instructed her to do so. It's not unusual for missed deadlines on content delivery from the client to gum up the works in a Web development schedule. Once your design is hashed out, you should draw up a list of content, along with delivery dates and the person responsible.

Organizations with rich content and a need for steady or frequent updates should consider a content management system. Throughout this book, we have recommended the advantages of a database-driven website. The content management system allows the various people who create, edit, or adapt content to access it, review it, and import or export it from the database.

Managing content is an important aspect of website production, which is the subject of the next chapter. We raise the issue here because of the option of a technology solution, which, if pursued, would be a consideration in developing the technology specification.

Build-Out and Production

You can plan, plan, and plan some more, but ultimately a delivery date looms in your future. In the design and prototyping process, you have developed the plans that are the foundation of the site. Build-out, or production, brings together all the elements toward the outcome of a final, complete, and fully tested website, sitting on the client's server and ready to go live. It is time to work the plan. Your payoff for the planning time will be a more organized, smoother production process. As much as you plan, you will undoubtedly still encounter surprises and obstacles. You will still need to call on your skills in communication, coordination, and cooperation in order to meet your client's expectations for a high-quality project.

Building out and producing the site encompasses such processes as the following:

- designing all the pages
- gathering, reviewing, and placing all content
- programming or scripting all site features
- testing the site and fixing bugs

The Web development process is continual. The processes described in Chapter 8 do not cease when the project goes into production. The transition is one of emphasis, from planning to implementation. The feedback loops of an iterative development process continue to raise design issues as the project proceeds, and even after going live. In fact, because a website is in effect always a work in progress, requiring maintenance and updating, the design of your site will always be up for discussion.

PRODUCTION PLANNING

For project managers, the planning never stops. When building out the site, the functional and technical specifications continue to guide the work of the

development team. Every production process needs a point person. In a website development project, many individuals work independently but are nonetheless part of a team effort. When the work of some individuals affects that of others with whom they are not in regular contact, communications breakdowns present a huge risk. On large-scale Web projects, a production manager or producer may take this responsibility of supervising production. That person would report to the project manager on a regular basis. In this book, we assume that the project manager is the "production lead."

The client and development team members alike must communicate all suggested changes to the workplan to the project manager for prioritizing. Direct contact between the client and production people, as well intentioned or innocent as it might be, can become a problem (Figure 9.1). The danger is a short-circuit to the flow of information. The project manager should give close attention to changes, considering the impact of each on the budget and schedule, as well as ripple effects on other aspects of the project. If the project manager doesn't hear of a change, others who need to know will be left out of the loop. The result will be a communication breakdown.

While planning the production process, the project manager is also keeping the end-goal in mind. Before going live, the website will be handed off to the client (or to the client's outsourced hosting service). During the course of development, the project manager should be preparing for a clean handoff. The client's technology team needs to be informed of the technical specifications of the site.

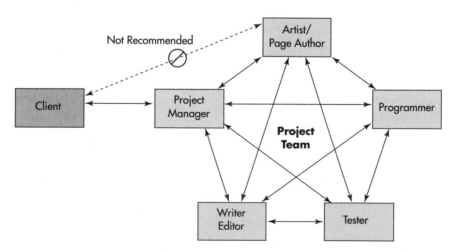

Figure 9.1 Preferred channels of communication. It is not recommended for a team member to communicate directly with a client, without including the project manager.

Their servers should be running identical versions of any software employed in the Web development efforts. If an e-commerce module will be used, the company will need a digital certificate and secure transmission capabilities.

The project manager should prepare written production guidelines that address specifics for development of the site, such as the following:

- *a directory structure*, based on the menu-tree diagram and navigation structure of the site: Developers authoring the Web pages need to know the directories in order to properly code internal site links.
- *file-naming conventions*, which help everyone on the development team: If the client can deliver properly named files, renaming is one small task the development team won't have to worry about.
- *programming and scripting notes:* Future modifications to the code will be much easier if all the programmers have followed conventions, which are documented.
- *production art notes*, which will save time for the graphic artists: Specify color palettes, size and resolution for images, and preferred file formats.
- *procedures for uploading content to a database*, either by the programmer or administrative user.

DESIGN

The graphic artists start their production work by extending the client-approved motif and home page images to other graphic elements and pages on the site. A basic principle of user interface design is that the navigation scheme should be consistent throughout the site. New users may take a wrong turn here and there, but if navigation is consistent and the buttons are always in the same place on the screens, they will quickly learn how to move around in the site. Without consistency, users feel lost and disoriented. Unless you have content or services they badly need, they will correct the situation by leaving your site. Also, graphics on the pages should offer visual cues that orient people. The popular directory Yahoo does this explicitly by placing at the top of the page the now-familiar text line showing the hierarchical path that has led to the open page. A common technique is to change the color on the label of the navigation bar for the section of the site the user is currently in.

These design principles do not apply only to navigation. In general, graphics and their placement should be consistent across the site (although certain banners, buttons, and controls will be specific to individual pages). Users will come to look for these common buttons in a standard place. Use of colors and text labels should also be consistent. Of course, the drive for consistency makes the graphic artist's life easier, too. Who wants to create 100 different designs for

individual pages? If the navigation bar and other design elements are consistently placed, designing the rest of the pages is usually a fairly straightforward task.

Authoring tools make the job easier. The World Wide Web Consortium (W3C) has developed a standard called cascading style sheets (CSS) that can help. CSS attempt to address the problem of display by defining how various kinds of content should be displayed in a consistent manner. Style sheets are one way to create consistency across the site. The CSS can be embedded into a page, but its true power is realized as a separate file that can be linked to other pages. Then, in making one change to the style sheet, you can modify the entire site. A site can also use embedded CSS on specific pages along with a linked style sheet. Of course, for consistency's sake, you will want to refrain from too much individual design.

CSS also can help maintain the design integrity of the site after it has been handed over to the client. Design specialists can create the style sheets during the development process. When the site is handed over, developers can train in-house personnel on how to use the CSS for new pages. Instruction, along with documentation in the form of a mini-manual or sample HTML, is important because haphazard use of style sheets can also make a big mess. With a bit of hand-holding, however, nondesigners will be able to update the site with new content while retaining the integrity of the design.

If the project is a database-driven site, graphic artists can prepare the standard template pages that draw information from the database. There is no need to await the content in the database. It's better to create the templates and set them in place using sample or dummy data so they can be reviewed and tested for usability.

DEVELOPMENT SITE

If you are working on a large or complex website, you may be using a *development server* to build out and test the site before copying it to the live server, known as the *production server* (Figure 9.2). As production work progresses, your team will continue to post content and install programs to the development server. You want this site to be accessible to members of the development team, but not to the whole world on the Web. At best, it is an embarrassment for a work-in-progress to be unveiled prematurely. Depending on the circumstances, exposing the site can potentially cause more serious problems. The most secure option is for the server to reside behind the firewall, on an intranet that is accessible only to those within the company or coming from select Internet protocol (IP) addresses. The site may even be posted "blind," which means it's available on the Web, but password protected or simply not yet assigned a domain name.

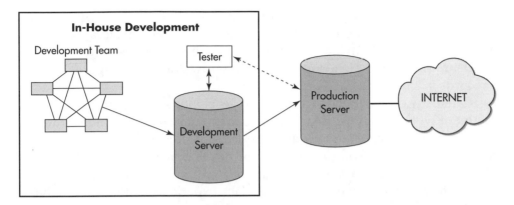

Figure 9.2 In-house development using development server and production server. Notice that the development team publishes to the development server. The tester tests the site on a development server before it is moved to a production server. The tester then tests on a production server.

The development server will be a hub of activity. Programmers, graphic artists, and editors will be enhancing the site on a regular basis. As new programming functions are added, they should be tested. Before a site is handed over to the client, all of the content and data will have been placed, and all databases and programming formally tested.

In an ongoing production environment, two servers may be running—both a development server and a production server. Under this arrangement, the development team can test and debug the new version without affecting service on the live site. When the site has been perfected, files can be released to the information technology (IT) department, which can then post new and updated files on the live site or install patches or new programs. This two-step process with separate but identical servers is a necessity for any site that runs programs. Software must be rigorously tested and debugged under real-time conditions. It's not something you want to perform on a live, stable site with your customers watching. Development programming can really make a mess of things. You want to perfect the site performance offline. Once you're live, it's showtime, and you want to be absolutely sure you're ready.

CONTENT DEVELOPMENT

The project manager must monitor the content development process closely. Programmers and graphic artists will be able to complete much of their work using dummy data. Sooner or later, however, the content must arrive. Missing or late

content, especially with accountability on the client end, is a leading cause of deadline slippage. It's important to stay on top of the content situation. Content encompasses multiple media—written text, graphics, photos, audio, or video. The files may be stand-alone for HTML calls into a static Web page, or they may be records in a backend database.

Often, the content needs work on the developer's end. You can control the amount of work by writing detailed specs for content in production guidelines; however, it might be advantageous to the schedule for members of the development team to take on some of the content development responsibility. For instance, suppose the marketing design staff of the client is modifying print graphics for use on the website, but they lack experience with Web graphics. It would be more efficient for your experienced Web artists to assume this task. In fact, they might end up redoing the client's work anyway, which leaves you with the worst of both worlds. Of course, preparing the graphics files is a commitment of time and resources. If this responsibility is beyond the scope of the agreement, then additional compensation is appropriate.

Not only does the content need to come in according to schedule, but it must also be satisfactory in quality. It probably will not be possible for you to check every piece of content personally, and in fact, you may not feel qualified to judge it. You should, however, establish a system that ensures that somebody is responsible. The Web is full of copy that, by all appearances, has never been edited. Companies take great care in editing and proofreading brochures or press releases, yet when it comes to publishing on the Web, quality control seems to relax or be nonexistent. The nature of Web pages is that editorial changes are easy to implement after publication, whereas with print pieces you get only one shot. Nonetheless, it's best to resist the temptation to "worry about that later." Print and graphical content should be checked against the specifications you've communicated and for a general quality review.

Content development for a website project is accomplished in one of two ways:

1. offline content development
2. online content development

Offline Content Development

In offline content development, as the name would indicate, you build pages offline, on a workstation rather than on a Web server. You would generally use this method in building a basic site of static pages. In this process, you build pages or content files and, when complete, they are uploaded (copied) to the server. This

procedure is generally the case for regular HTML pages or fully prepared database files. Master templates or style sheets for the design can make offline development much more efficient. Nonetheless, the technique is not very scalable to websites that contain many pages.

Online Content Development

As a site grows, the viability of updating and adding pages manually diminishes, until it becomes less and less feasible. As an extreme example, imagine building all of the pages for a site like Weather.com, which gives up-to-the-minute weather maps and forecasts for cities nationwide. Maintaining a site like Weather.com, or Amazon.com with so many individual product pages, is possible only because the content is drawn from a database.

Each page is created "on-the-fly" by the server in response to your request. When, for example, you request the weather report for Chicago, your computer sends the request in the form of a command to the Weather.com server. The server then follows three steps:

1. Finds the generic "weather report" page (an "empty" template page without data).
2. Looks up the data for that location and places it in the proper spots on the template page.
3. Sends you that newly created page.

So, through automation, creating such a rich site is a piece of cake. Well, almost. Data must still be created and placed in the database.

The Web development team can access the backend database online and maintain it from any Web-connected browser. E-commerce sites commonly use an online content development process. Company personnel must continually update information, adding new products, deleting old ones, and changing prices, or posting new promotions. Those closest to these marketing and product decisions are probably not database experts; however, user-friendly interfaces simplify the process. Using standard browser software, authorized staff can access Web pages set up to edit records in the database through text-based form fields, pulldown lists, and dialog boxes. With appropriate security and authentication processes in place, staff or contractors can maintain the site from any location connected to the Internet (Figure 9.3).

Online content development is a powerful tool. With some upfront investment, you gain tremendous scalability with database-driven websites, which is truly a strategic asset in today's Web marketplace.

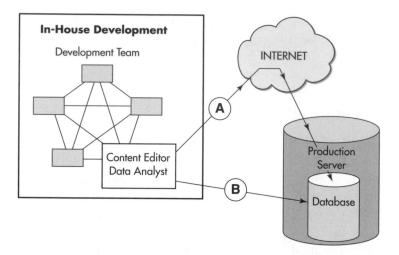

Figure 9.3 Content editor or data analyst posting new content to live website on production server. **A.** Online content development: posting content by using a Web page interface. **B.** Offline content development: posting content by copying data directly to server and database.

PROGRAMMING

If you're managing a database-driven site, you will need some software engineering to make it all work. As the functionality of websites has grown beyond basic HTML with JavaScript and plug-ins for multimedia, it's fair to say that any commercial website requires a programmer's skills for advanced scripting, if not in actually writing programs.

The most highly technical part of the development process, software programming is also the least predictable. Sometimes development goes as expected, but it is not at all unusual to meet with some bumps in the road. Traversing those bumps is where the going can get tough. The following concepts should be kept in mind:

Programming is a black art. Even its practitioners will tell you so. Some admit that their power over the mysterious innards of the computer is all voodoo. Whatever the source, the magic is difficult to perfect the first time. Programming is basically a process of invention and reinvention, trial and error. All in all, it's a messy, inefficient process, but that's the only way to do it.

Programming is a creative process. Sometimes, programmers can come up with a routine in a flash, whereas other times it requires more thinking and analysis. The more experienced programmers have the benefit of having addressed and solved similar problems in the past.

Programming is a precise, detail-oriented discipline. A slight mistake or omission can cause big, seemingly inexplicable problems. It may be difficult to identify the cause of the problem, and the time it takes to do so can easily take the project off schedule and over budget.

Programming work starts with the functional specification, the programmer's road map. The programmer is conceptualizing the relationships between pieces of data, and the functional specification shows how they are intended to work together. The technical specification is at once a planning document and a record of the work. With these documents, the programmer starts developing ideas about the code that will best deliver the desired functionality.

Programmers are known to log long hours. Therefore, after a good, thorough analysis, the work that ensues could go at a fast clip. Obviously, it's important to be sure that the programmers are moving in the right direction. Project managers have a couple of methods for doing so:

1. Communicating clearly through the functional specification and technical specification
2. Monitoring the work by reviewing a technical specification that is continually updated

A detailed, up-to-date technical specification is a way for the programmers and others on the development team to communicate with one another. A fix in one part of the program often causes a bug in another. Documentation of the work then becomes useful in debugging. Also, if new people are brought onto the team, the technical specification can be useful in communicating the project status and how it got where it is. That said, throwing new programmers onto a project already underway is probably not going to help your schedule any. Remember Brooks' Law, introduced in Chapter 1: "Adding manpower to a late software project makes it later."

SCHEDULING

By now, it's no doubt apparent that scheduling the programming phase is also a black art, if not a wild guess. One rule of thumb is to take the initial estimate and consider it to be not merely a best-case scenario, but quite possibly an insanely optimistic one with a probability teetering close to zero. To quote again from Frederick Brooks's *The Mythical Man-Month:*

> All programmers are optimists. Perhaps this modern sorcery especially attracts those who believe in happy endings and fairy godmothers. Perhaps the hundreds of nitty frustrations drive away all but those who habitually focus on the end goal. Perhaps it is merely that computers are young, programmers are younger, and the young are always optimists. But however the selection process works, the result is indisputable: "This time it will surely run," or "I just found the last bug."

So as a practice, you might as well take your initial estimate and double it; better yet, triple it to take into account testing and debugging. The ambiguity of the schedule is another argument for close tracking throughout the process. You should keep the technical specification current and pay steady attention. If you watch the progress and keep your eyes on the goal, you will more accurately estimate the completion date as the project moves along.

The incredible deviation, of course, is cause for concern. A $250,000 website that goes over budget because programming takes two or three times longer suddenly costs $500,000, which is enough off target to concern any senior manager. A $10,000 project can become $20,000, a lesser transgression in dollars, but as a percentage it's no better, and that's one way accountants will surely measure. Smaller projects seem more likely to come in close to estimates. It's simply a matter of dealing with fewer unknowns.

CONNECTING THE DOTS

While designers work with dummy text in developing their page design templates, programmers work with dummy page templates in their work. With two tracks progressing in parallel toward the endpoint of full integration, the project manager's role is coordination. Eventually, the programmers will be coding the Web applications that connect their backend database to the client-approved page templates. When those routines are completed, tested, and debugged, you are ready to start moving the actual content into the database. Suddenly the project starts to look like a real website. Having made this watershed point, the work can proceed quickly; however, before development moves too far along, it's time to solicit user feedback in a structured way.

USABILITY TESTING

Customer focus is the mantra of contemporary business, and website design is no different. With pages laid out and content ready to be poured in, you are in a position to gather users to test your design decisions. No matter how skilled and experienced a design team you've assembled, user testing always seems to offer new revelations.

True user testing is a structured observation of real users individually performing a standardized set of tasks. Start by developing a list of tasks that are representative of the functions of your website. In stating these tasks, use neutral language and emphasize the outcome, not the procedure. Questions you might ask for the Campus Posters, Inc. website (introduced in Chapter 8) could be as follows:

- Determine if any Jimi Hendrix posters are available for purchase.
- Locate the Shaquille O'Neal Slams poster and the Sammy Sosa poster and place one of each in the shopping basket.
- Go to the shopping basket and remove the Shaquille O'Neal poster and change the quantity of the Sammy Sosa poster to two.

A series of users then come to the usability testing sites and perform identical tasks. Request that users "think out loud" while they perform their tasks. How else can you know what's going on in their heads? At minimum, the project manager should attend the user testing sessions. Depending on the size of the project, others on the development team may want to join as well. You may also want to videotape the session as documentation, to share results in the group, and for future reference.

Testing out the site with actual users is always interesting and usually informative. You will see a surprise or two and experience insights on matters that hadn't occurred to you. You may well find yourself saying, "Aha! Of course!" For example, you may find that because of an overly creative visual design, users cannot find the home page button on your navigation bar. Or perhaps users want to search based on a criteria that you hadn't considered. Clearly, you need some design revisions. Usability testing should not be confused with software testing or quality assurance, which is the subject of the next chapter.

10

Quality Assurance Testing

Quality assurance (QA) testing is the process of locating, isolating, and describing software defects, commonly known as bugs, so they can be fixed by programmers or the data preparation staff. QA testing usually starts sometime during the latter part of the development process. QA testing is usually going full speed when the site is posted and close to going live. In a sense, testing is never really finished because it is performed as long as the site is live and being updated and maintained; however, testing activity generally tapers off once the site goes live and is in use.

In some websites, QA testing directly impacts the quality of the site. It is the final quality-control gate through which the site must pass before it is finished. The more users are expected and the more complex the website, the more important is the QA testing process. The testing phase is crucial because of the variety of user hardware configurations, including different versions of various browsers on different hardware platforms (e.g., PC, Mac, UNIX, Linux) and a variety of possible screen resolution settings (from 640×480 and 800×600 and higher). You should test your website for all of the different configurations your users might have.

Design flaws, suggestions for redesign, and proposed design changes are duly noted, but ideally user interface design decisions have already been made. QA testing focuses on identifying program malfunctions and, to a lesser extent, content errors, so they can be fixed before going live.

In general, QA testing becomes increasingly important as the site nears completion, until, by the end of the project, it is the main activity, along with fixing defects found. Unfortunately, people new to Web development often overlook this phase or underbudget for it. They see it as an indication of shoddy workmanship and resent having to repair a site that "should have been built correctly in the first place." This sentiment misses the essential point: Testing is an integral part of the process of "building correctly."

Experienced website developers have usually learned the hard way that attaining even a tolerable level of reliability and stability on various browsers and screen resolutions can only be achieved through QA testing. Taking the time to find the defects and fix them at this point is usually better than rushing to post the site live, risking an unfavorable response and the headache of frustrated users calling or e-mailing with their problems, or worse yet, simply abandoning the site forever.

QA testing marks the end of the product development cycle because a site should pass final QA testing in order to be of sufficient quality to be posted. QA testing usually starts up in force sometime during the later development phase and continues as part of the maintenance and support phase even after the site goes live. Typically, as discussed earlier, testing and debugging consumes about one-third of the development effort in one form or another, which can cause great consternation among those funding the project if it is not planned for. Even if you've planned, testing almost always takes longer than anticipated. Getting started on testing early is one of the secrets of successful website development.

SOFTWARE'S DISTINCTIVE QA

QA testing is one of the major differences between website or software development and the development of other media, such as print and video. Little in the way of print or video production compares with software QA testing. A video program may be reviewed several, if not many, times, but it is a linear medium, so it has only a single path to inspect. Software, however, is nonlinear, with an unlimited number of potential "paths," most of which have to be tested. Every functional choice and button must be tried alone and in combination with other features. Such testing is not analogous to proofreading a print product either. Software QA testing demands considerable technical skill and ingenuity, along with meticulous record-keeping of the results of actions performed in the various combinations and permutations allowed by the user interface.

This QA effort is a significant responsibility and usually requires significant resources. If the site is for public viewing, the client usually ends up testing it, whether the project is planned that way or not. The development shop can rarely test its own work adequately. Testing must be done objectively, and the skills necessary to test software are different from those needed to develop it. Because the client is ultimately at risk, it is their responsibility to ensure that the site is thoroughly tested and that defects are fixed before it is posted live on the Web. This often means finding an outside company to assist in testing or setting up an independent, in-house testing group.

Development servers are particularly useful when it's time to test. Once the site has been tested, fixed, and is running fine, it can then be copied from the development server to the production server with a minimum of expected prob-

lems; however, the site should then be retested on the production server, to make sure everything is running as expected.

TEST PLAN

To adequately test a complex, database-driven website site, you must develop a test plan (Table 10.1). A test plan provides a checklist of all the functionality in the program. With such a checklist, testing can be performed in a consistent, detailed, and thorough manner by one or many testers. This test plan gives the testers an

Table 10.1 Sample test plan for School Assemblies Guide website (see Figures 8.7 through 8.9). (Test plan is simplified for conceptual purposes.)

Page	Filename	Component	Expected result	OK? notes
Home page	Default.html	Category (button)	Category page	
		Performer list (button)	Performer list page	
		e-mail (link)	E-mail program opens, with proper address filled in	
Categories page	Categories.html	Categories (button)	Category page	
		Performer list (button)	Performer list page	
		Contact Us	E-mail program opens, with proper address filled in	
		Home	Home page	
		Individual performers (links)	Individual performer detail pages	
Performer detail pages	(it varies)	Categories (button)	Category page	
		Performer list (button)	Performer list page	
		Contact us	E-mail program opens, with proper address filled in	
		Home	Home page	

actual checklist of the features to try and often an order in which to try them, with clues as to areas that may exhibit defects because of the complexity of the code. With such a test plan, all the testers can be sure of trying most, if not all, features and functions in the program. Without such a framework, testing is merely a hit-or-miss exercise, relying on the skill and luck of individual testers. Even with a test framework, however, the challenge in testing is to find defects that exhibit themselves only in certain situations.

For example, the search function in an online catalog may work fine searching the product name field by a single word. But when the user conducts a multiple-word search on the product descriptions, the program does not retrieve known matches. In such a situation, the tester can start creating hypotheses to test and identify the fewest actions necessary to exhibit the defect, as follows:

- It may work with two words but not three.
- It may work in the product name filed but not in the product description.
- It may find only some records but not all.
- It may depend on the length of the word being searched for.

Using structured testing methods, a creative software tester can find a potentially serious problem then give programmers helpful feedback and clues for fixing it. Mere "trial-and-error" testing by people with little software testing experience may not identify the problem at all. If these testers do happen to stumble across a problem, they may not be able to reproduce it later. It is unlikely they will reproduce it in the fewest possible actions and provide an adequate defect report.

Once these software defects and errors are found, they are logged on bug report sheets. The sheets are then typically turned in to a person responsible for maintaining and updating the defect database. Without this approach, it is difficult to keep track of defects, make sure they have been fixed, or prioritize outstanding defects and make the best use of remaining programming and page-building time.

ISOLATING AND REPRODUCING THE DEFECT

In addition to simply finding a software defect and being able to reproduce it, testers must give directions for another person to be able to reproduce it as well, with a minimum of time and effort. If it can't be duplicated, it's hard to know whether it really exists, not to mention whether it's been fixed. Here is where testing borders on art. It is better to be able to reproduce a defect in fewer steps because it greatly assists the fixer in identifying the source of the defect. If it takes

five keystrokes to demonstrate the defect, the programmer has fewer variables and conditions to consider than if it takes six keystrokes. It takes experimentation, insight, and time for a tester to reproduce defects and demonstrate them with the fewest possible steps. The time necessary to identify, reproduce, and isolate defects largely accounts for the unexpectedly long time between the latter development stages and final release. Yet this is the most efficient method, because if the tester does not do a thorough job and isolate defects to the minimum number of steps, a programmer will spend even more time doing the same thing before the bug can be fixed.

TYPES OF ERRORS

When documenting errors and defects found through testing, it is helpful to categorize them according to one of three types of problems:

1. *design flaws*: user interface problems or suggestions, such as proposed new features, relabeling buttons, and screen layouts
2. *content errors*: inaccuracies, data with formatting problems, or data of poor quality in some other respect (photo image quality, text misspellings)
3. *software defects*: commonly called "bugs," these are technical problems encountered when trying to run and operate the site

During final QA testing, the biggest concern is with finding software defects because, by this time, all the data and content should have been created and checked, and final design decisions should have been made much earlier. "Mechanical" problems, such as system freezes and crashing, display and input problems, incorrectly calculated results, and conflicts with other programs, are examples of software defects.

KEEPING GOOD RECORDS

The goal of testing is not only to find problems but also to document them and the conditions under which they were found, so they can be fixed. You should keep good records so that these defects can be referred to again by number, reproduced, and referenced to the user's Web connection and system configuration. This information can be valuable in eventually getting to the source of a defect, especially when the defect is difficult to isolate and or reproduce.

The most effective tool for record-keeping is a database, rather than a spreadsheet or a word processing program. With a database, you can keep track

of the defects found and their current status—whether they have been fixed (closed) or remain unfixed (open). You can also sort through the data by various attributes, which is extremely helpful. For example, if the defects have been prioritized, they can be sorted in the order of priority, to see which defects are next in line to be fixed. If they are classified into the three kinds of defects—design issues, software defects, and content errors—the list can be sorted and tasks assigned to different individuals with appropriate information. Databases allow lots of flexibility for custom searches according to the nuances of your circumstances.

PRIORITIZING FIXES

Perhaps no website has ever launched without at least one known defect. Even sites with few defects when first developed may exhibit problems when viewed on marginal systems or those with poor Web connections. Although zero defects is an admirable goal, it is virtually unachievable on most such projects, so someone has to decide where (and how) to draw the line on defects before releasing a website.

The main issue is one of priority. Defects can be prioritized by severity, obscurity, and difficulty to fix. If a defect is hard to find and reproduce (obscure), relatively harmless (low severity), and hard to fix, it is probably low priority. On the other hand, if it crashes the user's system (high severity) in a commonly used part of the user interface (obvious) and is easy to fix, it should have high priority. By fixing defects in order of priority until a crucial project parameter (time or money) is reached, you can maximize the site's quality.

If you know the site must go live by a particular date, with no chance of altering that date, you obviously need to fix the highest-priority defects first. One way to establish priority is to assign a severity level, difficulty level, and obscurity level to each defect and then multiply those numbers. For example, defects can be ranked on the basis of severity from 1 to 10 (1 = most serious, 10 = least serious). Then they can be ranked by expected difficulty (1 = easiest to fix, 10 = hardest to fix). Then assign each an obscurity ranking (1 = most obvious, 10 = least obvious). When these numbers are multiplied together, the items with the lowest total are the most serious, most obvious, and easiest to fix, and should be started on immediately. The items with the highest numbers are the least serious, least obvious, and hardest to fix, and therefore should be worked on only as time and money permit. Although not an exact measurement tool, this method is a good way to establish a rough order in which the defects should be worked on; however, this rough order should not be followed in lockstep. Sometimes arbitrary decisions have to be made, given the unique qualities of a particular project.

TYPES OF TESTING

Several kinds of testing are appropriate for websites, including the following:

- functionality testing (i.e., unit, integration, regression, compatibility)
- layout testing
- load testing
- link testing
- usability testing (see Chapter 9)

Functionality Testing

Functionality testing refers to the testing of programmatic features and is most appropriate for sites of higher complexity that contain features such as database access, dynamic page generation, and Java applets, namely features that require actual programming (rather than HTML page building).

Unit Testing

Functionality testing should start at the source, namely by the programmers who write the code. When programmers test their own code, module by module, it is referred to as *unit testing*. Each programmer tests his or her own modules thoroughly and does not start a new module before testing and fixing the previous one. The programmer tests not simply by running the code a few times to see if it works, but rather by feeding the code common, uncommon, and even unexpected inputs to make sure it handles them correctly and does not malfunction. This technique is the most cost-effective and efficient testing method and is a way of promoting "quality at the source." Programmers who are willing and able to thoroughly test their own code module by module, after each is written, generally find defects faster than other testers and are able to fix them in the shortest time. Unit testing stops problems before they can crop up in other modules, and it prevents other testers from having to spend time finding, isolating, and documenting these defects, then retesting for them later (regression testing) to make sure they were fixed.

Requiring programmers to thoroughly test their own code can be difficult to enforce, however, for several reasons. First, most programmers like to write code, not test it. Some see testing as monotonous work that is not part of their job. Second, programmers are often under extreme pressure to produce usable code as fast as possible. Therefore, the emphasis is often on quantity rather than quality. If programmers are on a tight schedule, there is little chance they will want to spend "extra" time thoroughly testing their own code instead of logging the completion of that module and starting work on a new feature.

You should do your best to encourage programmers to take the time to test their own code thoroughly and fix defects they find before turning it over. One motivation is to let it be known that you will be monitoring the quality of the modules during testing.

Integration Testing

When the various modules are combined and the features are all running together, it is said to be integrated, and testing of the full program is called *integration testing*. Although all of the modules may seem to work perfectly in isolation, they often exhibit defects when combined as a system. Reasons include unexpected inputs and outputs between modules, incompatible variables, and just about anything else that can go wrong. Professional software testers are experienced in finding such flaws, and integration testing is usually performed in force by nonprogrammers. By not knowing how the site is constructed, they are more likely to operate the software in a way programmers had not anticipated, and so uncover errors programmers would not uncover.

Website features should be tested in an ongoing manner, while still in development. Testing the site this way allows the project manager to realistically monitor the site's progress, by building testing time right into implementation. For example, if QA testing does not start until after the whole site is supposedly "finished," you would have no idea how many defects are actually lurking out there in the code and how long it will take to fix them. In addition, there is a good chance the defects will be repeated in various forms throughout the site. If the site is tested as it is being built, however, defects—especially those in the software architecture—can be caught earlier and will be easier to fix, and will cause fewer follow-on defects, lending a gauge of actual progress to date.

Regression Testing

The most thorough method of testing is not only to test for defects fixed from the previous versions, but also to retest for defects fixed in earlier versions. This process of repeatedly retesting for defects to see if any old ones have reappeared is called *regression testing*. Good record-keeping of what version of the software exhibited the defect is essential to regression testing. For example, if a particular defect was found in a database query on Monday, and fixed on Tuesday, it is wise to continue testing for it in subsequent days and even weeks to follow. At first glance, this process may seem excessive; however, regression testing can uncover serious problems and safeguard against them. Defects that were apparently fixed may recur for various reasons. An old copy of a particular file may have been used by mistake to build a later file, or a new or different programmer may attempt to optimize code and reintroduce an old error.

Another reason to perform regression testing is that in the process of fixing old defects, new defects may be introduced. It is entirely possible for a program-

mer to inadvertently introduce one new defect for every 20 fixed. Regression testing allows a much better chance of discovering these potentially serious defects.

Compatibility Testing

Testing the site on the various kinds of user hardware and software configurations is called *compatibility testing*. If the site has programs that run on the user's browser (client-side programs), such as Java applets, JavaScript, or various plugins, it should go through compatibility testing. With the various versions of Java and JavaScript that have been released, it is possible that features that work fine on one machine may stall or malfunction on another. Problems reveal themselves in such situations that might never be discovered otherwise.

Layout Testing

Layout testing refers to the ability of the website page layout to accommodate various user browser and hardware display configurations, a fundamental difference between Web development and print production. In print production, you can be virtually certain that different users will see the same thing because the page or print ad is laid out only once. In websites, however, the pages are displayed by the user's browser, which can have a myriad of settings, so you never know for sure how it will look. For example, a user with a 640×480 display may see a very different page layout than a user with a $1,280 \times 1,024$ display. The wider display will make the elements look smaller, lines may wrap differently, and tables may shift or stretch to fit the display. A maximized browser window may show a different page view than if the window is only partially open. In addition, users may have different color settings on their machines. A photo will appear to be of much lesser quality to a user with a monitor color setting at only 256 compared to 16 million colors.

Needless to say, all of these variations cause designers to lay awake at night. You should test the layout of your pages when viewed by a representative sample of various display configurations. The results may surprise you.

Load Testing

If you are expecting heavy usage of your website, you need to know if your server and Web connection are capable of handling the load. Testing such capabilities is called *load testing*. Load testing simulates the anticipated stress of the actual site usage to see if the system has any weak links. Load testing is not usually conducted on a development server, which is not the final platform for the site. Rather, it is reserved for the production server, before the site goes live.

In load testing, automated tools continually "hit" the site to simulate the effect of numerous users. Such testing is especially important if your site depends

on a lot of backend server processing (such as a heavily database-driven site) because the server needs to perform extensive processing for each new page that's generated. If the server has trouble keeping up with the request for database searching or new pages, it is a good indication that a more powerful server is needed or the features need to be simplified.

Another consideration is the data throughput from the site. For example, a server that is connected to the website through a T3 line can handle a lot more requests than one running off a cable modem because the pipe that connects the server to the Internet is so much larger. It does not do any good to have millions of hits if you can only supply thousands.

Link Testing

The testing of links from your site to other Web pages is called *link testing*. You probably have visited websites with obsolete links on their pages. Dead links are annoying and lessen the credibility of the site. Fortunately, automated tools perform link testing, moving from page to page on your site, and trying every link they find. If they try a link and do not receive a page in the specified amount of time, they generate an error message that you can follow up on.

If your site has only six such links, then using an automated tool is not worthwhile because you can test them manually with little trouble; however, if your site lists hundreds of links, it would be very time-consuming to test them manually. Automated link-testing tools are quite useful.

WHO CAN TEST

QA testing for programmatic and layout features is a specialized and unique skill, which must be learned. You cannot adequately test a site by giving it to a couple of teenagers to pound away on for a week after school. Proper testing includes designing a comprehensive test plan to ensure that the site has been thoroughly tested. Conscientious and detail-oriented personnel then work the plan. Good software testers are hard to find, and external professional testing services can cost nearly as much as external programming services. Include such testing services in the original project cost estimates, so that the project budget will allow for such expenses.

Outside Testing Companies

Testing companies can develop test plans, help identify platforms for compatibility testing, and test on machines with various display configurations. In addition, they are knowledgeable in providing detailed test reports that isolate and identify defects, so programmers can reproduce them.

Testing is a good task to have performed at least partially out-of-house, through an external organization. Doing some testing out-of-house results in a more independent and objective evaluation. If testing is done in-house, the testers are often under subtle pressure to curtail their efforts or lower their standards so a site can be released on time; however, outsourcing does not absolve in-house development staff from the responsibility for managing the testing process and keeping records. In addition, companies that specialize in such testing provide an essential cross-check of the quality of program code. The more complex and feature-laden a site is, the more reason to have it tested by these experienced, out-of-house personnel.

Uncontrolled Testing

Testing by casual users external to the company, often called *Beta testing*, can be of some limited value. The real world is always more diverse and surprising than even the most thorough test environment. When real potential users start using a site, things happen that the development team would never have expected.

Letting Customers Test

A company that goes live with a site without thorough testing is guilty of gross negligence and will suffer the consequences as the first wave of new users make their feelings known. You cannot subject real users to an untested site without negative repercussions. They expect a site to function reliably and with as much stability as possible.

Sometimes a preview version of the site is announced to select potential users and reviewers in a so-called Beta test; however, this is often done as much for marketing reasons as for product development benefit. The feedback from such casual Beta testers is usually anecdotal at best and is rarely of high enough quality to provide solid test results. Potential customers who are given a preview of the site in exchange for test reports usually validate what professional testers have already found and can at best point professional testers in the direction of possible new defects.

HIGH-QUALITY STANDARDS

Although you can be "realistic" and accept the fact that the site will probably be released with some remaining bugs, this view in no way condones lax quality control standards. You should commit to fixing as many defects as possible before posting a site, even to the point of refusing to post a site that is untested or is known to contain many significant errors. If time pressure is extreme and one or two defects are obscure or relatively harmless, it may be acceptable to post. If a

website contains a misspelling in the main body of the title screen, it may be harmless, but it is certainly not obscure, so it must be fixed. If the same misspelling is buried at the bottom of the page in a picture caption, it might not be severe enough by itself to hold back the whole site. The criteria for when a site is ready for posting and the relative importance of various errors are determined on a situational, case-by-case basis; however, every bug is a potential source of embarrassment that saps the credibility of the website, so try to maintain high standards and not succumb to pressures that would have you post a site before it's ready.

11

Going Live and Beyond

So you've made it through the development process, through testing and debugging, and you are satisfied with the website. You're more than ready. You're dying to go live. Your client is even more eager. Before you flip the switch, however, you may have some planning and preparation, and yes, quite likely some more testing to do. On the technical front, you will address both the server and the Internetworking connections. Also, after you've flipped the switch, you may be scrambling around to make sure all systems are working. You'll continue testing, and make sure you have a techie or two at your side and alert the other team members to carry their pagers.

Launching the site is not an end to the project, but rather a transition from the development phase to the maintenance phase. You or your client will follow many of the procedures described in previous chapters to manage "mini-projects" for maintenance, such as updating and adding new content, and perhaps new features as well. You will continue to test and troubleshoot. Eventually, you will take on major enhancements that qualify as projects themselves.

THE DOMAIN NAME SYSTEM AND IP ADDRESSES

In Chapter 2, we discussed the Internet protocols and how they make it possible for data to move through multiple networks and workstation platforms. The addressing system of the Internet is called Internet protocol (IP). Every machine on the Internet is assigned an IP address. Servers have stable IP addresses, which are a series of number sets separated by dots (e.g., 192.4.153.90). Domain names give a more human interface to IP addresses. If you're in New York City and want to visit One Rockefeller Center, you need to make a mental connection to a street and address to find your way there. Similarly, routers across the Internet need to know where www.nbc.com really is; that is, what IP number it represents. Domain name servers all around the Internet hold records that attach domain names to IP addresses.

When you have a website with a domain name, you actually have two hosting services: (1) the website host that has the server where your Web pages are located, and (2) the domain name host that broadcasts your domain name and the corresponding IP number to the Internet. The domain name host may or may not be the same as your Web host. Your domain name server broadcasts your domain name and the underlying IP number to which it refers to other domain name servers around the Internet, so they know where to find your website and the pages that are being requested.

If you switch your Internet service provider (ISP), your IP number changes as well. At this point, your domain name host must broadcast the new IP number. When you announce a new IP address for an existing domain name, the message is propagated to many different servers. This process of updating and reconciliation all takes place in sites over a complex and intricate series of networks that constitute the Internet. Therefore, although it is "automatic" in a sense, you really should allow up to one week for the new name to take effect across the Web.

If you do not yet have a domain name at the time you're ready to switch servers, do not delay, register today. The process takes some time. Ideally, it's all been taken care of before you're ready to go live.

WHAT GOING LIVE MEANS

When website builders talk about "going live" or "flipping the switch," what they mean is to enable the connection between the domain name and the home page. Many communication links make up the connection between the Web user and your home page file. Each connection constitutes a "switch" that can be "flipped," in order to make the site "go live." Depending on the situation, making these connections properly (i.e., "going live") may range in difficulty from the trivial (just an expression), to a major technical undertaking.

On the simple end of the spectrum, if you have a small "Web presence" site consisting of six static Web pages, you may have already been building it online under your domain name, but simply not publicizing it until it's ready. In this case, because it's already online, all you need to do to "go live" is to decide that you're ready to let the world know you're there. In this case, the term "going live" has little technical meaning.

On the complex end of the spectrum, you may have been building a database-driven website on an internal development server behind your firewall. Now that it's working internally, you move it to the production server so it is accessible to the public outside the firewall. In this case, you'll need to move the site, database applications and all, to a new server, hook up the IP number and domain name, and retest the site on the new server through the live Web architecture. The situation depends on how the site is hosted and the complexity of the

site itself, including version control and features such as e-commerce, database access, and security considerations.

If you don't mind that others might see your site in development, while it is a work-in-progress, then going live is a nonissue. You simply have your ISP host point the domain name to your home page and build your site online. When you're ready to advertise it, simply tell your audience it exists. This situation is analogous to building a retail store, while letting people enter and browse during construction. You may not mind if you are opening a small newspaper stand; however, if you are opening a larger, more complex store with more riding on it—say, a large department store—then letting people in to browse before your store is completed would not work out very well. You want everything set up, working, and staffed by sales personnel before the first customer is let in the door. In the Web world, this means getting your whole site up and running and tested, live, and online before letting Web surfers access it. You can accomplish this goal in various ways.

GETTING READY TO FLIP THE SWITCH

In general, the way to proceed is to build your site "offline" in a way that lets you test it in as realistic an environment as possible. Once you have the site working correctly, you can post it live on the Web for final testing. You should use password protection, though, or not connect the server IP address to your domain name.

To show how this task is accomplished, consider what needs to happen for a Web surfer to connect to a website. Figures 11.1 through 11.3 portray the steps to connecting as links in a chain; they are not network diagrams.

Or, the host server may point the IP number to a dummy home page. When you see an "under construction" home page, you are viewing a dummy page.

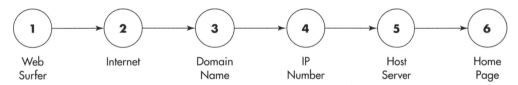

Figure 11.1 Normal connectivity between user (Web surfer) and site home page: 1) the Web surfer enters your domain name into the browser; 2) the request goes out to the Internet in search of the domain name; 3) the domain name is located; 4) the domain name is matched to an IP number (the real Web address); 5) the IP number is matched to the hosting server; 6) the hosting server matches the IP number to the right home page. If any one of these connections is broken, the user will not access your Web page. For example, if the domain name does not point to your IP number, then the user will not be able to get to your site.

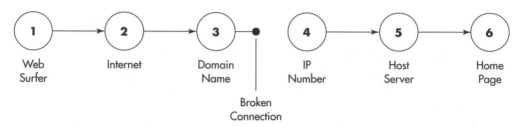

Figure 11.2 Connectivity disrupted because of incorrect matching of domain name (www.domainname.com) and server IP number (xxx.xxx.xxx.xxx). User cannot connect to website home page.

So, basically, to prevent people from getting to your website, all you need to do is break one of these connections. If you are building a website, you can break the link at position number 6. When your site is tested and ready to "go live," you can just reestablish the broken link and the world will be able to view your site. How you "go live" depends on which link is being "unbroken" or reestablished. In the previous example, you simply use a dummy home page to route people until your site is ready. When you are ready, you can connect up to the real home page easily by performing the following tasks:

1. Copying the real home page over the dummy home page.
2. Configuring the server to point to the real home page instead of the dummy home page.

Which option you choose depends on the control you have over the server.

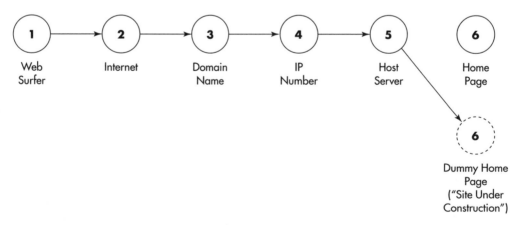

Figure 11.3 Website using dummy home page to route traffic, while real home page is being developed. To make site "go live," simply rename real home page with same name as dummy page (copy over the dummy page with the real home page).

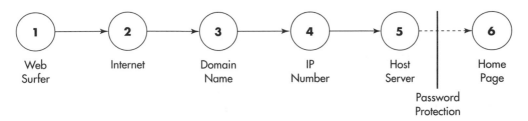

Figure 11.4 Website under construction, with password protection limiting access. Password protection can be removed at any time to make site "go live."

Another way to hide your site while in final preparations is to break the link between the domain name server (3) and the IP number (4) as in the first example. In this situation, you can build your website online, but no one can get to it unless they happen to know the IP number. When you're ready to go live, you simply instruct your ISP to establish the connection between your domain name and the IP number.

The main goal is to have your site working in the real online environment and fully tested, and to have an easy and immediate way to establish the connection (i.e., "flip the switch"). A very convenient way to do this is through password protection (Figure 11.4).

This method actually builds your site online in exactly the position it will remain, which is ideal for development and testing. Anyone who knows the password can get to it for testing and viewing purposes. Once you are ready to go live, you simply remove the password protection and you're open to the public.

HOSTING SCENARIOS

Your development server and your production server may be one and the same, and you may have been developing the site "blind" by using a dummy home page, or not attaching the domain name; however, you may be using an offline development server instead, with the intent of posting it on the production server for public use when the site is finally done. Why would you choose to do so? Following are some scenarios where it would make sense:

1. You have a large, complex website that needs to be built and tested truly offline, not in any way connected to the Web.
2. You already have a website in operation, and you are building new features for it. Obviously, you do not want to build and debug new features on a site that is in active use.

3. You have hired outside developers to build the site. They are working on their own server, with the intent of moving the site to your server when completed.

These three cases, combined with the various kinds of websites and technology in use, can generate many different situations. Regarding going live or adding new features, and the procedures for doing so, far too many situations exist to examine each one; however, let's consider some common situations:

- *A large, database-driven e-commerce site going live for the first time and being developed out-of-house*: In this situation, the site is being developed on a development server (the outside developer's server). Therefore, it needs to be moved over to the production server and tested before the site can go live. A good approach would be to use password protection until final testing and debugging on the production server is completed.
- *A new Java-based game is being added to a Web page on an already live, internally hosted website*: In this situation, the Java game can be placed on a copy of the target page on the live server. The file for the page with the game on it should be renamed and placed on the server in the same directory, so any path or linking information remains valid to the current home page. The page with the game on it can be tested and debugged in place on the live server, without affecting the current page that users are accessing. Once the game page is debugged and final, you can simply revert to the home page file name, overwriting the current page, and the new Java-game home page will be live.
- *You have an existing website and are switching over to a new ISP*: In this case, the domain name/IP address connection is the only real issue. To handle it, start by copying the old site over to the new server, without touching the existing live website. Next, get the IP number of your new site established and test the new site using the new IP number instead of the domain name. When the new site is ready to your satisfaction, ask your ISP to have the domain name switched over to point at the new IP number.

Many development projects involve a transition to a new server. If this is the case, it makes sense to communicate this information with technical personnel who will be maintaining the server, giving them as much lead time as possible. An outside hosting service deals with multiple customers with all kinds of projects going on. In vendor relations, it is a courtesy and often a necessity to give an early heads-up to an outside hosting service. You do not want to be the customer who says, "You'll have the files by 5 p.m., and, by the way, the site needs to go live tomorrow." Even if your service can scramble at your behest, you will have lost goodwill.

The irony is that in an in-house hosting scenario, the technology staff may be much less responsive to your needs. No matter what the internal accounting setup is, it tends not to frame you as a "paying customer" in the same way a vendor–client relationship does. A fact of organizational life is that projects are often prioritized by the status of the requester rather than by business objectives. In short, the project manager is called on again to use interpersonal skills and political acumen in this transition to a new server. You absolutely have to be on top of some technology issues here; but don't kid yourself, it takes people to make it work.

Internal technology personnel hold the keys to the kingdom. No matter what their position in the company hierarchy, they hold power over what goes on the machine. They also tend to be territorial about it. Communication as early as possible is important to gain their buy-in on the project. The technical specification is a key document for this communication. If you've kept the document current during the development, it will give technology staff a good idea of the technical requirements and the issues involved in making the site work.

PREPARING THE SERVER AND NETWORK

As previously mentioned, the goal in preparing the server is to get the site running on the live server, just as you want it to, before switching over the domain name. You will have made every attempt to mirror the environment of the production server when you set up the development server. Ideally, the new server to which you are moving the site uses the same operating system platform and version. If not, before you do anything, you should make the appropriate upgrades or installations to match the environments. Nonetheless, hardware and peripheral conditions are unlikely to be identical. Variations such as a different amount of memory or installed drivers will affect how your site runs and may cause bugs or conflicts.

You will also need to prepare the network for the new website. What exactly will be required depends on the hosting scenario. Whatever the arrangement, you will have to announce your domain name and IP address to the world, as described earlier. You can post a dummy or "under construction" page as the highest-level page (or index.html) on your site, and test it on various computers outside your host network to see if the new domain name and IP address are working properly.

Routers connect your network to the rest of the Internet. Depending on the level of security and authentication in your technical specs, you may also be using firewalls or proxy servers. A complex website may reside on several servers. For example, an e-commerce site may run the shopping basket and credit card verification portions of the site on a separate server running the appropriate software, while content pages of the online catalog reside on another server.

All of this hardware and software must work together. You may have conducted thorough testing on the development server, but now that the site is on the production server, you've gone and changed everything. So, it's time once again for testing.

MORE TESTING

When the new files have been moved over to the server, you're ready for the "final walk-through" for the site. You should run a check on everything you can think of, including such items as the following:

- making sure that all content is in place and meets quality standards (e.g., typos, spelling, grammar)
- checking currency of links
- ensuring that file names and page titles are correct and consistent
- checking that all images are in place, properly tagged, and conform to your specs
- testing software
- verifying backup and support procedures

The need for thoroughness in all of these checks cannot be emphasized strongly enough. Everything you've learned about the importance of first impressions applies equally to a website. Disappointed users will leave your site with a negative impression of your organization, and they won't be coming back to see how you fixed everything.

Follow the software testing process outlined in the previous chapter. One type of testing that merits particularly close attention at this stage is load testing. You are on your production server now. Therefore, the conditions that determine your system's capabilities in responding to heavy traffic are set, and you're nearly live. In general, you should analyze how the switchover affects every aspect of the site. What is most affected should be the most thoroughly tested after the transition. Do your best in testing and thinking through what will happen when real users are working the site. It is a time to anticipate, to make contingency plans, and to arrange for backup and support.

FLIP THE SWITCH AND BE ON ALERT

So, here we've come at last to the moment of truth, otherwise known as "flipping the switch." Make the appropriate connection, then stand ready and watch closely what unfolds. You can expect problems. Going live is the ultimate reality

check. It will flush out any problems or mistaken assumptions with the site. Unfortunately, as much as you try to anticipate, it's hard to foresee exactly what problems will arise. Don't panic or be discouraged when problems occur. All you can do is gather the force to respond to whatever arises. You better hold off on your launch celebrations for a while. Problems come in the following four varieties:

1. content errors
2. technical problems
3. user interface problems
4. back-office problems

Content errors are problems with the information provided on the site, including inaccuracies, outdated information, graphics, and so forth—anything that is working correctly but is not providing the correct information or display.

Technical problems are self-explanatory and depend on the kind of technology being used by your site. Any kind of technology in use on your site is a potential candidate for technical problems, including things you would not think of until they happen (e.g., database problems, server problems, domain name problems, case-sensitivity on UNIX). Although you don't know what exactly may come your way, you can still prepare for it. Your technical lead should be responsible for assembling a quick-response team. Requirements for the size of the team and its collective skillset depend on the site itself. Once again, the technical specification can guide your planning here.

User interface problems are those that users encounter while finding their way around and using the features on your site. It's difficult to anticipate these problems ahead of time, and there are always surprises. Things that look perfectly obvious to you and your Beta testers may completely confound the casual visitor to your site. Meanwhile they may sail through other things that seem confusing to you. You will probably get most of your feedback on user interface problems from e-mail from users. Remember that for every such comment you receive, dozens of other users have probably experienced the same thing but didn't take the time to tell you. Pay special attention to feedback from users. They are why you're creating the site in the first place.

The back-office process is what happens offline in response to users who visit your site. At its essence, a website is an interface between your organization and its customers. The interaction that takes place on your website often demands a response process that happens offline, which is what we mean by a back-office process.

One of the private delivery services runs a television commercial showing a website launch. Several young Gen Xers stand around a computer monitor watching a counter. They smile as the first few visitors hit the site. They grin with

satisfaction as the counter keeps rolling. They've hit their target. The counter keeps rolling faster and faster, and glee in their faces turns to dread as they realize that the site is generating more business than they can handle—too much of a good thing. The back-office process being advertised is a shipping service.

Most e-commerce transactions of bits eventually come to the point where the vendor ships something physical, but this is just one common example of a back-office process. Many sites strive to establish a one-on-one customer dialog, but it's not automated all the way. If you create expectations for a phone call or e-mail response to the customer, a back-office process has to make it happen. At the time of the launch, you should be benchmarking offline as well as online performance.

PLANNING FOR MAINTENANCE

Before your site ever goes live, you need to consider what will be involved in keeping it functional and current. The Internet is littered with sites that have gone stale from neglect. Accountability is key here. Clearly designate a person who is responsible for maintaining the site and give that person the resources to do so. Maintenance is a sort of ongoing project, or a series of "mini-projects," and the three project dimensions of time, task, and resources still apply. Few of the stale sites on the Internet were launched with the thought that the work was done and the site would not change. So what happened?

To find the answer, ask questions about the three tenets of project management. Organizations that are fairly new to the Web may underestimate what's involved in maintaining the site. They go outside the organization and hire a vendor to the site, thinking that once development is completed, they can handle the more modest requirements of maintaining the site. While surely the maintenance is a less intensive process than the development of the site, it is slow, steady, ongoing, and not going away. It must somehow get done. Therefore, the process must be institutionalized into the work of the organization. If you hear vague plans like "so-and-so will take care of things during their downtime," you can be sure nothing will happen. The maintenance plan, therefore, begins in the following predictable fashion:

1. *Task*: Define the task. What are the expectations for new content? What maintenance or updating tasks will need to be done? How will the site performance be monitored and tested?
2. *Time*: What are the schedule and cycles for maintenance? What tasks will need to be done daily? Weekly? Monthly?
3. *Resources*: What is the budget for maintenance? Who will be assigned to do it? Do they have the skills? What other obligations do they have? How much of their time can be dedicated to the website?

Maintenance falls into the following two general areas: technical and content. The technical issues of maintenance are essentially an extension of the testing process. Yes, more testing. (Did you think you were finished testing? Hint: You're never done testing.) When new content and features are added, or when changes are made to server software or to the network, you'll need to retest the appropriate areas of the site.

The most fundamental technical issue is keeping the connection live so your site is online and connected to the Web. Sometimes you try to call up your site to test it, and there is a problem accessing it. You may initially assume that there is a problem with your server, but this may not be the case at all. There are many links in the chain connecting your computer to your website, any one of which may be broken, as follows:

- your computer
- the connection to your ISP (dial-up or network)
- your ISP's connection to you
- your ISP's connection to the Web
- your Web host server
- your Web host server's connection to the Web
- your domain name host's IP information

ILLUSTRATION OF THE CONNECTION

You should have a system in place to monitor your connection. You can purchase various software programs and services to provide ongoing testing at regular intervals. These programs and services usually use "ping" testing to check that your server is responding. In ping testing, the testing program sends out packets to a Web address and measures the time it takes for a packet to return, in effect testing the presence of a host and the connection with the client. If there is a delay or no response at all, you are alerted either via an e-mail or a pager call. If you get a call, you'll need to start troubleshooting.

Not only does troubleshooting require significant technical skill and knowledge, but you must also be meticulous in your record-keeping and track all problems that have been reported and their status, whether fixed or open. Testers usually use a database to facilitate this process.

INTEGRATING WITH OPERATIONS

Maintaining content is not as complex as troubleshooting, but it is probably much more time-consuming because you do it continually. When the Web was young, people accustomed to print production, such as magazines, often felt a sense of release with Web publishing. No longer were they slaves to the publishing cycle's

steady diet of deadlines. Their content would drive the updates; however, in time, most sites that use the Web for publishing in the strictest sense of the word stick to a regular update schedule. The large content-driven sites update daily. Just about any site will want to plan for at least one area with dynamic content; however, few static sites are planned that way. A more common problem is to be overambitious in the initial analysis of the site, only to discover after launch that it's more than you can maintain. During the analysis process, you thought long and hard about why your customers would want to visit your site and what they would do there. Don't disappoint those who return to see what's new—they're looking for fresh content. Prudent project managers build the content updating into the processes of the business in some way.

Website strategies and operations go hand-in-hand with marketing. Once you're up and running, maybe even beforehand, you'll want to be marketing the site. Website domain names are now routinely incorporated into a company's advertising campaign. Buying banner ads probably works only if you have an established brand and a budget that can buy into the most heavily trafficked sites on the Internet; however, sites with small niche target audiences may find more reasonable outlets. In general, a Web ad model that satisfies both advertising purchasers and sellers has yet to evolve. Generally speaking, the website should be integrated into your full marketing mix. Send out press releases for the launch. Print the domain name on business cards. Encourage employees to use it in their signature lines. Plan an event. Run a contest. Many websites fall under the control of marketing. Even if yours is not, get marketing involved.

You will want to attempt to get your site listed in directories and identified by search engines. You should study how search engines work and what you can do to improve your site's chances of turning up in searches. For instance, metatags give you the opportunity to index the site with keywords that don't show up on the Web page itself, but are identified by some search engines. Your marketing people should get the news out about your site to any customers, partners, stakeholders, industry directories, and anyone who might possibly link to your site.

Websites inherently collect loads of data about users. Through Web logs and software to manage them, you can analyze your users' activities in many ways. In so doing, you can collect data that help you improve the design and technical performance of the website.

Aside from such usage data, website functions may be based on data collection. For instance, many companies are experimenting with e-mail marketing as a low-cost method to communicate with customers. Most are based on an "opt-in" method. Users identify themselves as wanting to receive future messages or information about the company. Many sites offer a free e-mail newsletter or alerts to new content on the site, which is an example of "opt-in" marketing. The foundation of this marketing tactic is collection of data from the customer. Through the software of the Web, the customer is creating or updating records on a back-

end database. The company must extract this data in order to market, and it may have other uses that extend further than the specific request. During the analysis and design phases, you made decisions about what data would be collected. To be effective, these strategies depend on successful integration of that data into the organization's operations. For example, if you collect the e-mail addresses of website visitors, then you might as well be doing something with them.

The collection of customer information can be controversial, touching on social and political aspects of information privacy. Some privacy advocates are lobbying for legislation that restricts what information can be collected and establishes rules on how it can be used. Industry groups suggest self-regulation in response. It has become standard for companies to post some sort of privacy statement that discloses what sort of information is being collected and how it might be used.

ENHANCEMENTS

Eventually, "mini-projects" will spring from the routine content updates and technical fixes of maintaining the website. Troubleshooting and debugging might lead to ideas for new software and functionality. Customer feedback may lead to many changes that go beyond what would be called maintenance, such as the following:

- Creating new sections.
- Reorganizing existing sections.
- Restructuring the site.
- Revising navigation bars or other graphical interface elements.
- Adding new, database-driven features.

Perhaps, from the outset you have planned your website to develop in stages with new functionality scheduled for introduction several months after launch. Websites tend to evolve through user interaction. Eventually, you'll want to respond to what's happening on your site and give customers more of what they like or perhaps simply a fresh, new look.

If what you have planned is a complete overhaul of the site, then you're back to square one; however, even if your enhancement project is minor, you should follow the phases we have described: analysis, design and prototyping, build-out, and testing.

The smaller the project, the more quickly you will be able to move through the phases. The two you may be tempted to skip on a "mini-project" are analysis and testing—Don't! Even with small projects, the failure to analyze and plan will cost you in the long run. Know where you are going before you set out. If your changes are mostly to content, such as new graphics or text, you may deem

testing to be unnecessary, but software can be quirky, and it's best to run the new site through the drills anyway. Because the browser software controls so much of the way your pages display, it's especially important that even content changes are tested in the various versions of the popular browsers. Any change to your site can cause unexpected repercussions. You'll want to continue the testing, once your mini-project goes live.

WHAT NEXT?

We are all looking for fame and glory on the Web, aren't we? Oh, and riches too. With any luck, your site will meet with great success. Your planning for scalability will come into play then. The reward for your success may be greater resources from your organization—larger budgets or additional staff. Success brings challenges, too. If your traffic skyrockets, you'll need to stay on top of your server technology as well as your backend response to the customer activity. You may want to review your hosting options, perhaps moving to a dedicated server with your ISP or bring the server in-house. Whatever ensues, your project management skill will come into play.

Appendix 1

Recommended Resources

BOOKS

Burdman, Jessica. *Collaborative Web Development: Strategies and Best Practices for Web Teams.* Reading, MA: Addison-Wesley, 1999.

DeMarco, Tom, and Timothy Lister. *Peopleware: Productive Projects and Teams,* 2nd ed. New York: Dorset House Publishing, 1999.

Humphrey, Watt S. *Managing Technical People: Innovation, Teamwork, & the Software Process.* WEI Series in Software Engineering. Reading, MA: Addison-Wesley, 1997.

Lewis, James. *How to Build and Manage a Winning Project Team.* New York: AMACOM-American Management Association, 1993.

Maguire, Steve. *Debugging the Development Process.* Redmond, WA: Microsoft Press, 1994.

McCarthy, Jim. *Dynamics of Software Development.* Redmond, WA: Microsoft Press, 1995.

McConnell, Steve. *Rapid Development.* Redmond, WA: Microsoft Press, 1995.

Nielsen, Jakob. *Designing Web Usability: The Practice of Simplicity.* Indianapolis, IN: New Riders Press, 2000.

Rosenfield, Lou, and Peter Morville. *Information Architecture for the World Wide Web.* Sebastopol, CA: O'Reilly & Associates, 1998.

Rosenthal, Stephen R. *Effective Product Design and Development: How to Cut Lead Time and Increase Customer Satisfaction.* Burr Ridge, IL: McGraw-Hill Professional Publishing, 1992.

Shneiderman, Ben. *Designing the User Interface: Strategies for Effective Human-Computer Interaction.* Reading, MA: Addison-Wesley, 1998.

Siegel, David. *Secrets of Successful Web Sites: Project Management on the World Wide Web.* Indianapolis, IN: Hayden Books, 1997.

Smith, Preston G., and Donald B. Reinertsen. *Developing Products in Half the Time: New Rules, New Tools,* 2nd ed. New York: John Wiley & Sons, 1997.

Whitaker, Ken. *Managing Software Maniacs: Finding, Managing, and Rewarding a Winning Development Team.* New York: John Wiley & Sons, 1994.

WEBSITES

Browserwatch: browserwatch.internet.com
Cyberatlas: cyberatlas.internet.com
Domain Name Buyer's Guide: www.domainnamebuyersguide.com
Project Management Institute: www.pmi.org
Serverwatch.com: serverwatch.internet.com
useit.com (Jakob Nielsen's Website): www.useit.com
Web Review: www.webreview.com
World Wide Web Consortium (W3C): www.w3c.org

Appendix 2

The Proposal Process

TIPS FOR A SUCCESSFUL PROPOSAL AND BID PROCESS

The following minimum information should be included in a request for proposal:

- project overview
- analysis of site and anticipated audience needs
- functional requirements
- technical requirements
- scheduling requirements
- performance criteria

Do:

- Consider the fit with your potential partner in the client–contractor relationship.
- Describe in detail and comprehensively what you want in a site, using plain language and no technical smokescreens.
- Be as brief as possible, while still covering all the major points, and write with clarity.
- Write an RFP that reads like a good business plan, presenting expected outcomes, willingness to invest, and technology resources.
- Align the effort required to respond to the RFP to the size and scope of the project.
- Get at least a ballpark estimate of the budget and timeline before responding to an RFP.
- Get whatever other information is reasonable from the other party before responding to an RFP or evaluating a response.
- Know when to walk away.

Don't:

- Be overly restrictive in RFP requirements.
- Present "bleeding-edge" features as requirements.
- Assume that big companies will work only with big development houses; or small companies with small houses.
- Ask for free consulting from a developer.

- Be in any way unethical or dishonest in using RFPs, such as writing specs that only one supplier can fulfill but sending them to others for the sake of appearances.
- Send RFPs to an overly large pool—sending a few recommended vendors is sufficient and actually as many as a client can reasonably handle if vendors pursue informed and substantive replies.

Factors to consider in evaluating proposals:

- technical qualifications of developer
- approach to the website
- recommendations and references
- compatibility of development tools with in-house resources and expertise
- presentation and thoroughness of proposal
- prior experience
- quoted price
- firm's resources and personnel

Purpose of agreements:

- Limits liabilities.
- Warrants and assigns or retains intellectual property rights.
- Clarifies the roles and deliverables.
- Sets a timetable.
- Defines task or scope.
- Establishes payment and terms.

Minimum requirements of a legally valid contract:

- valid offer
- valid acceptance of the offer
- consideration

SAMPLE EXCHANGE OF DOCUMENTS BETWEEN CLIENT AND CONTRACTOR

Client: Winding Trails, book publisher for the National Cycle Club
Contractor: Jane Developer, Twin Oaks Web Development

In this fictional example, the client and contractor have worked together in the past. The proposal process is not being used to qualify or select the contractor, but rather to define the project and come to terms. The project is a small one, consistent with what this book described as a "simple Web presence."

Disclaimer: Sample Agreement is presented only to illustrate typical issues addressed in an agreement. It is not supplied as a template for reader's agreements. We encourage readers to seek legal counsel in drawing up agreements.

Project Description: Winding Trails Website

1. Design of Web home page for Winding Trails, the publishing arm of the National Cycling Club (NCC).
 - Create splash graphic derived from the Winding Trails logo.
 - Design simple template for pages the next level down.
2. Development of templates and graphics for Reading Trails Website.

Winding Trails Home Page

For the home page, Winding Trails seeks a visual image with four navigation points on the home page. The "front door" of our Web presence, the page will welcome users with an image only, along with text links to navigational choices, and present four options for further exploration.

1. About Winding Trails. Will link to document(s) with mission statement, brief history, bios of staff.
2. Publishing with Winding Trails. See material on current website as representative examples: proposal guidelines, FAQs about publishing process, and similar information.
3. NCC Online Store, which sells Winding Trails books as well as other products of interest to cyclers.
4. Reading Trails. Redesign of existing promotional site.

The home page splash should use our logo integrally and create visual connections to the graphics of Reading Trails and the online store.

Winding Trails will be where we pour all our content to generate interest in our publishing program. The online store is our place for e-commerce. Design should give those two navigational choices the appropriate prominence. About Winding Trails will be static basics. Publishing with Winding Trails is important, but only to a niche of our website audience—writers.

Reading Trails

Goal:
Our goal has been an image thing. Websites give surfers a quick read on the personality, creativity, and usefulness of an enterprise. Winding Trails serves a niche market. Reading Trails is the place where bicycling junkies and newbies alike can read about their sport from some of its most skilled and knowledgeable practitioners. They can see what Winding Trails is up to, who the players are, and what opportunities there are for themselves. It will draw on the common interests of the cycling community, presenting practical content drawn from our books in an engaging, informal way. As we pour in more content, we hope the site will evolve beyond image into a rich and useful information resource for serious cyclists.

Metaphor:
Winding Trails is a publisher of books, and the proposed main categories of Reading Trails for the most part expands on the metaphor of the publishing process: direct excerpts from books; drafts of manuscript shown before publications; updates and expansion of content of the book.

Organization:
Riding Trails content will be organized in the four main areas.

1. Writers: News items about authors. Author websites with annotations. Races or other events where authors will be participating. Announcements of new projects in progress.
2. Inside the Covers: Direct excerpts from books organized by category. Each page will indicate the category, but design elements should be the same in this section regardless of category. The categories therefore serve as an index/browsing function.
3. Beyond the Book: Links to websites perhaps on our server or off-site that expand and update the content of a book. Possible partnering with travel sites for regional touring trail books.
4. The Editor's Shelves: Draft material posted and readers invited to e-mail feedback. (Perhaps forms with JavaScript). This material would come and go and would not be archived for longer than a few months.

Content will usually be in the form of excerpts that will be approximately 500–1,000 words. Longer pieces would be broken down into discrete pages that are "continued" with links. We may also want to post full chapters that are PDF files of published books, available for download or online reading with Acrobat Reader.

Each category should have an icon that serves as a visual cue telling readers where they are. To a certain extent, these four categories should have a distinct look, while still remaining consistent among each other. Backgrounds are okay but should be subtle. Reading Trails will be a mostly text site, so readability is a critical factor.

Each category should have two templates:

1. A navigational page, which will tout "current" features. Below these new listings, archived articles would be listed, organized by category.
2. A destination page, the articles themselves. As indicated, longer articles would be broken into pages.

While we are requesting eight templates covering these categories, the class of templates "navigational" or "destination" will be very similar among categories. The graphics (icons) will serve as the identifiers of category.

Each book excerpt will end with a thumbnail of the cover of the book and with the image and text title linked to the book's catalog entry in the store.

Searching/Browse

We would like a page that lists the content on the site by book category (e.g., under bicycle maintenance, all content would be listed, whether they are from "Beyond the Book" or "Inside the Cover" pieces). The NCC site uses the Excite Search engine, which could be configured to search our directory only. This will be coordinated with in-house technology staff. I mention it here for whatever guidance you can offer from past experience for design pages that facilitate efficient searching in Excite.

NCC Design Guidelines

- Background is attached, from various Web design guidelines.
- The site will reside on a Microsoft NT platform running parts of which will use Active Server Pages.
- The NCC pages follow a template created with a server file call. The Winding Trail home page will be in the template as well as other informational pages in "About" and "Publishing with Winding Trails" sections. The Riding Trails site will not be in these templates but should be designed with some consistency to the rest of the NCC site.

Budget

Under $10,000.

Schedule

We can be flexible. Most of our content still has to be gathered, so we need time before development starts. Would like to have some templates to work with in late December. We don't anticipate having a new site up until late February.

Attachments

URLs for reference
Sample design pieces

PROPOSAL: READING TRAILS/WINDING TRAILS WEBSITE PROJECT

Background

The National Cycling Club (NCC) wishes to create a website for the Winding Trails publishing imprint, including a home page and associated screens; also including a subsite entitled Riding Trails, as described in the NCC document "Project Description: Reading Trails Website" (attached).

The NCC has requested a proposal from Twin Oaks to design and develop Web pages for this National Cycling Club/Winding Trails site. Responsibilities include screen design, graphic arts development, and Web page authoring.

Apart from the Reading Trails subsite, screens must be designed to fit the NCC template in use. This template makes use of Microsoft NT Active Server Pages technology to provide predetermined HTML frame templates in which to display the Winding Trails/Reading Trails site pages.

Description

The site will consist of approximately 17 screens and page templates, with associated graphics, as shown on next page.

Template	Number of pages
Winding Trails home page	1
About Winding Trails page	1
Publishing with Winding Trails page	1
Reading Trails home page	1
Writer's page	1
Writer's templates	2
Inside the Covers	1
Category templates	2
Beyond the Book page	1
Beyond the Book—2 templates	2
Editor's Shelves page	1
Editor's Shelves—2 templates	2
Search page	1
Total	**17 pages**

Personnel

The graphic artist to be assigned to this project is Steve Tilson, an experienced Web designer with more than 10 years of experience designing graphics for interactive and multimedia applications, including the NCC Online Store. He also designed websites for WKRP Radio, BigBiz Studios, and numerous corporate intranet sites. In addition to Web and multimedia design, his background includes design and graphics for print and video. Skills include many graphics and Web development tools, including Adobe Photoshop, Illustrator, Dreamweaver (HTML authoring), Debabelizer, and more.

Process

Our first goal will be to establish a visually appealing design treatment (look and feel) for the website, to serve as a basis for individual screen layouts. Twin Oaks Development will present Winding Trails with a selection of three alternative initial design treatments, from which Winding Trails may choose their preference and provide feedback for modifications. Twin Oaks will then revise the design treatment until it meets with Winding Trails' approval.

Having established the main graphical treatment, the individual screens will be designed and associated graphics created. These will be reviewed by Winding Trails for visual appearance and also to ensure that they can be implemented within the architecture and technologies of the NCC site. Twin Oaks will then make any necessary revisions or modifications, and provide them to Winding Trails for incorporation in the greater NCC site.

Schedule

Design Kickoff meeting *(within one week following contract signing)*	Day One
Initial home page design concepts presented *(Feedback then provided by Winding Trails)*	2 weeks after Day One
Home page design revision delivered *(Approval then provided by Winding Trails)*	2.5 weeks after Day One
Remaining screens presented	4 weeks after Day One
Final screens delivered *(Approvals then provided by Winding Trails)*	6 weeks after Day One

Schedule may vary according to Winding Trails requirements and workflow.

Cost/Hours Estimate

	Hours	*Cost*
Home page approved	24	$1,920
Remaining screens presented	40	$3,200
Remaining screens approved	28	$2,240
Total		**$7,360**

Assumptions

- The number of screens and their functions is accurate and will remain approximately constant through the duration of the project.
- Web page authoring will deliver standard HTML suitable for the display of static Web pages. Any HTML coding necessary for incorporating in any NCC Web technology will be provided by NCC staff upon delivery of final screens by Twin Oaks.

At Twin Oaks, we appreciate the opportunity to make this proposal. We look forward to working with Winding Trails and the NCC to deliver an attractive, functional, and effective Web design.

WEBSITE DEVELOPMENT AGREEMENT

This Website Development Agreement dated as of _____ , 200__ ("Effective Date") is between Jane Developer, of Twin Oaks, Inc. ("TO"), with an address at 101 Main St., Chicago, IL 60006, and the National Cycling Club ("NCC") with an address of 40 Peach Blvd., Sheboygan, WI 54001.

Under this Letter of Agreement, TO will provide project management and website design and development services to NCC to develop the Winding Trails Home page and subpages, including the Reading Trails Website.

Ownership and Copyrights

Any and all of the materials produced by TO in the course of the project shall belong exclusively to NCC, and are considered Works for Hire.

Confidential Information

Information exchanged in the course of this project will be treated as confidential by TO, and not divulged to any third party, without prior written agreement.

Representations

TO makes the following ongoing representations and warranties:

A. TO has full legal rights to perform services assigned herein.
TO warrants to NCC that materials produced are original and that TO is the sole proprietor of the materials and of the copyright therein and has full power to enter into this agreement. If any part of the material is not original, TO shall obtain permission for use of the material on the NCC Website.
B. TO is not under, and will not assume, any obligation or restriction that prevents TO from performing its obligations as assigned in this Agreement.
C. TO will work with NCC technical personnel, as instructed and determined by NCC.

Deliverables

1. Reading Trails Prototype Website
To consist of nongraphical (text only) sample pages, showing proposed linking, site navigation, and sample content.
2. Design Concept Alternatives
To consist of several design alternative image files for use in establishing a graphical design treatment for the overall Reading Trails Website.

3. Final Reading Trails Website
 To consist of approximately 20 Web pages and page templates, including:
 - Winding Trails Home page
 - About Winding Trails
 - Publishing with Winding Trails
 - Main Reading Trails page
 - Site Map
 - Search Engine (page)
 - Writers
 - Writer News
 - Writer Websites
 - Works in Progress
 - Dialogue
 - Beyond the Book
 - Webliographics
 - Inside the Covers
 - Inside the Covers—Excerpts
 - Inside the Covers—Excerpts—Continued
 - PDF Directory
 - Manuscript
 - Manuscript—Excerpts
 - Manuscript—Excerpts—Continued

Deliverables include all graphics, logos, banners, and navigational elements required for these pages.

Assumptions

- Text content and written copy will be provided by NCC.
- NCC will provide support regarding any technical specifications required, and NCC personnel will post pages to NCC Website.

Payment

NCC will pay TO at a rate of $80 (eighty dollars) per hour for work performed. It is estimated that the project, as currently specified, will require approximately 100 hours of development time.

Anticipated Schedule

Deliverables will be provided according to the following schedule, subject to NCC requirements and project workflow.

Deliverable	Scheduled
Web Site Prototype	1 week after signing this letter
Graphical Design Alternatives	3 weeks
Final Website	7 weeks

By signing below, the parties agree to the terms of this Agreement.

ACCEPTED AND AGREED TO: ACCEPTED AND AGREED TO:
TWIN OAKS, INC. WINDING TRAILS, INC.

By: _____ By: _____
 Authorized Signature Authorized Signature

Name: _____ Name: _____

Title: _____ Title: _____

Date: _____ Date: _____

Appendix 3

Integrated Product and Process Development

Modern project management has its roots in the 1950s Cold War defense programs. Only fairly recently has the discipline transcended its beginnings in major aeronautic or construction projects to be applied in businesses of all types and sizes. Some assert that the Web changes everything, and the old rules don't apply—certainly not models from a hierarchical, linear organization like the Department of Defense. Not true. The following document describes a team-based, customer-focused systems engineering process called integrated product and process development. The document not only validates the ideas of this book, but also identifies best practices that are directly applicable to website development.

Integrated product and process development (IPPD) is a widely defined management technique normally implemented by integrated product teams (IPTs). IPPD is currently in growing use in many commercial and government organizations. This guide has been written to serve as a primer for the Defense Acquisition Workforce to foster, facilitate, and understand the use of IPPD. Its focus is how industry implements IPPD and how this impacts the DOD's role in the acquisition process and the program office interfaces with their industrial counterparts. It is a nondirective, living document that contains industry and government best practices acquired from a survey regarding IPPD implementation.

IPPD CONCEPT

The DoD defines IPPD as "a management process that integrates all activities from product concept through production/field support, using a multifunctional team, to simultaneously optimize the product and its manufacturing and sustainment processes to meet cost and performance objectives." IPPD evolved from concurrent engineering and is sometimes called integrated product development (IPD). It is a systems engineering

From *DoD Guide to Integrated Product and Process Development*, Office of the Under Secretary of Defense (Acquisition and Technology), 1996.

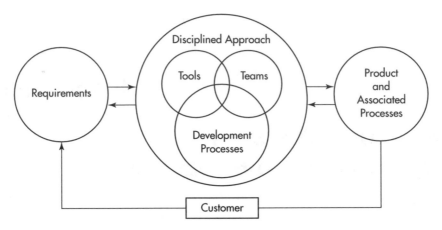

Figure App 3.1 A generic IPPD iterative process.

process integrated with sound business practices and common sense decision making. Organizations may undergo profound changes in culture and processes to successfully implement IPPD.

IPPD activities focus on the customer and meeting the customer's need. In DoD, the customer is the user. Accurately understanding the various levels of users' needs and establishing realistic requirements early in the acquisition cycle is now more important than ever. Tradeoff analyses are made among design, performance, production, support, cost, and operational needs to optimize the system (product or service) over its life cycle. In order to afford sufficient numbers of technologically up-to-date systems, cost is a critical component of DoD system optimization. Cost should not simply be an outcome as has often been the case in the past. Thus, cost should become an independent rather than dependent variable in meeting the user's needs.

Although there are common factors in all known successful IPPD implementations, IPPD has no single solution or implementation strategy. Its implementation is product and process dependent. A generic IPPD iterative process is shown in Figure App 3.1.

Resources applied include people, processes, money, tools, and facilities. The IPPD process reorders decision making, brings downstream and global issues to bear earlier and in concert with conceptual and detailed planning, and relies on applying functional expertise in a team-oriented manner on a global-optimization basis. It is necessary to understand early the processes needed to develop, produce, operate, and support the product. Equally important are these processes' impacts on product design and development. Basic elements of the iterative process are:

- *Requirements*: a first step in the iterative process, are generated by the customer in a negotiation among many parties, each with serious and important concerns. Knowing and understanding the customers (command structure, doctrine, tactics, operating environment, etc.) and their needs is essential. Integrating the user's requirements, logistical requirements, and the acquirer's budgetary and scheduling constraints is a fundamental challenge in DoD acquisition.

- *Disciplined Approach* includes five general activities: (1) understanding the requirements, (2) outlining the approach, (3) planning the effort, (4) allocating resources, and (5) executing and tracking the plan. Decisions made using this approach should be reevaluated as a system matures and circumstances (i.e., budgetary, threat, technology) change. A disciplined approach provides a framework for utilizing tools, teams, and processes in a structured manner that is responsive to systematic improvement efforts.
- *Tools* in this IPPD process include documents, information systems, methods, and technologies that can be fit into a generic shared framework that focuses on planning, executing, and tracking. Tools help define the product(s) being developed, delivered, or acted upon, and relate the elements of work to be accomplished to each other and to the end product. Examples of tools used include integrated master plans, three-dimensional design tools and their associated databases, cost models linked to process simulations/activity-based costing, development process control methods, and earned value management.
- *Teams* are central to the IPPD process. Teams are made up of everyone who has a stake in the outcome or product of the team, including the customer and suppliers. Collectively, team members should represent the know-how needed and have the ability to control the resources necessary for getting the job done. Teams are organized and behave so as to seek the best value solution to a product acquisition.
- *Development Processes* are those activities that lead to both the end product and its associated processes. To ensure efficient use of resources, it is necessary to understand what activities are necessary and how they affect the product and each other. Examples include requirements analysis, configuration management, and detailed design drawings.
- *Product and Associated Processes* include what is produced and provided to the customer. Customer satisfaction with the product, in terms of mission effectiveness, as well as operating and support aspects and costs, is the ultimate measure of the team's success.
- *Customer* is the user and a team member and also the ultimate authority regarding the product. Any changes to the formal requirements driving the product/process development must come through negotiation with the customer.

This generic IPPD iterative process is a systems engineering approach. It differs from the long-held view that systems engineering is essentially a partitioning, tradeoff, control process that brings the "-ilities" and test functions together. This IPPD process controls the evolution of an integrated and optimally balanced system to satisfy customer needs and to provide data and products required to support acquisition management decisions that, themselves, are part of the IPPD/IPT process. This approach also transforms the stated needs into a balanced set of product and process descriptions. These descriptions are incrementally matured during each acquisition phase and used by DoD and its contractors to plan and implement a solution to the user needs. This process balances cost, system capability, manufacturing processes, test processes, and support processes, as identified in DoD Instruction 5000.2.

The IPPD process is an integrated team effort within DoD and contractor organizations and with each other. DoD crafts the basic acquisition strategy, almost always

with industry assistance. Contractors usually play a significant role in development, design, and manufacturing with DoD in a management role. Both participate in each other's major activities through team membership, and the implementation and use of tools and technology.

IPPD KEY TENETS

To implement IPPD effectively, it is important to understand the interrelated tenets inherent in IPPD. These key tenets, as follows, were outlined by the Secretary of Defense mandate on IPPD and are consistent with those found in industry.

Customer Focus

The primary objective of IPPD is to identify and satisfy the customer's needs better, faster, and cheaper. The customer's needs should determine the nature of the product and its associated processes.

Concurrent Development of Products and Processes

Processes should be developed concurrently with the products they support. It is critical that the processes used to manage, develop, manufacture, verify, test, deploy, operate, support, train people, and eventually dispose of the product be considered during product design and development. Product and process design and performance should be kept in balance to achieve life-cycle cost and effectiveness objectives. Early integration of design elements can result in lower costs by requiring fewer costly changes late in the development process.

Early and Continuous Life-Cycle Planning

Planning for a product and its processes should begin early in the science and technology phase (especially advanced development) and extend throughout every product's life cycle. Early life-cycle planning, which includes customers, functions, and suppliers, lays a solid foundation for the various phases of a product and its processes. Key program activities and events should be defined so that progress toward achievement of cost-effective targets can be tracked, resources can be applied, and the impact of problems, resource constraints, and requirements changes can be better understood and managed.

Maximize Flexibility for Optimization and Use of Contractor Approaches

Requests for Proposals (RFPs) and contracts should provide maximum flexibility for employment of IPPD principles and use of contractor processes and commercial specifications, standards, and practices. They should also accommodate changes in requirements and provide incentives to contractors to challenge requirements and offer alternative solutions that provide cost-effective solutions.

Encourage Robust Design and Improved Process Capability

The use of advanced design and manufacturing techniques that promote (1) achieving quality through design, products with little sensitivity to variations in the manufacturing process (robust design), (2) a focus on process capability, and (3) continuous process improvement are encouraged. Variability reduction tools such as ultra-low variation process control similar to "Six Sigma" and lean/agile manufacturing concepts should be encouraged.

Event-Driven Scheduling

A scheduling framework should be established that relates program events to their associated accomplishments and accomplishment criteria. An event is considered complete only when the accomplishments associated with that event have reached completion as measured by the accomplishment criteria. This event-driven scheduling reduces risk by ensuring that product and process maturity are incrementally demonstrated before beginning follow-on activities.

Multidisciplinary Teamwork

Multidisciplinary teamwork is essential to the integrated and concurrent development of a product and its processes. The right people at the right place at the right time are required to make timely decisions. Team decisions, as a result of risk assessments, should be based on the combined input of the entire team (technical, cost, manufacturing, and support functions and organizations), including customers and suppliers. Each team member needs to understand his or her role and support the roles of the other members, as well as understand the constraints under which team members operate. All team members must operate to seek global optima and targets.

Empowerment

Decision making should be driven to the lowest possible level commensurate with risk. Resources should be allocated to levels consistent with risk assessment authority, responsibility, and the ability of people. The team should be given the authority, responsibility, and resources to manage its product and its risk commensurate with the team's capabilities. The authority of team members needs to be defined and understood by the individual team members. The team should accept responsibility and be held accountable for the results of its efforts. Management practices within the teams and their organizations must be team-oriented rather than structurally, functionally, or individually oriented.

Seamless Management Tools

A framework should be established that relates products and processes at all levels to demonstrate dependencies and interrelationships. A management system should be established that relates requirements, planning, resource allocation, execution, and program tracking over the product's life cycle. This integrated or dedicated approach helps ensure that teams have all available information, thereby enhancing team decision making at all

levels. Capabilities should be provided to share technical, industrial, and business information throughout the product development and deployment life cycle through the use of acquisition and support shared information systems and software tools (including models) for accessing, exchanging, validating, and viewing information.

Proactive Identification and Risk Management

Critical cost, schedule, and technical parameters related to system characteristics should be identified from risk analyses and user requirements. Technical and business performance measurement plans, with appropriate metrics, should be developed and compared to best-in-class government and industry benchmarks to provide continuing verification of the effectiveness and degree of anticipated and actual achievement of technical and business parameters.

EXPECTED BENEFITS OF IPPD

Applying the IPPD management philosophy can result in significant benefits to the customer, DoD, and industry. The primary benefits are reduced cost and schedule while maintaining, and often increasing, quality. Essentially, a more balanced tradeoff is achieved among cost, schedule, and performance. These gains are realized by the early integration of business, contracting, manufacturing, test, training, and support considerations in the design process, resulting in fewer costly changes made later in the process (e.g., during full rate production or operational test). Figure App 3.2 displays anticipated

Figure App 3.2 Traditional serial approach versus IPPD.

design changes resulting from IPPD implementation versus traditional (serial) acquisition approach, overlaid on a curve of relative cost of making changes. In a traditional approach, the most changes occur late in development, when change costs are high, resulting in higher program costs. In an IPPD process, most changes occur early in development, when change costs are low, resulting in lower program costs.

The traditional acquisition approach involved each specialist group completing its work in isolation and then passing results on to the next specialist group. This serial approach has resulted in stovepipe competition for organizational rewards. It establishes walls between organizations with resulting inefficiency and ineffectiveness, including a lack of networking and interfunctional communication.

Use of IPPD and IPTs is the antithesis of the traditional approach. The central notion is that product quality and user satisfaction can best be achieved by the integrated concurrent design of the product and its processes. For example, in IPPD, future process requirements are identified and integrated into the evolving product design while still very early in the design phase; however, IPPD does not stop with a one-time identification of process requirements. As product design matures, continued emphasis is placed on the processes, and their attendant costs, required to manufacture, operate, and support the product. This approach greatly reduces the risk associated with design and development. Product and process maturity are achieved earlier, obviating some of the costly late redesign efforts that characterize traditional developments. Moreover, the upfront tradeoffs result in more cost-effective designs. Designs can be optimized for cost effectiveness based not exclusively on acquisition cost, but on overall life-cycle cost. Such considerations can be critical, since operations and support costs may far exceed acquisition cost.

Successful IPPD implementation can result in:

- *Reduced overall time to deliver an operational product.* Decisions that were formerly made sequentially are now made concurrently and from an integrated perspective. These decisions are based on a life-cycle perspective and should minimize the number and magnitude of changes during manufacturing and eventual operational deployment of the product. This perspective, in turn, reduces late, expensive, test-fix and test-redesign remanufacture cycles that are prime contributors to schedule extensions and overruns.
- *Reduced system (product) cost.* Increased emphasis on IPPD at the beginning of the development process impacts the product/process funding profile (as shown in Figure App 3.2). Specifically, funding profiles based on historical data may not be appropriate. Some additional funds may be required in the early phases, but the unit costs as well as total life-cycle costs should be reduced. This will be primarily the result of reduced design or engineering changes, reduced time to deliver the system, and the use of tradeoff analyses to define cost-effective solutions.
- *Reduced risk.* Upfront team planning and understanding of technologies and product processes permits better understanding of risk and how it impacts cost, schedule, and performance. This understanding can result in methods or processes for reducing or mitigating assumed risks and establishing realistic cost, performance, and schedule objectives.
- *Improved quality.* Teamwork coupled with a desire for continuous improvement results in improved quality of the processes and a quality product for the user.

Index

Page numbers followed by 'f' denote figures; those followed by 't' denote tables.